THE LIBRARY OF GREAT PAINTERS

PAUL CEZANNE

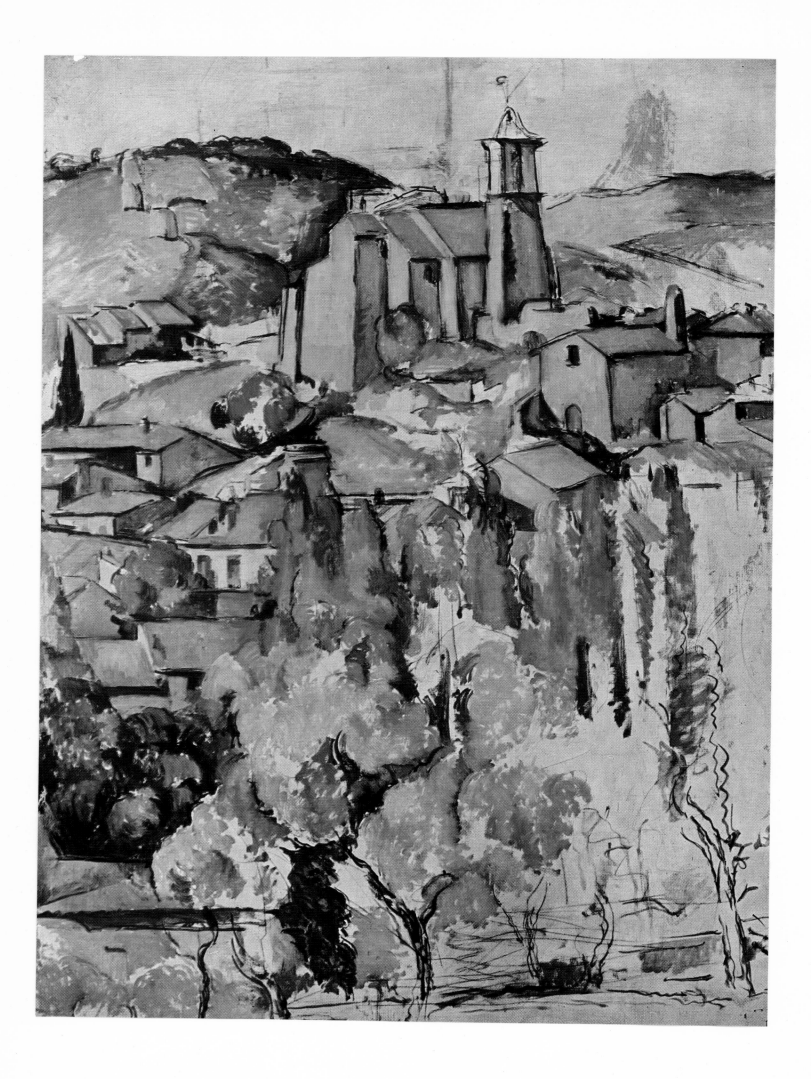

PAUL

CEZANNE

TEXT BY

MEYER SCHAPIRO

THE LIBRARY OF GREAT PAINTERS

HARRY N. ABRAMS, INC., *Publishers*, NEW YORK

Standard Book Number: 8109–0052–1
Library of Congress Catalogue Card Number: 63–5318
All rights reserved. No part of the contents of this book may be
reproduced without the written permission of the publishers,
HARRY N. ABRAMS, INCORPORATED, New York
Text printed and bound in the Republic of Korea
Illustrations printed in Japan

TABLE OF CONTENTS

PAUL CEZANNE

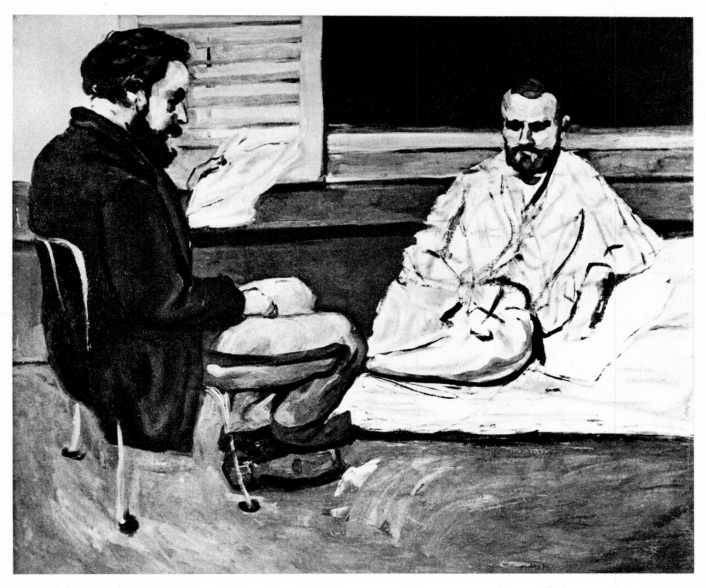

PAUL CEZANNE

by MEYER SCHAPIRO

THE MATURE PAINTINGS OF CÉZANNE offer at first sight little of human interest in their subjects. We are led at once to his art as a colorist and composer. He has treated the forms and tones of his mute apples, faces, and trees with the same seriousness that the old masters brought to a grandiose subject in order to dramatize it for the eye. His little touches build up a picture-world in which we feel great forces at play; here stability and movement, opposition and accord are strongly weighted aspects of things. At the same time the best qualities of his own nature speak in Cézanne's

works: the conviction and integrity of a sensitive, meditating, robust mind.

It is the art of a man who dwells with his perceptions, steeping himself serenely in this world of the eye, though he is often stirred. Because this art demands of us a long concentrated vision, it is like music as a mode of experience—not as an art of time, however, but as an art of grave attention, an attitude called out only by certain works of the great composers.

Cézanne's art, now so familiar, was a strange novelty in his time. It lies between the old kind of

picture, faithful to a striking or beautiful object, and the modern "abstract" kind of painting, a moving harmony of colored touches representing nothing. Photographs of the sites he painted show how firmly he was attached to his subject; whatever liberties he took with details, the broad aspect of any of his landscapes is clearly an image of the place he painted and preserves its undefinable spirit. But the visible world is not simply represented on Cézanne's canvas. It is re-created through strokes of color among which are many that we cannot identify with an object and yet are necessary for the harmony of the whole. If his touch of pigment is a bit of nature (a tree, a fruit) and a bit of sensation (green, red), it is also an element of construction which binds sensations or objects. The whole presents itself to us on the one hand as an object-world that is colorful, varied, and harmonious, and on the other hand as the minutely ordered creation of an observant, inventive mind intensely concerned with its own process. The apple looks solid, weighty, and round as it would feel to a blind man; but these properties are realized through tangible touches of color each of which, while rendering a visual sensation, makes us aware of a decision of the mind and an operation of the hand. In this complex process, which in our poor description appears too intellectual, like the effort of a philosopher to grasp both the external and the subjective in our experience of things, the self is always present, poised between sensing and knowing, or between its perceptions and a practical ordering activity, mastering its inner world by mastering something beyond itself.

To accomplish this fusion of nature and self, Cézanne had to create a new method of painting. The strokes of high-keyed color which in the Impressionist paintings dissolved objects into atmosphere and sunlight, forming a crust of twinkling points, Cézanne applied to the building of solid forms. He loosened the perspective system of traditional art and gave to the space of the image the aspect of a world created free-hand and put together piecemeal from successive perceptions, rather than offered complete to the eye in one coordinating glance as in the ready-made geometrical perspective of Renaissance art. The tilting of vertical objects, the discontinuities in the shifting levels of the segments of an interrupted horizontal edge (page 91), contribute to the effect of a perpetual searching and balancing of forms. Freely and subtly

Cézanne introduced besides these nice variations many parallel lines, connectives, contacts, and breaks which help to unite in a common pattern elements that represent things lying on the different planes in depth. A line of a wall is prolonged in the line of a tree which stands further back in space; the curve of a tree in the foreground parallels closely the outline of a distant mountain just below it on the surface of the canvas (page 75). By such means the web of colored forms becomes more cohesive and palpable, without sacrifice of the depth and weight of objects. These devices are the starting point of later abstract art, which proceeds from the constructive function of Cézanne's stroke, more than from his color. But however severely abstracted his forms may seem, the strokes are never schematic, never an ornament or a formula. The painting is finally an image and one that gives a new splendor to the represented objects.

Cézanne's method was not a foreseen goal which, once reached, permitted him to create masterpieces easily. His art is a model of steadfast searching and growth. He struggled with himself as well as his medium, and if in the most classical works we suspect that Cézanne's detachment is a heroically achieved ideal, an order arising from mastery over chaotic impulses, in other works the conflicts are admitted in the turbulence of lines and colors. In his first pictures, painted in the 1860's in his native Aix and in Paris, he is often moody and violent, crude but powerful, and always inventive—to such a degree that in his immaturity he anticipates Expressionist effects of the twentieth century. This early art is permeated by a great restlessness. Impressionism released the young Cézanne from troubling fancies by directing him to nature; it brought him a discipline of representation, together with the joys of light and color which replaced the gloomy tones of his vehement, rebellious phase. Yet his Impressionist pictures, compared to those of his friend, Pissarro, or to Monet's, are generally graver, more troweled, more charged with contrasts. Unlike these men, he was always deeply concerned with composition, for which he showed since his youth an extraordinary gift—he was a born composer, with an affinity to the great masters of the sixteenth and seventeenth centuries in the largeness of his forms, in his delight in balancing and varying the massive counterposed elements. The order he creates is no cool, habitual calculation; it bears evident signs of spontaneity and the bias im-

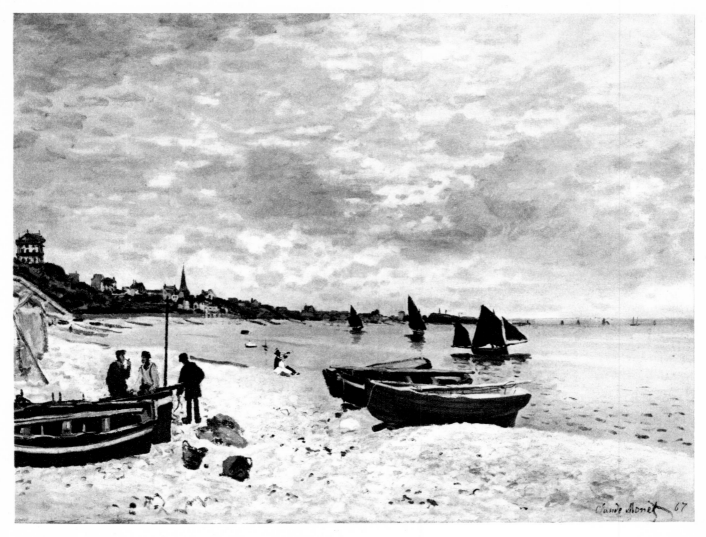

Monet THE BEACH AT SAINTE-ADRESSE (oil on canvas, 1867) *The Art Institute of Chicago*

posed by a dominant mood, whether directed towards tranquillity or drama. Some of his last works are as passionate as the romantic pictures of his youth; only they are not images of sensuality or human violence, but of nature in a chaos or solitariness responding to his mood. A great exaltation breaks through at times in his later work (page 125) and there is an earlier picture with struggling nudes (page 49) that tells us—more directly than the paintings of skulls and muted faces—of the burden of emotion in this shy and anguished, powerful spirit. Still more, the late works allow us to see the range of his art which transposes in magnificant images so vast a world of feeling.

T HIS, IN SHORT, is how Cézanne appears to us today. It is a broad account which says too little about the intimate character of his art. For that we must consider individual works and especially their color in a more attentive way.

It is instructive to see his *Bay from L'Estaque*

(page 63) beside an early painting by Monet, *The Beach at Sainte-Adresse* (above), which is also divided into land, sea, distant shore, and sky. In Monet's work the colors of these great zones are close to each other in relative brightness and strength. The blue-green of the sea is a delicate tint, the sky is a bluish grey with faintly pink clouds, and the sandy beach a warm grey with pale yellowish tones. A peculiar diluteness or greyness prevails in all these colors; it is subtle and the source of the airy charm of the work.

In Cézanne's picture, the large divisions of the landscape are re-enforced by tones of a great span of intensity and hue. The sea is a full blue robustly paired with orange in the foreground land and with a lighter green-blue tint in the sky; the lightness of this sky tint points up the intense greens on the red and orange shore. These great differences of intensity also suggest depth. The pairing of the blue and orange of the water and land, or of the green and orange within the land, is a much

stronger contrast than the pairing of the sky and the distant blue and violet shore.

In Monet's painting there is little range of intensity between the foreground beach and the sky. The differences between large fields are more delicate; the few intense tones are small scattered spots and the strongest single color is the blue of the boat beached at the right. The large areas around it look all the more neutral and pale. When, in later pictures, Monet uses brighter colors throughout, the contrast of the great zones is still restricted in span: strong blues are set beside strong greens. His principle remains in general the same: the sharpest contrasts of color are in small touches from point to point, and the colors of large adjacent fields are neighboring tones of the scale, with relatively little span. In a later version of a scene like *The Beach at Sainte-Adresse*, the four fields would be even less distinct.

To this difference in color corresponds a different treatment of the forms. In Cézanne's painting we feel at once the cohesion of the sea and earth as engaged counterpart shapes. Broadly similar, these inverted complementary forms are accented by the powerful contrasts in their colors. In Monet's picture, these triangles are less strongly defined and less firmly joined. Their bond is loosened not only by the dilute tones and the varying textures of the water and sand, but by stronger episodic contrasts with the small objects lying across them—the dark reddish sails on the pale green sea, and the blue and brown boats on the sand. In the *Bay from L'Estaque*, the major contrast of water and earth along a common sloping line is strengthened through the soft gradations beyond; the sky and the farther shore, together forming a rectangle like the sea and the foreground earth, are parallel horizontal masses with colors less sharply opposed.

Cézanne's colors, one might say, have more weight than Monet's. This is also true of his forms. He divides the surface of the canvas so that earth and sea leave little room for the filmy sky which continues their recession and seems to lie on their upward-tilted plane; while Monet's more substantial sky, with its mottled clouds, high above the observer, dominates the scene. Cézanne's earth and sea are a larger part of the whole; the diagonal is stronger, and the equilibrium of the painting has more suspense, a deeper drama of forms. His water is heavy; it cuts into the land, pressing downward into the hollow line of the shore. Monet's sea is translucent, bland and light; the boat on the shore cuts into the shallow water, which is carried easily, lifted up by the convex line of the beach.

To the use of these maximal forces of color and shape, Cézanne's painting owes its greater power and its air of permanence; from the attenuated contrasts, Monet's work acquires its delicacy and momentariness. His vision is directed towards small things which break up or interrupt the large continuous forms, like the passive eye that delights in the distractions of the unexpected and piquant. Hence the scattering of parts and the taste for the subtle surfaces of formless sand and cloud. Cézanne, no less attentive to nuance and detail, is more concentrated and absorbed, and more deeply moved by the grandeur of the scene.

It is often said that Monet is concerned with the flux of appearances, while Cézanne paints the timeless aspect of things. But Cézanne's picture is also an image of the landscape at a certain time of day, and renders with great truth the beautiful light and atmosphere of the Mediterranean coast. Both men seek out the flicker of tones; but Monet chooses a moment when atmosphere or light becomes an independent force imposing its own filminess or vibrancy upon the entire scene, reducing objects to vague condensations within the medium of air and light, while Cézanne discovers in air and light the conditions for the clearness and density of things. Monet and Cézanne proceed alike from a conception of the medium; for Monet it is the source or counterpart of an all-enveloping mood; Cézanne sees light as the eternal ground of the sensations through which he can reconstitute a stable and richly colored world of things.

THOUGH PAINTING DIRECTLY from nature, like the Impressionists, Cézanne thought often of the more formal art he admired in the Louvre. He wished to create works of a noble harmony like those of the old masters; in his talk about painting the name of Poussin comes up more than once as a model of great art. Not the method of seventeenth-century composition, but its completeness and order attracted Cézanne; in his own words, he wished to re-do Poussin from nature, that is, to find the forms of the painting in the landscape before him and to render the whole in a more natural coloring based on direct perception of tones and light. In a story by Duranty, the novelist and defender of the Impressionists, published posthu-

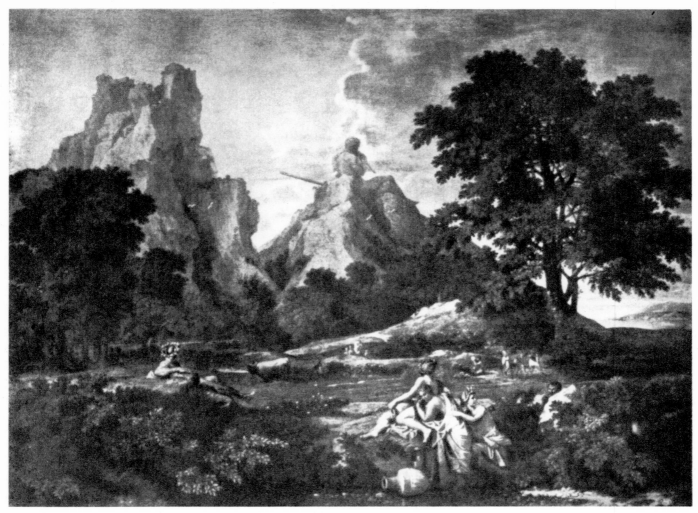

Poussin POLYPHEMUS (oil on canvas, about 1649)

mously in 1881, there is an Impressionist who copies a Poussin in the Louvre in scandalously bright tones.

What we call classic in a Poussin landscape proceeds in part from a concept of drama, while Cézanne would have us contemplate the stillness of a purely visual world from which all human action has been banished. In Poussin's *Polyphemus* (above) the mythical inhabitants of the landscape recline in the foreground, some of them watching the action like spectators in a theater. If we place ourselves among these spectators, our eyes are led from their rocky seats to the mountain on whose peak the giant sits, playing the flute. Cézanne, too, offers in his painting of Mont Sainte-Victoire (page 75) a vision of a central peak, flanked by trees. But while Poussin has arranged his scene like a dramatic spectacle focused on a dominant figure and enclosed by the landscape that forms its natural setting, Cézanne's open vista has been singled out by a moving observer from a unique or momentary point of view outside the scene. His landscape includes the foreground trees which are incomplete forms, cut by the spectator's framing eye. At the right, great branches sweep across the sky, parallel to the curve of the horizon. Yet in this view which unites in contrast and accord things near and far— the objects at the spectator's standpoint and those on which his eye is fixed—there is no path between foreground and distance. The spectator does not dwell in this landscape, and nothing that happens in it concerns him; he is suspended above the foreground, a pure contemplator for whom all nature is one—here the duality of action and contemplation hardly exists. If the superb mountain in the distance has an ideal balanced energy and repose— the opposite of the foreground trees—it is not accented as a focal object through light and dark or the broad symmetry of surrounding forms, as in the painting by Poussin, who even marks the axis of his giant by the luminous edge of a cloud, a beautiful echo of the trees. In Poussin's canvas the ideal spectator is closer to the objects he looks at;

the landscape is a grandiose setting for man, his natural home in which he is both actor and observer. Here man with his laurel crown is assimilated to the trees, while the savage giant is likened to the rocks. Cézanne's landscape is external to the solitary spectator, who is more self-consciously contemplative, seeking a vantage point where he can remain outside his vision. Yet his space is finally part of the landscape; his contemplation is, so to speak, comprised in the contemplated whole through the incomplete, marginal forms of the foreground trees which, in their restlessness, convey something of the turmoil of the observer who finds in the serenity of the distant view a resolution of his own conflicts.

In THIS COMPARISON with Poussin I have considered mainly the vision of the landscape, rather than the more intimate artistic aspects. Some will object that the themes of a painter have little to do with the value or character of his art. But I believe it is revealing to consider Cézanne's paintings as images of the real world—in doing so we have the support of his letters in which he often speaks of his joy in the sites he paints and the importance of his sensations and emotions before the bit of nature he selects for painting. The kind of objects that attract him, his point of view in representing them, count for something in the final aspect of the pictures and bring us nearer to his feelings.

His landscapes rarely contain human figures. They are not the countryside of the promenader, the vacationist, and the picnicking groups, as in Impressionist painting; the occasional roads are empty, and most often the vistas or smaller segments of nature have no paths at all. In many pictures the landscape, seen from an elevation, is cut off from the spectator by a foreground of parallel bands or by some obstacle of rocks or trees. We are invited to look, but not to enter or traverse the space. Cézanne has given us an ideal model in the painting of a path to a house which is blocked by a barrier in the foreground (page 81). Elsewhere a deep pit or quarry (page 111) lies between us and the main motive; or steep rocks obstruct the way inward (page 79). The ground itself, extending into the far distance, is often broken and difficult, without the neat roads, marked by trees and buildings, that carry us through the breadth and depth of the land in the earliest Western landscapes. The nature admired and isolated by Cézanne exists

mainly for the eye; it has little provision for our desires or curiosity. Unlike the nature in traditional landscape, it is often inaccessible and intraversable. This does not mean that we have no impulse to explore the entire space; but we explore it in vision alone. The choice of landscape sites by Cézanne is a living and personal choice; it is a space in which he can satisfy his need for a detached, contemplative relation to the world. Hence the extraordinary calm in so many of his views—a true suspension of desire.

The same—or a similar—attitude governs also his choice of still life. This may seem paradoxical, for the idea of still life—an intimate theme—implies another point of view than landscape. Indeed, Cézanne is unique among painters in that he gives almost equal attention to both types of subject. We can hardly imagine Poussin as a painter of still life or Chardin as a landscapist. Yet common to both themes is their relative inertness, their non-human essence. That Cézanne was able to represent still life and landscape alike shows how deeply he was possessed by this need for painting what is external to man. But in the still life, as in the landscape, it is the choice of objects and his relation to them that are important. Here again we discover a unique attitude which is significant for his art as a whole.

Still life in older painting consists mainly of isolated objects on the table conceived as food or decoration or as symbols of the convivial and domestic, or as the instruments of a profession or avocation; less common are the emblems of moral ideas, like vanity. Things that we manipulate and that owe their positions to our handling, small artificial things that are subordinate to ourselves, that serve us and delight us—still life is an extension of our being as masters of nature, as artisans and tool users. Its development coincides with the growth of landscape; both belong to the common process of the humanizing of culture through the discovery of nature's all-inclusiveness and man's power of transforming his environment.

Cézanne's still life is distinctive through its distance from every appetite but the aesthetic-contemplative. The fruit on the table, the dishes and bottles, are never chosen or set for a meal; they have nothing of the formality of a human purpose; they are scattered in a random fashion, and the tablecloth that often accompanies them lies rumpled in accidental folds. Rarely, if ever, do we find

in his paintings, as in Chardin's, the fruit peeled or cut; rarely are there choice *objets d'art* or instruments of a profession or hobby. The fruit in his canvases are no longer parts of nature, but though often beautiful in themselves are not yet humanized as elements of a meal or decoration of the home. (Only in his early works, under Manet's influence, does he set up still lifes with eggs, bread, a knife, and a jug of wine.) The world of proximate things, like the distant landscape, exists for Cézanne as something to be contemplated rather than used, and it exists in a kind of prehuman, natural disorder which has first to be mastered by the artist's method of construction.

The qualities of Cézanne's landscapes and still lifes are also present in his human themes, at least after 1880.

Many writers have remarked on the mask-like character of Cézanne's portraits. The subject seems to have been reduced to a still life. He does not communicate with us; the features show little expression and the posture tends to be rigid. It is as if the painter has no access to the interior world of the sitter, but can only see him from outside. Even in representing himself, Cézanne often assumes an attitude of extreme detachment, immobilized and distant in contemplating his own mirror image.

The suspended palette in his hand is a significant barrier between the observer and the artist-subject (page 65).

This impersonal aspect of the portraits is less constant than appears from our description. If their abstractness determines the mood of some portraits, there are others of a more pathetic, responsive humanity.

The idea of painting portraits, foreign to Poussin, is already an avowal of interest in a living individual. We must admit that Cézanne's contemplative position varies with his objects (and with his mood at the moment); some draw him nearer than others, involving him in a current of emotion.

But as we turn from the isolated human figure to the group, entering the domain of the social, his detachment becomes even more marked than in the landscapes. His bathers, and especially the women, are among the least "natural" of all his subjects. Except for secondary distant figures in a few versions, there is little sportiveness among these idyllic nudes in the open air. Most often they neither bathe nor play, but are set in constrained, self-isolating, thoughtful postures. They belong together as bathing figures, but like his still life objects their relations are indeterminate and we can imagine other groupings of their bodies which

HOUSE AMONG TREES (water color, 1890–1900) *The Museum of Modern Art, New York (Lillie P. Bliss Collection)*

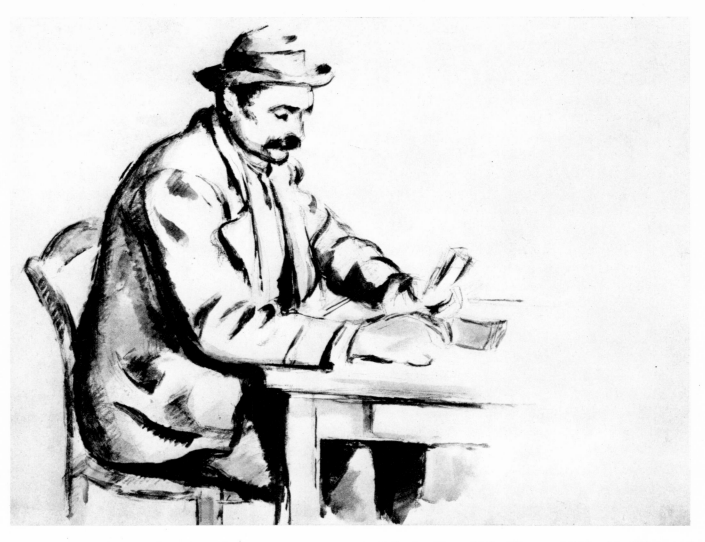

CARD PLAYER (water color, 1890–92)　　　　　　　　　*Collection Mr. and Mrs. Chauncey McCormick, Chicago*

will not change their meaning. Transpositions of older images of mythical nudes, which expressed a dream of happiness in nature (still vivid in Renoir's pictures), Cézanne's bathers are without grace or erotic charm and retain in their unidealized nakedness the awkward forms of everyday, burdened humanity. The great statuesque nude (page 69) in the Museum of Modern Art stands for all the bathers in the strange combination of walking and pensiveness, with contrasted qualities of the upper and lower body.

The *Card Players* (page 89) is perhaps the clearest example of Cézanne's attitude in interpreting a theme. It is a subject that has been rendered in the past as an occasion of sociability, distraction, and pure pastime; of greed, deception, and anxiety in gambling; and the drama of rival expectations. In Cézanne's five paintings of the theme we find none of these familiar aspects of the card game. He has chosen instead to represent a moment of pure meditation—the players all concentrate on their cards without show of feeling. They are grouped in a symmetry natural to the game; and the shifting relation between rules, possibility, and chance, which is the objective root of card playing, is intimated only in the silent thought of the men. Cézanne might have observed in an actual game just such a moment of uniform concentration; but it is hardly characteristic of the peasants of his Provence—their play is convivial and loud. In selecting this intellectual phase of the game—a kind of collective solitaire—he created a model of his own activity as an artist. For Cézanne, painting was a process outside the historical stream of social life, a closed personal action in which the artist, viewing nature as a world of variable colors and forms, selected from it in slow succession, after deliberating the consequence of each choice for the whole, the elements of his picture. (In a letter to Pissarro he has likened the landscape of L'Estaque to playing cards, but what he had in mind were the stark contrasts of the colors of the bright

16

Provençal scene, as in the flat primitive designs on the cards.) The painting is an ordered whole in which, as Cézanne said, sensations are bound together logically, but it is an order that preserves also the aspect of chance in the appearance of directly encountered things.

Observation of his subjects shows then a fairly uniform or dominant attitude. Within the broad range of themes—and no other artist of his time produced this variety, at least in these proportions —Cézanne preserves a characteristic meditativeness and detachment from desire. His tendency coincides with what philosophers have defined as the aesthetic attitude in general: the experience of the qualities of things without regard to their use or cause or consequence. But since other painters and writers have responded to the religious, the moral, the erotic, the dramatic, and practical, creating for aesthetic contemplation works in which the entire scope of everyday life is imaged, it is clear that the aesthetic attitude to the work of art does not exclude a subject matter of action or desire, and that Cézanne's singular choice represents an individual viewpoint rather than the necessary approach of artists. The aesthetic as a way of seeing has become a property of the objects he looks at; in most of his pictures, aesthetic contemplation meets nothing that will awaken curiosity or desire. But in this far-reaching restriction, which has become a principle in modern art, Cézanne differs from his successors in the twentieth century in that he is attached to the directly seen world as his sole object for meditation. He believes—as most inventive artists after him cannot do without some difficulty or doubt—that the vision of nature is a necessary ground for art.

Turning now to the process of painting, let us see how the content of his imagery is related to the artistic substance of his work.

We will begin with his drawing, which was perhaps the most disturbing feature to his contemporaries. His many deviations from correctness have been explained as the result of a defect of the eye. But they are not so uniform that one can attribute them to an anomaly of vision; besides, we judge from many works, early and late, that Cézanne knew how to draw "correctly." On the other hand, it is unlikely that all his modifications of perspective and of the familiar shapes of objects were due to a rigorous ideal of unity. The great painters of the fifteenth to the seventeenth centuries, masters of composition with highly unified styles, were able to harmonize natural forms in a strict perspective. If Cézanne gave up both the perspective system and the precise natural form, it was because he had a new conception of painting with which these could not be reconciled.

In his landscapes and still lifes, the convergence of foreshortened lines tends to be blunted and the movement inward is slowed up (pages 61, 81); an extreme example is the side of a house drawn as if in the same plane as the front that faces us, much as in a child's drawing (page 71). To understand this blunting of the convergence, let us imagine Cézanne's painting of a table top re-done in correct perspective form.

Considered as a shape, Cézanne's version looks somewhat fuller and more solid. We are not pulled inward with the same intensity; the outline, approaching the form of the actual table, is also more like the rectangle of the canvas. If the depth is less marked and the dramatic movement to a vanishing point very much reduced, the whole seems nearer to us; we feel more strongly both the table and the canvas as objects. Finally, we observe that Cézanne's table, more irregular than both the real table and the apparent perspective form, is a unique piecemeal construction; we see it as something put together rather than as a single whole.

Among the curved forms, the "squaring" of the ellipses of pots and dishes agrees with the blunting of foreshortened lines of the table (pages 55, 61). Like the latter, it does not arise from a particular position of the eye, arbitrarily chosen by Cézanne, but is a pattern that satisfies the same needs as the pattern of the table. The flattening of the curve arrests the intensity of recession; it is also an approach to the real object-form, the fullness of the circular opening, and assimilates the latter to the rectangle of the canvas. It is, besides, more stable than the correct ellipse would be, and is often set above a simple horizontal line at the base of the vessel, contrary to perspective laws. The composite character of the ellipse as a drawn shape is even more pronounced than the same aspect of the table's outline. The free variations of the ellipse within the same picture increase this effect.

This last aspect reappears in the surprising discontinuities of edges. The horizontal line of a table, interrupted by falling draperies and other objects, emerges again at another level (page 61). (The

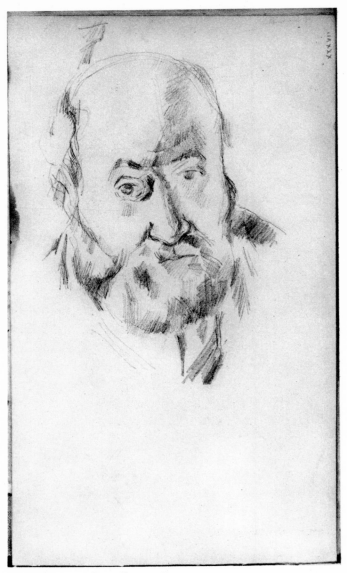

SELF-PORTRAIT (pencil, 1886?)

The Art Institute of Chicago

distortion usually does not interfere with our perception of the table; we see the table top as a continuous surface underneath the overlapping objects.) This peculiarity has been explained as the result of a frequent shifting of Cézanne's viewpoint while looking at the objects; but it occurs also in his vertical lines, in walls and tree trunks and bottles, and is often so marked that we must ask why he shifted his eye or accepted the result of such shifting, if that is indeed the cause.

If we are to look for the source of such breaks of alignment in direct perception, we shall find it more readily perhaps in the minute changes that occur in the apparent size and shape of an object (or a part of an object) when it is brought close to another, as in the optical illusions which have been explained as phenomena of figural contrast. But such odd perceptions have first to be accepted as

eligible for painting, and this requires a special attitude to the visual, different from the customary one which admits only what is constant in the form of an object and its perspective foreshortenings. It may be that just as the Impressionist painters introduced into their pictures the so-called simultaneous contrasts of color, for example, the fugitive sensation of red induced in vision by a bright green —what had once been described as "ghost colors" and studiously subtracted from perception by the artist as a perturbing factor in his effort to capture the true local color of an object—so Cézanne was attentive to the induced contrast effects in his perception of neighboring forms and represented the resulting apparent deformations, with more or less intensity, on the canvas. For the Impressionists, who wished to overcome the bareness and inertness of local color, it was precisely these volatile, "subjective" contrast colors that gave to the painting a greater vibrancy and truth to sensation, the evidence of the artist's live sensibility. But Cézanne, unlike the Impressionists, was much concerned with the constant object-form and with local color; and unlike the older artists, he built up this object-form and local color out of his immediate impressions, including the most subtle and unstable effects of contrast. The subjective in his perceptions has then a quite different role than in these other styles. Yet we are not sure that the shifting alignments and other distortions in Cézanne's work can be explained by such visual facts alone, although he might have been encouraged to draw more freely because of his experience of the fine inconstancy of forms in perception. We must also take into account their expressive aspect, the new qualities they contribute to the picture, just as the deformations of his perspective produce an effect of stability and reduced tension.

Compared with the normal broken line of an interrupted and re-emerging edge, Cézanne's shifting form is more varied and interesting; by multiplying discontinuities and asymmetry, it increases the effect of freedom and randomness in the whole. It is a free-hand construction through which his activity in sensing and shaping the edge of the table is as clear to us as the objective form of the original table. We see the object in the painting as formed by strokes, each of which corresponds to a distinct perception and operation. It is as if there is no independent, closed, pre-existing object, given once and for all to the painter's eye for representation,

but only a multiplicity of successively probed sensations—sources and points of reference for a constructed form which possesses in a remarkable way the object-traits of the thing represented: its local color, weight, solidity, and extension.

The strokes that build up the objects in all their compactness are open forms. The edge of an apple is shaped by innumerable touches that overlap each other, but also slip into the surrounding objects. The outline sometimes lies paradoxically outside the apple (page 77). Yet its discontinuous strokes are no different finally from those that model the continuous solid mass of the fruit.

Cézanne once experessed the wish to paint nature in complete naiveté of sensation, as if no one had painted it before. Given this radically empirical standpoint, we can understand better his deformations of perspective and all those strange distortions, swellings, elongations, and tiltings of objects that remind us sometimes of the works of artists of a more primitive style who have not yet acquired a systematic knowledge of natural forms, but draw from memory and feelings. We cannot say how much in Cézanne's distortions arises from odd perceptions, influenced by feeling, and how much depends on calculations for harmony or balance of forms. In either case there is an expressive sense in the deformation, which will become apparent if we try to substitute the correct form. Some accent or quality of expression will be lost, as well as the coherence of the composition which has been built around this element. In general, one may say that for Cézanne a strict perspective would be too impersonal and abstract a form. The lines converging precisely to a vanishing point, the objects in the distance becoming smaller at a fixed rate, would constitute too rigid a skeleton of vision, a complete projective system which precedes the act of painting and limits the artist. But with his desire for freshness of sensation, he could retain those space-building devices which are not bound to a fixed armature of converging lines: the overlapping of objects and the variation of contrast of tones from the foreground to the distance. The loosening of perspective had already been prepared by the Impressionists and older artists who were more attentive to color, light, and atmosphere than to the outlines of things and painted directly from nature, without a preliminary guiding framework. But Cézanne's deviations, which are accompanied by a restoration of objects, have other roots.

How are these peculiarities of form related to Cézanne's conception of the objects? We have observed that just as he often selects themes which have little attraction for desire, he represents objects in space so as to reduce the pull of perspective to the horizon; the distant world is brought closer to the eye, but the things nearest to us in the landscape are rendered with few details—there is little difference between the textures of the near and far objects, as if all were beheld from the same distance. To his detached attitude correspond also those distortions and breaks that reduce the thrust of dominant axes and effect a cooler expression. Cézanne's vision is of a world more stable and object-filled and more accessible to prolonged meditation than the Impressionist one; but the stability of the whole is the resultant of opposed stable and unstable elements, including the arbitrary tiltings of vertical objects which involve us more deeply in his striving for equilibrium. In the composition, too, our passions are stilled or excluded; only rarely is there a dramatic focus or climax in the grouping of objects and their rich colors. The composition lacks in most cases—the *Women Bathers* and the *Card Players* are exceptions—an evident framework of design, an ideal schema to which the elements have been adapted and that can be disengaged like the embracing triangle in older art. The bond between the elements, the principle of grouping, is a more complex relationship emerging slowly in the course of work. The form is in constant making and contributes an aspect of the encountered and random to the final appearance of the scene, inviting us to an endless exploration. The qualities of the represented things, simple as they appear, are effected by means that make us conscious of the artist's sensations and meditative process of work; the well-defined, closed objects are built up by a play of open, continuous and discontinuous, touches of color. The coming into being of these objects through Cézanne's perceptions and constructive operations is more compelling to us than their meanings or relation to our desires, and evokes in us a deeper attention to the substance of the painting.

The marvel of Cézanne's classicism is that he is able to make his sensing, probing, doubting, finding activity a visible part of the painting and to endow this intimate, personal aspect with the same qualities of noble order as the world that he has imaged. He externalizes his sensations without

strong bias or self-assertion. The sensory element is equally vivid throughout and each stroke carries something of the freshness of a new sensation of nature. The subjective in his art is therefore no isolated, capricious thing, but a manifestation of the same purity as the beautiful earth, mountains, fruit, and human forms he represents.

I T HAS BEEN SAID that a classic artist is a repressed romantic. Although this hardly applies to all classic artists, it seems particularly true for Cézanne, who grew up during a period of romantic art. His earliest works contain many themes of sensuality and violence. They are pictures of murder, rape, orgy, temptation, and stormy nature, painted with a wild energy and conviction. It is a tenebrous, melodramatic art; powerful, even savage; unconstrained in conception and force of contrast; executed with a heavily loaded brush or with the troweled strokes of the palette knife; but always harmonious in color and with many striking inventions in the forms. If Cézanne had died in 1870 be-

LOUIS-AUGUSTE CÉZANNE (oil on canvas, 1860–63)
Collection Raymond Pitcairn, Bryn Athyn, Pa.

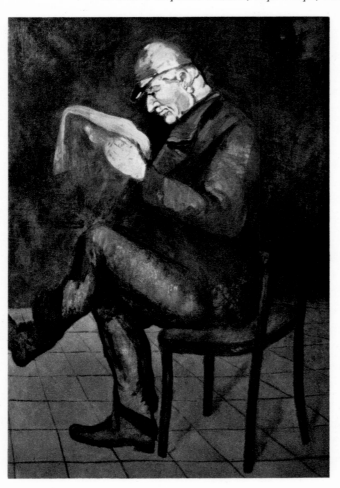

fore he matured as a painter, we would surely notice these works and be astonished by their freedom. It is the art of a solitary spirit, a refractory being who works naively from impulse, almost a madman. Yet some of the forms anticipate basic devices of his later, slowly deliberated art; and there is a virile largeness of conception which is a permanent character of his style.

When in the later 1860's, under the influence of Manet and the new taste for scenes of picnics and boating parties—the weekend pastorals of the middle class of the cities—he undertakes to represent this gayer world, he transforms it into an atmosphere of dream or a haunted imagery of desire (page 35). In a version of the *Luncheon on the Grass* (page 22), he outdoes Manet by painting three nude women and three clothed men. One of the latter, like Cézanne in appearance, lies on the bank in an attitude of grave thought. The trees, with their projecting shapes, are more pronounced than the human beings and echo their forms; and near the center of the space, Cézanne has designed an exotic symmetrical pattern of a tall tree and its reflection in the water, which terminates below near an analogous bottle and wine glass, the counterparts of the paired men and women. Such activation of the landscape through vaguely human forms is rare in the painting of the time. The background of Manet's *Luncheon* (page 23) is an almost shapeless foliage in keeping with the indifference of the conversing figures. Cézanne approaches the pastoral theme in a more passionate spirit; where the Impressionist blurs the elements of the landscape, Cézanne over-interprets them, endowing them with the feelings or relationships insufficiently expressed in the human figures. The picture abounds in odd parallelisms and contrasts, independent of nature and probably issuing from unconscious impulses, as in psychotic art.

The character of his early work agrees with what we learn of the young Cézanne from his letters and the accounts left by his friends. He appears in these documents an unsociable, moody, passionate youth who is given to compulsive acts which are followed by fits of despair. He is one of those ardent temperaments tormented by profound feelings of inadequacy, whose shyness does not constrain their imagination but stirs it to more urgent and inspired expression. The fact of his illegitimate birth—repaired by the later marriage of his parents—and the humble origin of his devoted mother, who had

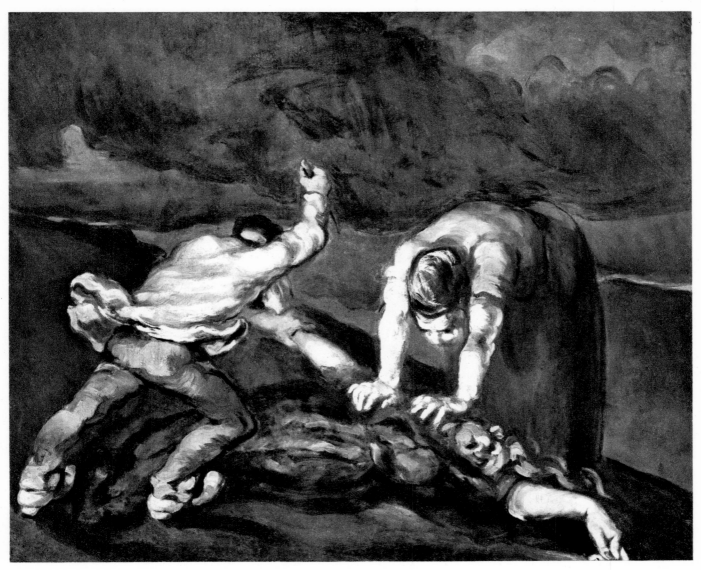

THE MURDER (oil on canvas, 1870) *Museu de Arte, São Paulo, Brazil*

been a worker in his father's shop, tell us nothing certain about the formation of his character. But we know of a prolonged struggle with his powerful father whom he feared greatly and who destined him, as the only son, for the family bank, sending him to law school against his wishes. Since his boyhood in Aix, in the company of his fatherless schoolmate, Émile Zola, he had filled his mind with dreams of literature, art, and the vague freedom of a bohemian existence. His youthful letters alternate between ironical self-disparagement and fulsome verses on the joys of nature and imaginary loves. The one mention of a real woman concerns a working-girl in Aix whom he dares not approach and who, he discovers, is already loved. These letters contain also fancies of a macabre violence in prose and verse, centering on women and the family. They have been ignored as immature effusions, but they are worth considering for the light they throw on Cézanne's personality and his relations to his parents. With ferocious humor, he describes and illustrates in a Dantesque hell a family at table devouring a severed human head offered by the father. (Elsewhere he rhymes "Cézanne" with "*crâne*"—skull.) In a visionary poem, we see him beset in a dark forest on a stormy night by Satan and his demons; at the sound of a coach drawn by four horses, the devils disperse; within the coach he discovers a beautiful woman whose breast he kisses—she instantly turns into a horrid skeleton which embraces him. In still another poem, "The Dream of Hannibal," written in mock-classical style, the young hero, after a drunken bout in which he has spilled the wine on the tablecloth and fallen asleep under the table, dreams of his terrible father who arrives in a chariot drawn by four white horses. He takes his debauched son by the ear, shakes him angrily, and scolds him for his drunkenness and

wasteful life and for staining his clothes with sauce, wine, and rum. These fantasies convey something of the anxiety of the young Cézanne under the strict regime of his father. They lead us to ask whether in his lifelong preoccupation with still life there is not perhaps an unconscious impulse to restore harmony to the family table, the scene and symbol of Cézanne's conflict with his father.

With all this emotional tumult, there is in the young Cézanne an irrepressible will to achievement, a devotion to art more stubborn than Zola's. He finally won his father's consent, more by his tenacity than because of any obvious promise as a painter. The family's support—at first modest and conditional and later, at his father's death, enough to free him from all economic cares—was indispensable for the maturing of his work; helpless in practical matters, he could hardly have survived otherwise. In twin photographs of the painter and his father we recognize an evident opposition of temperament in the faces of the tense, introspective artist and the old, self-made merchant and provincial banker, with his shrewd, confident air of the French bourgeois of the old style launched by the Revolution; but the son has his own certitude, too, an obstinate concern with *his* affair which is perhaps not unconnected with the example of the strong-willed and severe philistine father.

Whatever the roots of his character and of his call to art, Cézanne as a painter begins with the ideas and possibilities of his time. Born in Aix in 1839, he grows up in a province where the teaching of art is of the old-fashioned academic kind, but where the Romantic poets and painters awaken the young to ideas of liberty. In 1860, Delacroix was still alive, a heroic model of revolt in art. For over thirty years painting in France had been a field of great insurgent movements. The concept of mod-

LUNCHEON ON THE GRASS (oil on canvas, 1870) *Collection J.-V. Pellerin, Paris*

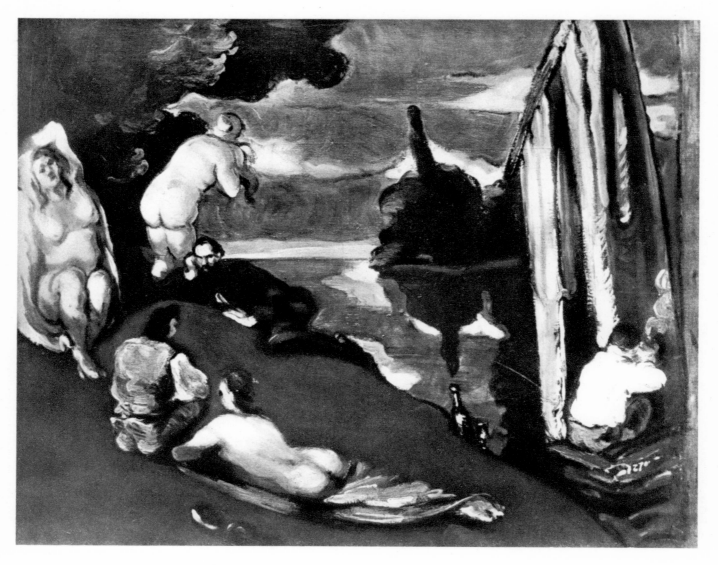

22

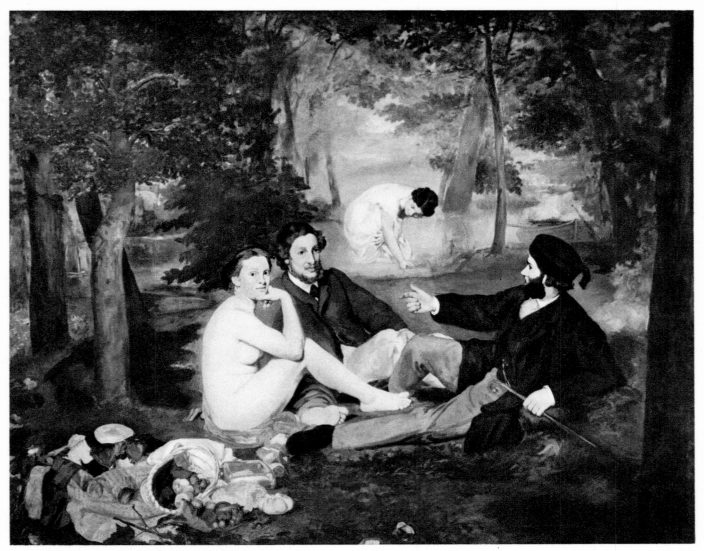

Manet LUNCHEON ON THE GRASS (oil on canvas, 1863)

The Louvre, Paris

ernity—the notion that art has to advance constantly, in step with a changing contemporary outlook independent of the past—was well established. To become a painter then was to take a stand among contending schools and to anticipate an original personal style. It was, above all, to be an individual. Courbet said at this time that he was a painter in order to win his freedom, and that he recognized no authority other than himself—"I too am a government"

This sentiment of personal independence stimulated by the revolutions in France made artistic life tense with combat and self-assertion. The Romantic movement had left a powerful heritage in the rebellious attitude of artists, and the sober middle class in turn looked down on the advanced painters and poets as a disorderly crowd of doubtful morality and use. The existence of a caste of academic artists who decided the purchase of paintings by the State and excluded the new forms from the Salon, pro-

voked violent reactions among the young independent painters. These formed loose groups united by a common interest against the officials of art; many were anarchist or vaguely radical in thought, although their art was unpolitical in theme. So strong was this opposition in 1863 that the Emperor Louis Napoleon, who had suppressed the Republic by force twelve years before and had now to face a growing political unrest, was compelled to grant a special showing of the works rejected by the jury of the Salon.

Cézanne was one of those who exhibited in this Salon des Refusés. He had come to Paris in 1861 just after the battle over Realism, a turning point in art. From the very first, he declared himself a Realist, although in practice his art hardly conformed to the Realist approach. As a young man in conflict with his strict bourgeois father and restless from unsatisfied dreams of love, he was attracted by the advanced artistic milieu in Paris with its freer life

and rebelliousness against authority. Courbet's Realism had been connected at first with democratic ideas; to the public his *Stone-Breakers* and his *Burial at Ornans* were a continuation of the radicalism of 1848. The painting of "Reality"—as opposed to the imaginary or exotic scenes of Romantic and Neo-Classical art—meant, among other things, the picturing of the lower classes, and had a tendentious sense. The assertion that direct experience was superior to imagination implied also a criticism of traditional beliefs.

But by 1860, the defense of Realism, while insisting that the contemporary, everyday world was the only matter for a modern art, had lost much of its earlier political suggestiveness. It was more concerned with temperament and tones and with the charm of nature sincerely observed than with the realities of lower class life. A general concept of modernity as new experience, movement, and self-reliance replaced the social awareness of 1848. If Realism did away with the Romantic scenes of pathos, the art of Manet and the young Impressionists preserved something of Romantic color and sensibility in their new themes of performers, spectacle, traffic, and holiday pleasure. Instead of *The Barque of Dante* and *The Raft of the Medusa,* they painted the boating parties on the Seine. What is striking in the 1850's and 1860's is precisely this change from a painting of action to a painting of movement without drama in the landscape and human milieu.

Thus Realism, at first ambitious to represent society as a whole, became a purely lyrical art. Courbet himself was to say that he painted from nature according to his sensations of color without knowing what it was he represented. Such subtle naiveté was an ideal of the artists of the 1860's who admired Courbet chiefly for his tones. It is at this time that arises the practical concept of "pure painting" of which Manet is the great exemplar. Pure painting meant the dedication to the visual as a complete world grasped directly as a structure of tones, without intervention of ideas or feelings about the represented objects; the objects are seen, but not interpreted (although we recognize, today, how much this pure painting depends on the taste for a particular world of pleasurable objects and a passive attitude to things).

The young Cézanne responded to this new state of French art in an original way. "Reality" meant to him, as to Zola, the courageous experience of life, as opposed to the tormenting futility of adolescent dreams. But a career of art was itself an uncertain dream, and the decision to become a painter, instead of resolving Cézanne's self-doubt, created a new source of anguish. He took over the direct approach of Courbet and Manet, but he could not assimilate their art fully, since painting was for him a release of the passions. He lacked Manet's cool virtuoso spirit and was incapable of the young Impressionists' delicate, unsentimental enjoyment of nature. His brush strokes were an assault on the canvas, which he sometimes destroyed in despair, and the palette knife was for a while his chief instrument. For rendering his dark moods, he found congenial models in the realistic Baroque paintings of the old Spaniards and Italians, with their dramatic contrasts of light and deep shadow, and in the French Romantic tradition. Although he painted some mythical themes, Cézanne's fantasies should not be mistaken for the Romantic imagination which represented ideal episodes of the past, admitting the contemporary only in remote scenes or great events. It was in opposition to this now declining taste for the borrowed and idealized image that Cézanne could regard his own impassioned pictures as realistic. Delacroix, too, imagined scenes of violence and despair—because of the frequent massacres, Baudelaire called his art a "molochism" —but the figures, inspired by his reading, were set in a distant time or place. Cézanne's painting is a more direct instrument of the self and represents a violence in everyday life, with figures in contemporary dress. A similar violence colors the first writings of his closest friend, Zola, whose stories are passionate in tone and deal with extreme situations: murder, suicide, horror, and hallucination. Even in avowing an exact, dispassionate realism as his aim, Zola uses a macabre image; in the preface to *Thérèse Raquin* (1868), he writes of his characters that he wishes "to note scrupulously their sensations and actions: I have simply performed on these two living bodies the job of analysis that surgeons do on cadavers."

In 1869 Cézanne formed a stable union with a beautiful young girl, Hortense Fiquet, who was later to become his wife. How this affected his art, one can hardly say. But in the following years it develops toward refinement; he is inspired by Manet, whom he now appreciates more for his tones and exquisite execution than for his startling contrasts. The remarkable still life *The Black Clock*

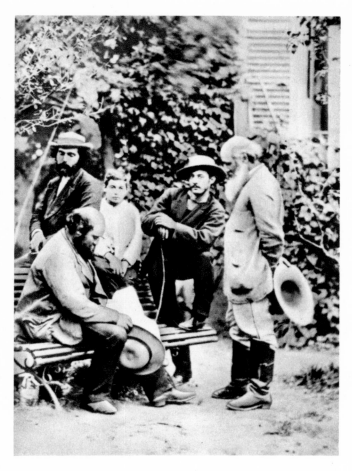

Cézanne (seated) and Pissarro (standing at right), 1877
Collection John Rewald, New York

are, with a few exceptions, still governed by the tonalities of studio painting.

Pissarro's personality was surely important for the change. He was more than a teacher and friend to Cézanne; he was a second father. Cézanne spoke of him with veneration—thirty years afterwards he called him "the humble and colossal Pissarro"; "he is a man to consult, and something like the good Lord." Cézanne had left Paris to live near Pissarro shortly after the birth of his child, whom he loved dearly but could not reveal to his own father in Aix; his common-law marriage was still a secret. Looking at the photograph of the two men, taken at the time they worked together (page 25), we are surprised to learn that the white-bearded Pissarro (born in 1830) was only nine years older than his pupil. Both had aged prematurely. Their heads are similarly bowed, and we sense a spiritual accord between them which we do not feel in the twin photographs of Cézanne and his father. Pissarro, too, had come to painting against the wishes of his family after having abandoned a business career. The fact that he was something of an outsider, a Jew, was significant perhaps to the rebellious young

Photograph of Cézanne, about 1871
Collection John Rewald, New York

(page 37), the great unfinished *Portrait of Alexis and Zola* (page 9), are examples of this new absorption of Manet. The first looks studied—it is an accumulation of brilliant painterly effects—yet retains some traces of his earlier passionateness. The second, based on Manet's portrait of Zola, is simpler and exceedingly subtle in tones—a beautiful scale of black, blue, and grey; in its breadth and harmony of spacing, it surpasses Manet.

Nevertheless, during this period his original vehemence persists, as in the views of L'Estaque, painted in the winter of 1870–71.

THE DECISIVE CHANGE came through Impressionism. Cézanne had known the Impressionists and especially Pissarro in the 1860's. As early as 1866 he avowed to Zola his desire to work only in the open air and to capture the "true and original aspect of nature" which he missed in the old masters. But this program, which was also that of the Realists, had to wait until 1872 when he apprenticed himself to Pissarro and worked with him directly from nature in the country around Pontoise and Auvers. His outdoor pictures before this time

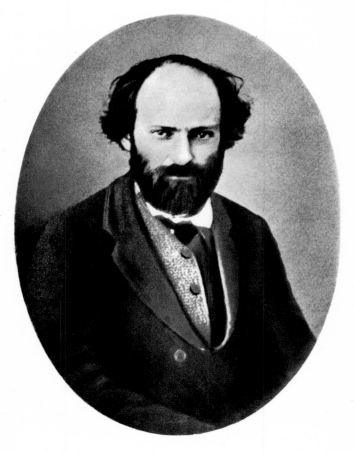

Cézanne. All through his life, Pissarro was faithful to his generous anarchist convictions. In the Impressionist circle he stood out as the most ethical personality, the head of a large family, and the most seriously concerned about others; his fine letters are impressive for their sympathy and gentle wisdom. Among the painters of his advanced group, he was the most eager to learn from others and the most appreciative of their varied genius. Although he painted some admirable pictures of Paris and Rouen, there is little of the urban rococo feeling of the time in his art—the scenes of picnics and boating parties and holiday crowds and the charm of modern costumes, which today give an historical interest to so many Impressionist pictures. A disciple of Corot, he is perhaps the most idyllic of the Impressionists, the only painter of peasants in that group.

Pissarro taught Cézanne a method of slow, patient painting directly from nature. It was a discipline in seeing, which led him to replace by fresh colors all those conventional gradations and brusque passages of light and dark that had served him as modeling or as dramatic accents. The Impressionist approach thus made painting for Cézanne more visual, freeing him from his too impulsive imagination without sacrificing his need for a vigorous style. It evoked in him a receptive, aesthetic attitude, awakening him to the intimate charm of landscape after it had possessed him through its power and dark moods. His first flower pieces date from this time. Under the new teaching, Cézanne reduced the stress of contrasts in favor of a soft harmony. The rhythm of the brush stroke shifted from the great drive of impulse to the steadier flicker of sensations; the stimulus came more from outside than from within. The big forms were broken up or interrupted by little touches; composition lost its dramatic sweep, becoming more decorative and minute through variations of color from point to point (page 45). Even in the most casual sketches we feel that Cézanne is now very conscious of the canvas as well as of nature. He has a new habit of studying the smallest units of the painting.

Cézanne's art for a few years after 1872 is Impressionist in spirit and method. But his paintings are no less clearly those of a unique artist of a different inclination than the other Impressionists. No other member of that group was so disposed to tangible forms and to the order of responding lines.

Even in works of a loosened, delicate play of colored spots, like the *View of Auvers*, we recognize a will to construction in the vertical and horizontal strokes. With all its luminosity and atmosphere, *The Suicide's House* (page 43) is severe and grave, an anchored form rare in the Impressionist painting of the time. When shown beside those of the other Impressionists in 1877, Cézanne's pictures stood out already as works of a classic spirit. The critic, Rivière, described them as Greek, comparing them with the art of the greatest period of antiquity. It is astonishing that he should have written this, for what we regard today as Cézanne's classic or constructive phase had barely begun.

The characteristics of this later phase have already been described. I shall not analyze in detail the interesting process of its development, which may be followed broadly in the color plates from the *Chocquet Seated* (page 51) and the *Compotier* (page 55) through the pictures of the mid-eighties (pages 67, 73), although some important stages and variants are not represented in the plates. This development is not uniform; it looks somewhat different if we attend to the landscapes rather than the still lifes or figure pieces.

Much has been written about Cézanne's new rigor of composition and plastic use of color; but I would emphasize the importance of the object for this new style. There is here a kind of empiricism, naive and deeply sincere, which is a necessary condition of the new art. In reconstituting the object out of his sensations, Cézanne submits humbly to the object, as if in atonement for the violence of his early paintings. The object has for him the same indispensable role that the devotion to the human body had for the Greeks in creating their classic sculpture. The cohesiveness, stability, and individual character that Cézanne strove for in the painting as a whole he also sought in realizing on the canvas the object before him. It is true that he had always been a studious painter of objects, and even in his Impressionist phase he rarely carried the dissolution of things in atmosphere and sunlight as far as did the other Impressionists. But compared to his older painting, the new weight and clearness of the object are a true reform of his art. Just before 1875 we observe in his landscapes and still lifes much unstable spotting, a rich, picturesque blur of color; the composition, though unified, is not as legible through the contours of things, and lacks the noble simplicity of the later works. The closer scrutiny of

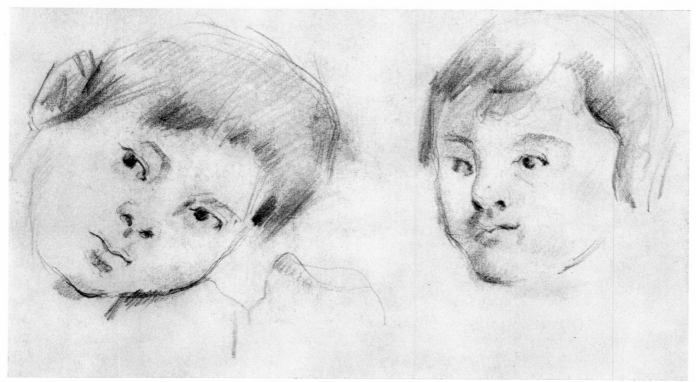

TWO STUDIES OF THE ARTIST'S SON (pencil, 1876?) *The Art Institute of Chicago*

the object goes hand in hand with a firmer consolidation of the canvas as a whole. I should add, however, that the new feeling for the object is anticipated on the margin of the Impressionist style, in the early 1870's, in his careful studies of still life which are like exercises—little paintings of a few apples, precious for the purity of vision of the roundness and color of the fruit. In the 1880's, Cézanne presents objects very simply and frankly, often in centered arrangements like the primitives, but with an aspect of chance in the varied positions and overlappings, which are balanced with a powerful ingenuity. Cézanne had been thinking seriously about the grouping as well as the appearance of objects, and had no doubt learned much from the masters in the Louvre.

Although cézanne becomes more conservative in his thinking as he grows older, he never becomes settled in his art. The years from 1890 to his death in 1906 are a period of magnificent growth. The still lifes of the 1890's include works of an imposing complexity and sumptuousness; the formerly simple background is filled with richly ornamented drapes, the table and its surroundings are often cut oddly by the frame and are set at an angle in space; the tilting of objects is more pronounced. The Louvre *Still Life with Apples* (page 103), the

Still Life with the Cupid (page 99), and the *Portrait of Geffroy* (page 95) are great examples of this new elaboration of the canvas, which is more than an assertion of mastery. The abundant colors and forms, a luxury of the senses, awaken ideas of pleasure, and through the odd perspectives involve the observer more intimately in the space of the objects. In their open and unstable forms, these paintings may be compared to the Baroque style that followed the art of the classic Renaissance.

This development of Cézanne does not exclude, however, his practice of the other pole. While creating these baroque still lifes, he produced also the series of *Card Players* and the *Women Bathers* in Philadelphia (page 117)—works in the classic mode, with an ideal compactness and stability. They show that for Cézanne the broad conceptions and even the single features which are called classic and baroque, were not a final goal of his art, but only single possibilities which he explored for what they were worth, as ideas of form suited to different demands of his nature. Already in the 1880's, he produced a work like *The Blue Vase* in the Louvre (page 77) in which the main grouping is a simple parallel alignment of objects, yet the angle of the background and the bottle cut by the frame belong to a more baroque approach, which we feel also in details of the sketchy execution. The polarity of

27

styles that had become evident since the seventeenth century in the divergence between the followers of Rubens and Poussin in France and in the nineteenth century between Ingres and Delacroix, was for Cézanne no longer an artistic problem. Both poles were available to him as equally valid conceptions which he discovered within his own experience in looking at nature as well as in the museums. The alternative constructions of depth by parallel or diagonal receding planes were familiar to him very early. As an Impressionist in the 1870's, he painted many views of landscapes with sharply receding houses and roads at the same time that he set up still lifes of a simple formality before a wall parallel to the plane of the canvas. As a youth, he adored Delacroix; but he also painted for the family salon in a linear style a series of panels of the Four Seasons which he signed in mock-heroic spirit with the name of Ingres (perhaps to please the taste of his father whose portrait was in the central field). But unlike those who in admiring both artists supposed that Classic and Romantic were incompatible kinds of art—the art of the colorist and the art of the pure draftsman—Cézanne discovered a standpoint in which important values of both could co-exist within one work. (This was also the goal of the mad Frenhofer, the tormented hero of Balzac's moving story, *The Unknown Masterpiece*, in whom Cézanne once recognized himself.) The fact that his classic style, stable and clarified as any work of Raphael, was built upon color and the directly given space of nature already freed him from the narrow partisan views. Firmly dedicated though he was to color and to nature, he filled his notebooks in his journeys through the Louvre with drawings after sculptures of the Renaissance and the seventeenth century. In his thought, the essence of style was no longer sufficiently defined by the categories of classic and romantic. These were only modes in which a personal style was realized, more concrete than either. In this new relation to the old historical alternatives, Cézanne anticipates the twentieth century in which the two poles of form have lost their distinctness and necessity. Since then, in Cubism and Abstraction, we have seen linear forms that are open and painterly that are closed, and the simultaneous practice of both by the same artist, Picasso.

But the baroque aspect is only a part of the originality of his late works. What strikes us most of all in the 1890's is the resurgence of intense feeling—it may be related to the new tendencies of the forms with their greater movement and intricacy. The work of his last years offers effects of ecstasy and pathos which cannot be comprised within the account of Cézanne's art as constructive and serene. The emotionality of his early pictures returns in a new form.

The truth is that it had never died out. When Cézanne in the 1870's was converted to the Impressionist method, he repudiated romantic art in ironical sketches of a *Homage to Woman* in which the painter, the poet, the musician, and the priest all celebrate the Eternal Feminine who poses in shameless nudity before them. He continued to paint the nude, at first in versions of Saint Anthony's temptation, then in groups of bathers who recall in their postures the nude women of the hermit's imagination. But later there are bacchanals, scenes of violent passion, and copies of Delacroix's *Medea Slaying Her Children* and *The Abandoned Hagar and Ishmael in the Wilderness*. These fanciful themes are only a small part of Cézanne's later work and had little effect on the main course of his art after 1880. Yet it is worth noting these exceptional pictures—they permit us to see more clearly how the new art rests on a deliberate repression of a part of himself which breaks through from time to time. The will to order and objectivity has the upper hand in the 1880's, although he does not exclude his feelings altogether. He understands the emotional root of his need for order and can speak of "an exciting serenity." Besides that strangely impersonal self-portrait in which the artist is assimilated to his canvas, easel, and palette (page 65), there is another, now in Bern, in which Cézanne, without signs of his profession, gazes at us in sadness and self-concern, a figure of delicate frame, painted with a feeling half-Gothic, half-Rembrandtesque. The inner world of solitude, despair and exaltation penetrates also some landscapes of this time. One of them, *The Great Tree* (page 109), a work of tumultuous feeling, with swaying form and tall crown of foliage silhouetted against the deep blue sky, revives the sentiment of verses about a tree that he had composed as a boy thirty years before, under the spell of the Romantic poets.

In the last years of his life he often seeks out themes of grandiose solitude. He loves the secluded, shadowy interiors of the woods, rocky ledges, unused quarries, ruined buildings—sites where man

is no longer at home and which are marked by the violence of nature. He recreates on his canvases a space, still detached, but even farther from humanity, in which his old aggressive impulses have been transposed to nature itself. For the early scenes of murder and rape and gloomy introspection, he substitutes an abandoned catastrophic landscape. It is the world of a hermit who is still occupied with his own impurity and guilt but can feel, too, in the stony or overgrown solitude some ecstasies of sense. He alternates between the dimness of the forest and the dry, burning heat of the sun in the silence of the quarry. Ideas of death are never far away. Returning to his studio, he delights in painting skulls upon the table where he had recently piled the red fruit and adjusted the folds of cloth. Among the great works of this time is the portrait of a young man meditating before a skull, like another hermit Jerome. (Is there here some identification with himself—the son remembering the father whom he had once pictured ironically with a skull at table?)

These ideas of solitude and death and nature's violence are not in themselves the ground of the baroque tendency in his forms, although it would be hard to imagine certain of these late scenes in the calm style of the 1880's. The angular view and greater depth of the still lifes, their new elaborateness, can hardly come from the same sentiment as the pictures of pathos. Yet, considered together beside the earlier phase, they are alike in their aspect of movement and intensity. The emotions of the contemplating mind have begun to have their say and stamp the painting with their mood, whether of melancholy or exaltation. We have from this time a number of pictures in which a single note of color or accent of form dominates the whole, unlike the more tempered, balanced works of the preceding period. The old Cézanne paints the peak of Mont Sainte-Victoire isolated from its base and the surrounding valley and plain as a striving, culminating object, all in blue like the sky; the forest scenes are sometimes suffused with a violet haze, and the redness of the Provençal rocks imposes itself on the whole canvas. There is here a willing abandonment of measure, but without loss of control. In other landscapes the pathos of solitude and obstacles gives way to a visionary mood, a mystical immersion in nature's hidden depths—the *Pines*

and Rocks in the Museum of Modern Art is a beautiful example.

In still other works, particularly in the forest scenes, but also in the open landscapes (page 125), the formless vegetation is translated into large mottled patches of pulsing color, so large and yet so unconfined by contours, that they approach the state of a pure painting without objects, in which the density of things has been transferred to the single chords of color—great elemental forces. In the continuous play of spectral tones, in the passionate dissolution of objects, this late art seems a revived Impressionism, but of incomparably greater weight and conviction than the earlier phase. It is altogether unlike any Impressionist work in the daring extremity of its idea; the color is independent of sunlight and seems to owe its force to intense local colors released in a climactic decomposition of the solid material objects. In such paintings Cézanne belongs to the twentieth century, anticipating by a few years the art of the Fauves and Expressionists. Here again, he is not completely held by one emotion, and in the same years he produces works in which this explosion of color is only an element of a whole conceived with a more constrained fervor, as in the noble portrait of his gardener, Vallier (page 127).

CÉZANNE'S ACCOMPLISHMENT has a unique importance for our thinking about art. His work is a living proof that a painter can achieve a profound expression by giving form to his perceptions of the world around him without recourse to a guiding religion or myth or any explicit social aims. If there is an ideology in his work, it is hidden within unconscious attitudes and is never directly asserted, as in much of traditional art. In Cézanne's painting, the purely human and personal, fragmentary and limited as they seem beside the grandeur of the old content, are a sufficient matter for the noblest qualities of art. We see through his work that the secular culture of the nineteenth century, without cathedrals and without the grace of the old anonymous craftsmanship, was no less capable of providing a ground for great art than the authoritative cultures of the past. And this was possible, in spite of the artist's solitude, because the conception of a personal art rested upon a more general ideal of individual liberty in the social body and drew from the latter its ultimate confidence that an art of personal expression has a universal sense.

Indispensable for the study of Cézanne is the catalogue of his works by Lionello Venturi, Cézanne, son art, son oeuvre *(2 volumes, Paris, Paul Rosenberg, 1936, 1600 illustrations). I have followed Venturi's datings of almost all the pictures reproduced here. For the criticism and interpretation of Cézanne, I have received the greatest stimulus from Roger Fry,* Cézanne, a Study of His Development *(New York, Macmillan, 1927), and Fritz Novotny,* Cézanne und das Ende der wissenschaftlichen Perspektive *(Vienna, Schroll, 1938). The translation of a letter of Cézanne's on page 48 is taken from Gerstle Mack,* Paul Cézanne *(New York, Knopf, 1935), to which I owe also my acquaintance with the early letters and poems of Cézanne.*

COLOR PLATES

Painted about 1866

UNCLE DOMINIC AS A MONK

Collection Mr. and Mrs. Ira Haupt, New York

$(25\frac{5}{8} \times 21\frac{1}{4}'')$

THE YOUNG CÉZANNE made several pictures of passion and dark fantasy. In portraying his uncle—his mother's brother—in the costume of a monk, he avowed a desire for solitude and for mastery over the flesh. During this period he also painted a large canvas of the Temptation of Saint Anthony. The choice of the white Dominican robe is perhaps more than a play on the uncle's name. The order had been revived some years before by the preacher Lacordaire, an ardent religious figure who stirred the youth of France by his attempt to win the Catholic church for republican ideals and later opposed the dictatorship of the Emperor Louis Napoleon. Many painters, especially among the Romantics, were drawn to Lacordaire who founded a society for the renewal of religious art. The Dominican order was a retreat for despairing romantic spirits.

The painting of Uncle Dominic is not a true portrait, but something between an ideal symbol and a masquerade, through which the artist could re-live his own struggles and dream of release. Painted in the solitude of the family estate near Aix, it is the image of a strong, fleshy person who strives to contain his passions through the religious habit—it encloses the somber, powerful head yet allows the body to show its fullness—and through the self-inhibiting gesture, a crossing or reversal of the hands, which is a kind of resignation, a death of the self.

The opposites of the sensual and the meditative, the expansive and self-constraining, are well expressed here. The color is imbued with the pathos of the conflict. A scheme of white, grey, and black plays against the ruddiness and earthen tones of the flesh. We pass from white to black through a cold series of bluish tones and a warm series of yellows, reds, and browns. The cold, piercing gleam of blue in the neckpiece brightens the whole. The execution, rude and convinced, is of a rare vehemence, even ferocity, like an Expressionist painting; the palette knife is its chief instrument, raising a relief of thick pigment. Within the common intensity of the paint each large area has its own texture and rhythm of handling.

The conception has a certain grandeur through its simplicity. The figure fills the space to bursting, but is also rigid. The starkness of the form is moving. The dark spots of the face and hands are like three leaves on the common stem of the axis marked by the cross. This cross, in line with the vertical of the left sleeve and tying the head to the hands, is part of a longer double-armed cross formed by the lines of the left hand and sleeve—a remarkable invention that points to later works in which such continuities of neighboring objects are a constructive, anti-dramatic device. The projecting tip of the hood is a sensitive point, prolonging and narrowing the head and displacing its axis—a vaguely spiritual, even Gothic suggestion; it is like the pointed tips of the hands, through which these are further assimilated to the head.

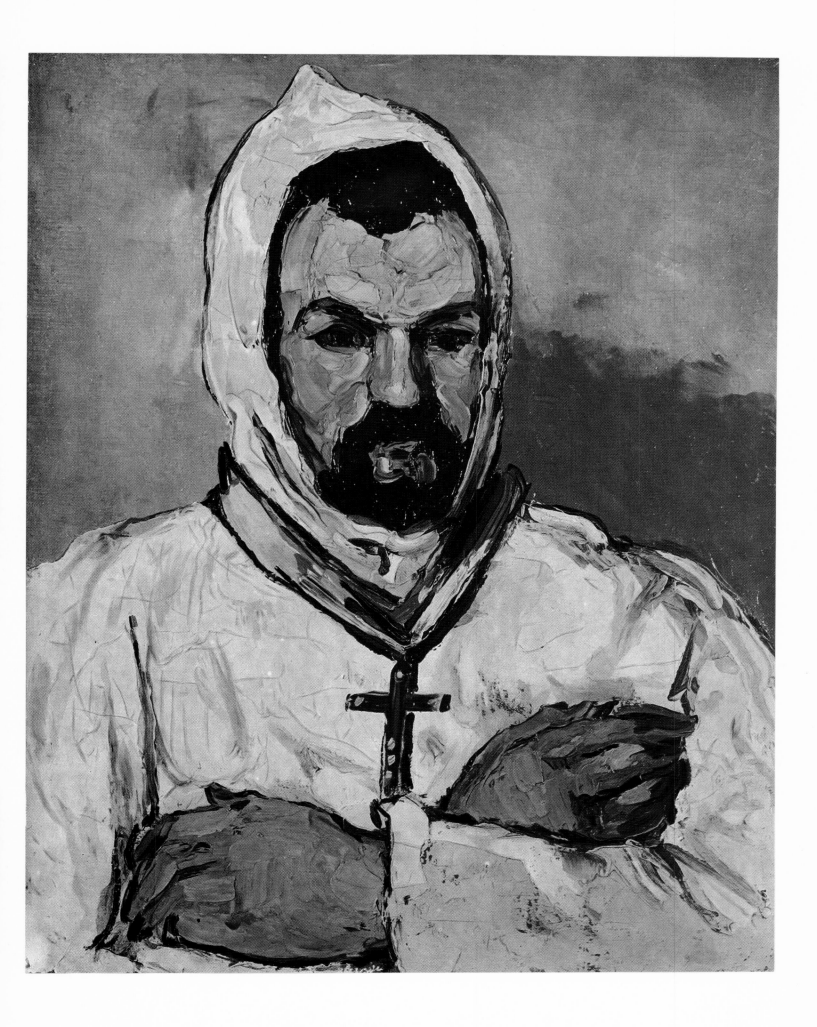

Painted about 1869

THE PICNIC

Collection Mr. and Mrs. René Lecomte, Paris

$(23\frac{5}{8} \times 31\frac{7}{8}'')$

THE ORDINARY MEANINGS OF A PICNIC are overlaid here by a strange, dream-like atmosphere. Above a tablecloth spread out on the grass, on which lie nothing but two oranges—the apparent objects of the meditations of the figures—hovers a tall, bent woman with loosened golden hair, a sibyl who holds a third orange in her extended hands, as if performing a sacramental rite or pronouncing an incantation. She turns her gaze to the frock-coated, gesturing man in the foreground; he resembles the young, prematurely bald Cézanne. In the distance stands a solemn, rigid figure, smoking a pipe, with folded arms like a guard or a celebrant of a ritual; on the left, a man and woman, dressed like Cézanne and the sibyl, go off into the dark woods arm in arm (as in a picture by Watteau, *L'Accord Parfait*).

Painted not long after Manet's *Luncheon on the Grass* (page 23), at a time when the picnic was a favored theme as a type of modern idyll—a refreshment of the senses and the whole being through air, light, and informal play—this picture is a measure of Cézanne's distance from the mood of his contemporaries, even of those to whom he feels closest. His burdened spirit does not enter easily into the freedom and gayety of his friends. He is the odd man at the party, the one without a woman, and among the men in shirtsleeves he is exceptional in his more formal dress. He cannot surrender to the innocence of the occasion; it is full of mystery and doubts. The third fruit intimates a question.

In this troubled fantasy Cézanne was not far from Manet's scandalous picture. There two men in formal city dress sit with a nude woman—a second bathing woman is hidden in the distance under an exotic bird. In juxtaposing the naked and the clothed, Manet pointed too directly and dispassionately to the instincts behind the picnic. (The grave philosopher of evolution and progress, Herbert Spencer, explained the vogue of the picnic as a reversion to savagery.) In Cézanne's mind the picnic called up hidden, personal meanings which the Impressionists ignored in their light-hearted images of the theme. The dog and the paired parasol and hat in the right corner belong perhaps to that underground sense.

Cézanne's early paintings are often regarded as immature sketches, too impetuous to permit the critical pondering of forms that gave order to his later work. Yet the abrupt, nervous execution and the roughness of detail should not hide from us the strength of the canvas; there is nothing banal in its forms. The concentration of the figures about the white cloth, the silhouetting of the tall woman against the dark woods, and the parallel tree trunk at the right, are striking effects. The young Cézanne was acutely aware of the grouping and found the right directions and spotting of colors for the tense expression he desired. Interesting for his later art is the continuity of the horizontal cloud and the edge of the woods; we see this device again in the edge of the tablecloth and the sibyl's hem. Time has darkened the color, submerging the nuances in the large areas; but the play of somber neutralized tones of warm and cool shows Cézanne's natural, even exquisite, feeling for harmony.

34

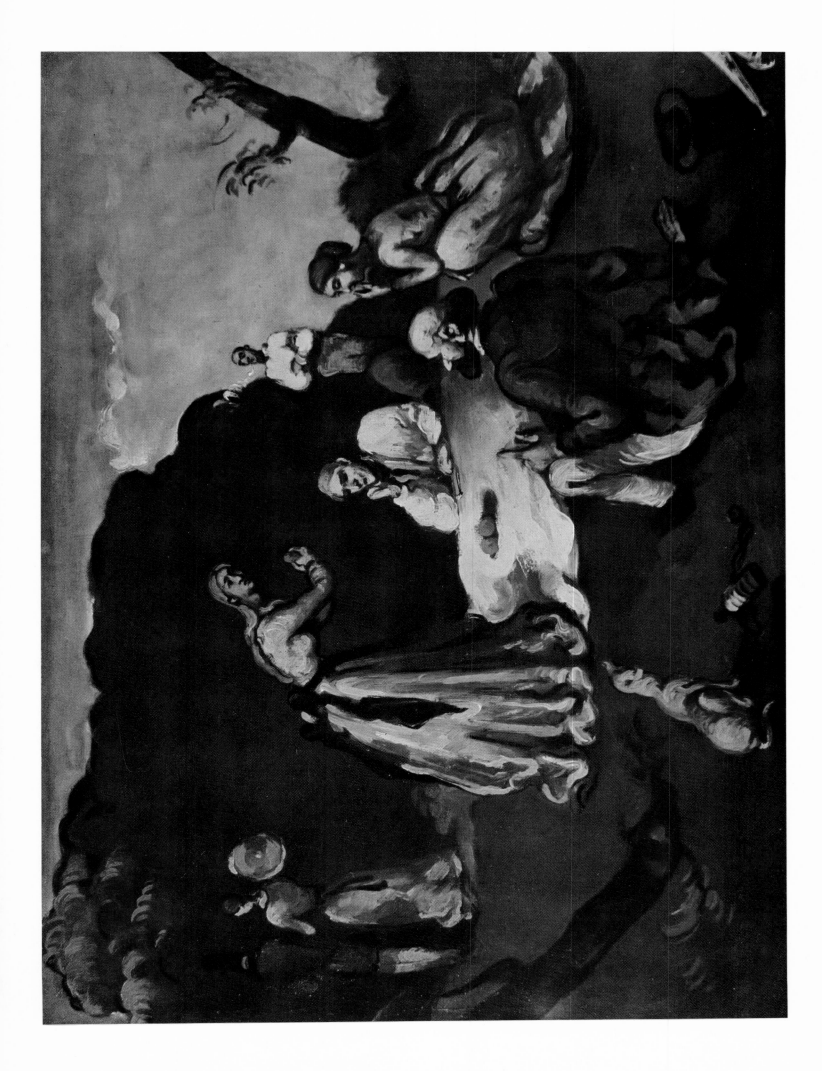

Painted about 1870

THE BLACK CLOCK

Collection Stavros Niarchos

$(21\frac{1}{4} \times 28\frac{3}{4}'')$

BY THE END OF THE 1860's the need for carefully considered, nuanced painting—decisions made stroke by stroke—was already part of Cézanne's nature. Much in his later still lifes—their composition and serious mood—may be found in this canvas. It is astonishing to see how the young Cézanne is able to combine the finesse of tones separated by tiny intervals of brightness and hue with bold contrasts in the large areas and lines. The dominant white-grey-black pointed up with sharp yellow and red, and the breadth and virility of touch, recall Manet. The conception of the still life is also like Manet's in such elements as the chocolate cup and saucer, the lemon, and the ormolu clock—objects of piquant taste and shiny texture. But the profusion of things, the varied execution, in places thick and rough, elsewhere thin and transparent, and, above all, the monstrosity of the shell, reflect another temperament—more intense, involved, and ungainly. Like Manet, Cézanne turned to still life as a subject matter inciting contemplation of contrasts and harmonies latent in the neighborliness of different silent objects touched by the same light. Manet savored the objects, distilling their essences of texture and light (and even of taste and fragrance) with a magically sure brush; while Cézanne, a more gravely contemplative mind, studied them as the model of a complete world, a semblance of both nature and man, in which order and freedom, regularity and chance, could be made visible throughout. But at this point in his career, feeling is important in his choice of things to paint; there are, we sense, vague fancies behind the clock without hands and the huge sea shell with reddened gaping mouth. Twenty years later, he will place a plaster Cupid among the fruit, and still later a human skull.

The shell is the most richly colored and organic-looking object of all and stands out against the severity of the neighboring lines. There is a baroque exuberance in its upper edge, and we see its influence in the scalloped vertical band behind it and in the contrasted zigzag mouth of the glass vase as well as in the billowing rumpled cloth at the right.

The beauty of this little painting—it is a surprise to see how small it is—lies especially in the play of dark and light, not simply as light and shadow but as a harmony of tones concentrated at the black and white ends, with the most delicate variations of cool and warm. The zone of middle values is less rich. To the scale of light and dark values corresponds the scale of opposed verticals and horizontals tempered by the few curves. The varying lengths, intervals, and colors of these straight forms are finely conceived. The rhythm is clearest in the table cloth with its spacing of folds in progressively broader bands and changing contrast of shadow and light. The whites of the cloth are picked up and varied in the objects above; and its darker accents reappear within the same objects and the background. Each of the still life pieces is wonderfully painted and deserves the closest scrutiny as an original little world of color, light, form, and the painter's touch.

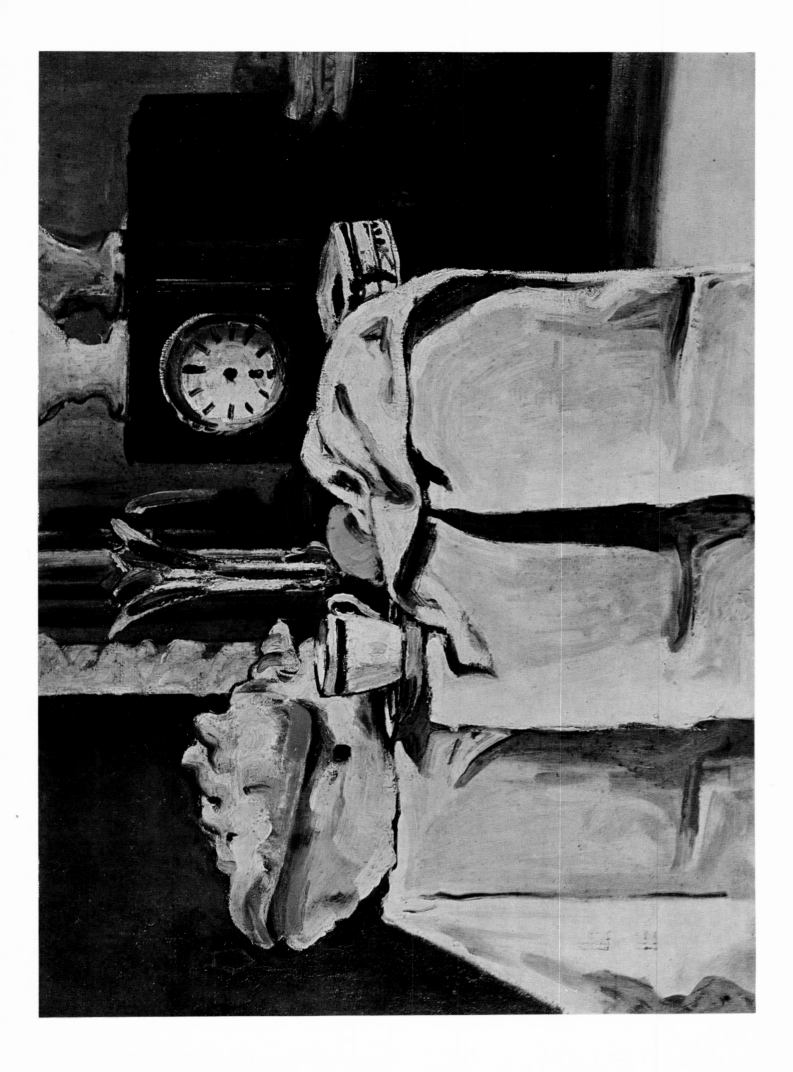

Painted 1870–1871

L'ESTAQUE, MELTING SNOW

Collection Emil G. Buhrle, Zurich

$(28\frac{3}{4} \times 36\frac{1}{4}'')$

WHEN THE WAR WITH PRUSSIA broke out in 1870, Cézanne evaded military service; he was not eager to die for Louis Napoleon and the Second Empire. He hid at first on the family estate in Provence and later in L'Estaque, a small manufacturing town on the Mediterranean near Marseilles. While there, he did this original winter landscape which has more the aspect of twentieth-century painting than of the French art of his time.

It is a remarkable example of a space that has been shaped by intense feeling, as in the work of van Gogh a decade or more later. The foreground—the observer's space—is a steep hillside which divides the canvas diagonally in its avalanche descent from left to right down to the sloping red roof, and gives a rushing force to the image. There is no foothold for the spectator, and the trees on this unsteady ground maintain themselves on twisted trunks. To this downward slope of the hill are opposed the rapid recession of the middle field with its rising, converging lines, and the immense horizontal sweep of the overhanging grey clouds. From the dark foliage of the tormented black tree at the left starts another movement of trees descending inward on the crest of the hill and merging with the distant horizon in a single rhythm of declining pulse. The foreshortened diagonal lines in depth are parallel to the diagonal profiles in the plane of the canvas; the sinuous contour of the earth—the whole ground of the scene—is repeated in the form of the great tree trunk and in the amazing zig-zag of roof and roads at the right. By these parallels Cézanne unites into a coherent pattern the opposed movements in different planes in depth. The color, too, is a powerful force in holding together the near and far. It is obvious in the grouping of the red roofs; but Cézanne also ties the distant sky to the foreground through the cold flashing lights on the horizon—white touches that are skillfully adapted to the adjoining silhouette, forming a minor zigzag halo centered over the peak of a hill which corresponds to the viewpoint of the entire scene. Cézanne has discovered the dramatic in space, an effect of great movements and brusque oppositions. The perspective has an irresistible urgency in the swift flight of lines and the rapid rhythm of change in the diminishing size of things.

Color and brushwork sustain the hurricane violence of the scene. A blackish tint permeates the landscape, and even the snow, which in places is a pure unmixed tone, seems a partner of black. Painted in stark contrasts, with an overwhelming, almost monotonous fury—less to capture the essence of a changing scene than to express a gloomy, desperate mood—the picture has some subtle tones: the varying whites of the snow and the many greys, including the warm tones of the middle ground set between the red roofs. The taste for cold black, cold white and grey, seems natural to Cézanne's mood; but this taste presupposes Manet's elegant and impassive art of which the tones and the directness of vision have here been put to emotional use and strangely transformed.

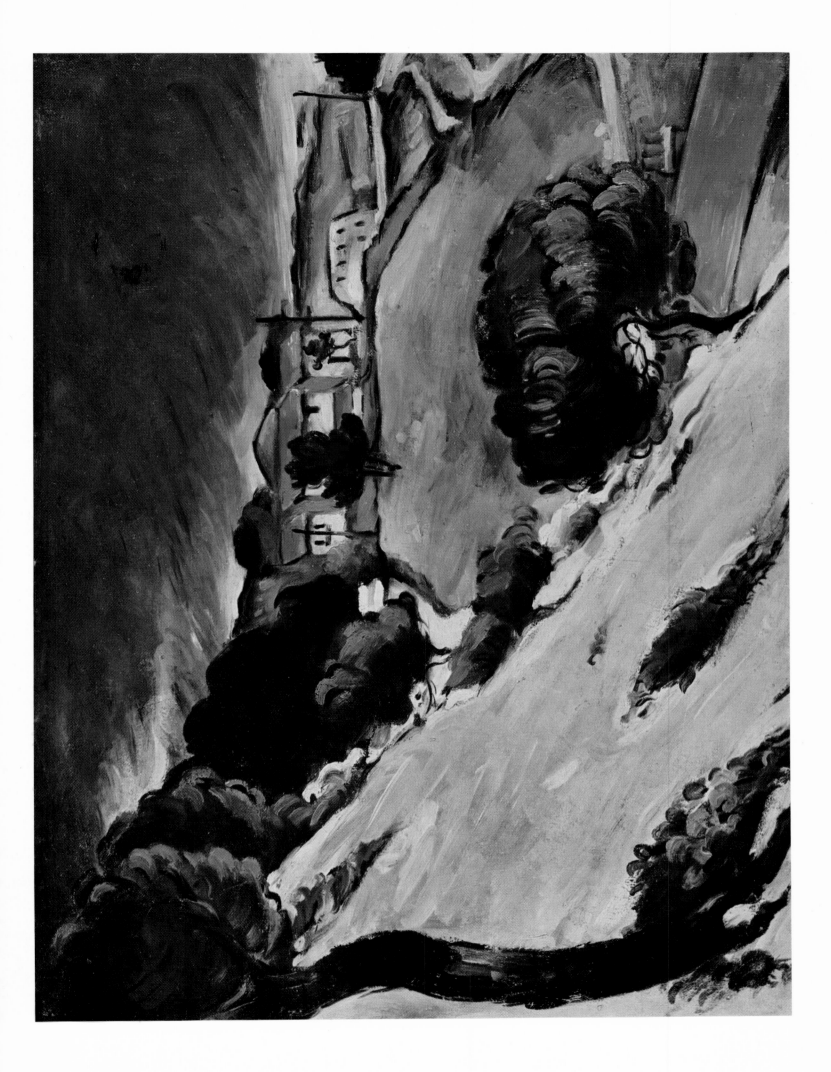

Painted 1870–1871

THE MAN WITH A STRAW HAT
(PORTRAIT OF BOYER)

The Metropolitan Museum of Art, New York
(Bequest of Mrs. H. O. Havemeyer, 1929.
The H. O. Havemeyer Collection)

$(21\tfrac{5}{8} \times 15\tfrac{1}{4}'')$

CÉZANNE HAS GIVEN TO HIS BOYHOOD friend the quality of a Balzacian provincial character, ambitious and determined, with something of the bearing of his own father, as we see him in a photograph taken at that time. We are not sure it is a good likeness of the man; in Cézanne's other portraits of Boyer we see a more mediocre face. The force of the characterization comes not so much from the details of the features as from Cézanne's robust art, which endows the man with the energy of the painter's forms and the mood of his favored colors. The construction and proportioning of bust, head, and hat build up a dominating presence. The projecting silhouettes of the hat and jacket on the right create a strong profile as marked as the features on the face; and the tones, which recall the blacks and greys of the landscape of L'Estaque (page 39) and even the passage of light on the horizon (like the light along the lapel), give to the portrait an aspect of somber will—perhaps Cézanne's own. Add to these the extraordinary vigor of the brush which in passing from the thinly painted areas to the more solid, studied region of the face with minute modeling of the fleshy features, retains its fluency and directness. There is in the choice of tones and especially in the harmonizing of the warm light areas of the hat and face with the surrounding darks through greys and other neutralizing touches a wonderful subtlety and sureness equal to the best of Manet.

It is a more penetrating portrait than the kinship with Manet suggests. As we study the features we discover how deeply Cézanne has searched his friend, disclosing underneath the idealized appearance of romantic will and pride the forms of a weaker, more passive nature, and within the firm carriage of the head, surmounted by its high hat, the loose asymmetry of the eyes—the recessive left eye has something disturbed and sinister that contradicts the confidence of the other side. The sharp highlight of the right eye detaches the glance from the assertive axis of the face, an axis that is broken by the persistent spotting of light and dark, of cool and warm tones on the nose, mouth and chin.

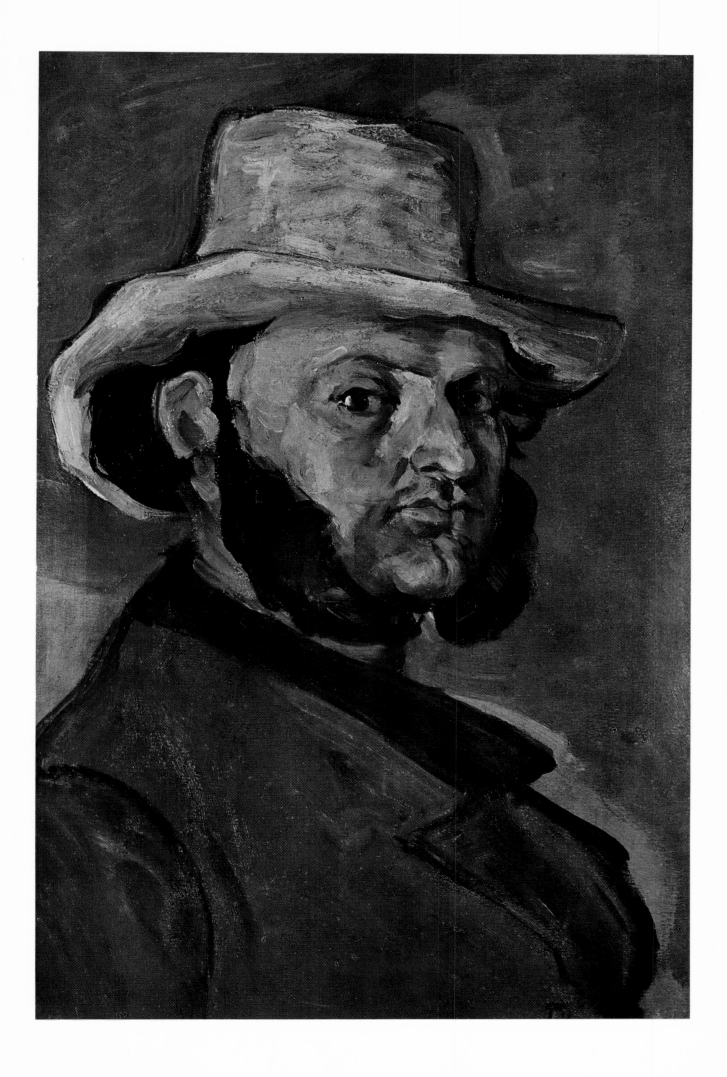

Painted 1872–1873

THE SUICIDE'S HOUSE

The Louvre, Paris

$(19\frac{7}{8} \times 26\frac{1}{4}'')$

IT IS THE MASTERPIECE OF CÉZANNE'S first year as an Impressionist. The whole is more luminous, vibrant, and colorful than the previous paintings; the touch is smaller and more varied, but is like his earlier practice in the thick granular patching. It is a studied picture, more earnestly constructed than the paintings of his Impressionist friends. Although attentive to light, Cézanne is equally observant of objects and is able to capture the material quality of the plastered masonry walls, the rocky and grass covered surfaces, the bare branches of the trees, and the precise feel of the sky and the distant landscape. From this arises the variety of pigment texture—something Cézanne overcomes in his later work— and also the point to point interest and individual complexity of parts, which are replaced in time by a broader play of contrasts.

With all its delicacy, the whole is a powerful image, more striking than any by his teacher Pissarro. This is due, I think, not only to the seriousness of the color, with its richness in a middle key, but above all to the conception of the scene and its strong composition. It is an intriguing, novelistic vision of an inhabited space, although the method of painting belongs to the poetic-idyllic and the aesthetic of light. The symmetry of house and rock, with similar structure, the abruptness of their confrontation, the unstable ground with steep places and contending directions, the complicated, indirect entry into the depth of the landscape, and the view of the distance and horizon through the narrow opening between house and rock—these are highly evocative and create a space with a nuance of conflict and doubt, very different from the mild, shapeless, open spaces in Impressionist art. The title of the picture—*The Suicide's House*—suggests that the conception might have something to do with Cézanne's response to the story of the house; but this is uncertain. What is likely, however, is that he has retained in this Impressionist phase his earlier taste for sharp cuttings in nature, brusque contrasts, and difficult passages in space. The taste for close views of buildings crossed by a network of branches he owes to Pissarro.

As an Impressionist, Cézanne preserved and developed his gift for composition. Conceived in color and light, the picture has also a great beauty of lines and directions. To retrace the edges of things is to discover, beside the ever-changing tones, a surprising dense network with many subtle correspondences. If we attend only to the diagonal elements, we see how finely he has related the lines of the road below to the buildings and branches and rock. Observe in particular the sensitive grouping, on a diagonal axis, of the door and windows of the main house, or the dark curved line over the door which is like the longer shape on the rock at the right and like other curves nearby.

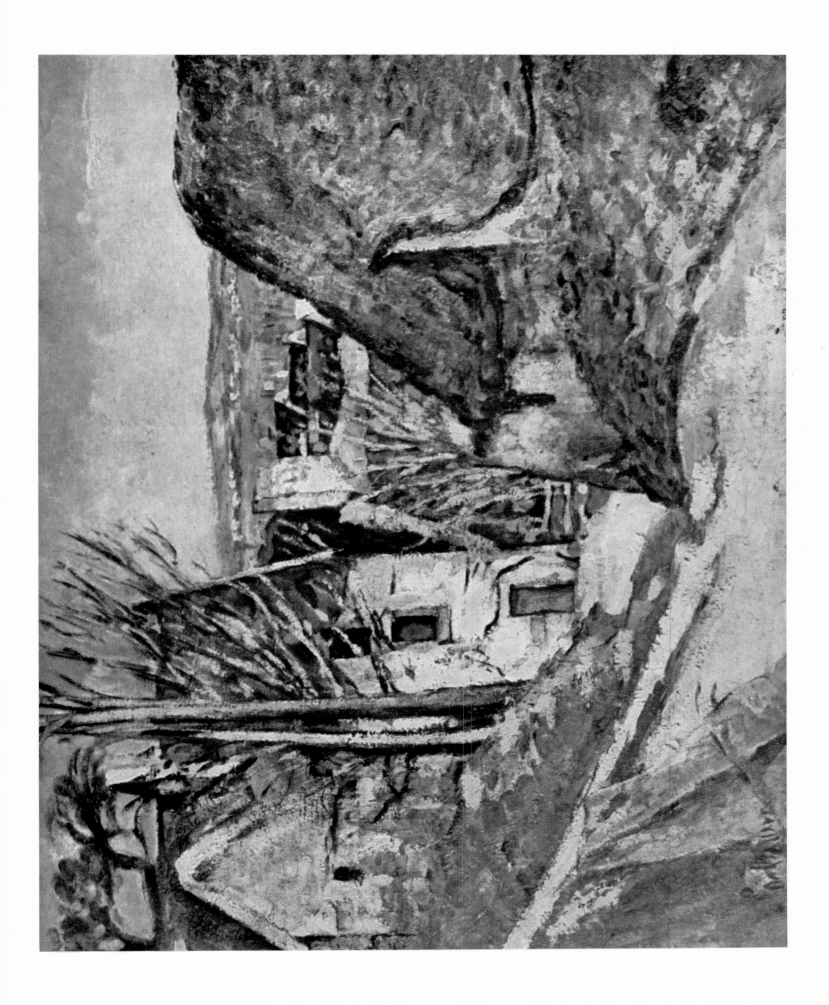

Painted about 1874

VIEW OF AUVERS

The Art Institute of Chicago

$(25\frac{1}{2} \times 31\frac{1}{2}'')$

AUVERS IS A VILLAGE NEAR PARIS where the Impressionists often came to work. Here lived Dr. Gachet, an amateur artist and friend of Pissarro and Cézanne, who was to care for the despairing van Gogh some fifteen years later.

The landscape extends almost equally in all directions, without clear paths or dominant lines below the high horizon (although a movement from the lower right to the upper left emerges discreetly). Endlessly spotted by houses, trees, and fields, it is seen from above with no road for the observer to enter the village which lies embedded in the soft green plain. This open, dispersed world offers a great freedom to the eye; at many points is some bright color or contrast—it is a kaleidoscope that gives a different picture with every turn, but all the pictures have the same twinkling elements and the same unsorted, unarranged quality (except for the broad band of the sky). Without deep feeling, but with a great charm and ease—the result of the profusion, delicacy, and lightness of the elements—its prevailing tone is a high green, unbounded, richly nuanced, and cool. The stronger touches—blue, red, and white—are small and scattered; the quantity of white, often weakly contrasted with the adjoining light colors, brightens and softens the whole.

The panoramic depth is created not by converging lines, but by the recession of overlapping parts which become smaller and smaller. The tones offer no obvious or legible order: there are strong greens near the horizon and sharp reds in the middle space, and the same soft colors appear in the foreground and distance. The difference between the series of greens in the nearer and farther space is extremely refined. The intensity of color, the degree of contrast of neighboring tones, change by tiny intervals between the foreground and the horizon. The blue roofs of the foreground are coupled with weakened reds, the bright reds of the middle distance with weakened blues and greens. Yet the span of contrast does change noticeably at certain points as we advance into depth: it is yellow against blue in the right foreground, red against green in the middle distance, green against light blue at the horizon. In the spotting of the thickly painted colors, we pass from the relative chaos of the foreground and middle ground to the clarity of the far distance. The surface feels unconstructed and motley yet all of a piece. The charm of light and color has been won by a sacrifice of Cézanne's usual solidity and concentration. It is mainly in the decided strokes of red and blue in the roofs and chimneys, many of them vertical and horizontal, that we see a tendency toward the constructive.

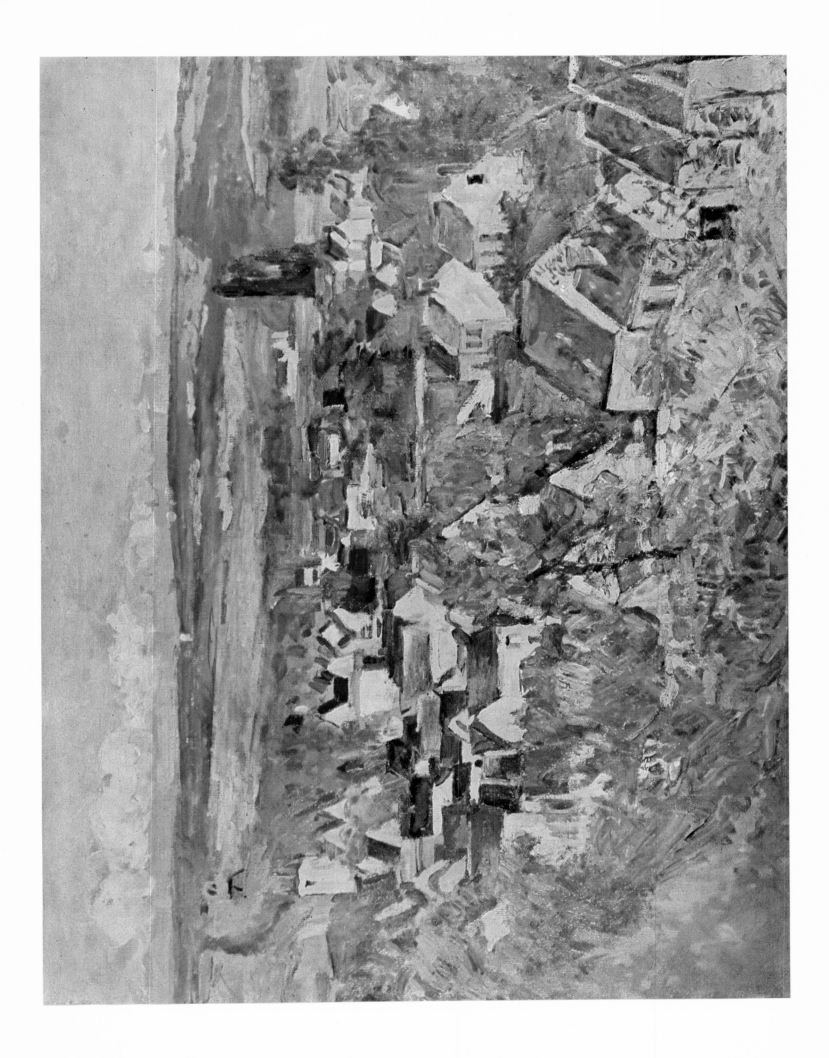

Painted 1875

PORTRAIT OF CHOCQUET

Collection Lord Victor Rothschild, Cambridge, England

$(18\frac{1}{8} \times 14\frac{1}{8}'')$

VICTOR CHOCQUET WAS A FRIEND of the Impressionists who has become a historical figure through his pure devotion to contemporary art. A minor government employee, without great means, he was caught by the beauty of Renoir's and Cézanne's works and collected these while they were still ridiculed by the critics and public. Both artists painted his portrait several times.

In Renoir's portraits, Chocquet appears a soft receptive nature, perfectly relaxed; he gazes gently at the observer. In Cézanne's painting, the features are no less sensitive, but there is in the bearing of the head, turned sharply to the side and culminating in the high mane of hair, an accent of grandeur, a reminiscence of the near-romantic portraits of the Napoleonic age. Such idealization is foreign to Impressionist portraiture; but we have seen before in the portrait of Boyer (page 41) how Cézanne endows a friend with a romantic aura. Chocquet is conceived as a lean Quixotic type. The lengthening of the head is like the attenuation of El Greco's figures; here the cult of art replaces a religious dedication, with a similar selflessness and purity of spirit. It is a homage to a noble devotee, a man of independent conviction. In the portrait of his admirer, Cézanne speaks also of himself.

The head is seen in a curious perspective, as if through a glass that narrows the face and sharply foreshortens the sides. The features are extremely contracted, and the turn of the eyes, by reducing the force of their axis, also brings out the vertical of the face, which is prolonged further by the angularities of the upper brow and the similar opening of the collar.

Compared to the portrait of Boyer, it is an advance in luminosity and freshness of color, like Cézanne's new landscapes. Outdoor tones replace the blacks and neutralized shades of the earlier portrait. And as in the landscapes, we follow the action of the brush everywhere, spirited and frank and creating a thick fleshy paste of pigment, rich in flicker, direction, and tone. The stroke is intense and direct throughout—in the background as in the head, in the hair as in the delicate features—but with a distinct movement in each part. It is nicely proportioned to the whole: small enough to permit subtle modeling, large enough to be perfectly visible as a constructive element of the whole. A few tiny red touches, capering and chaotic, liven the nose and cheek; and darker strokes, together with the edges of hair and beard, make an interesting, unstressed rhythm of curved lines. It is all built up without obvious trace of plan or guiding structural lines, as if from the spontaneous play of the brush in direct response to the man. Most remarkable of all—what we return to again and again—is the largeness of effect, the powerful possession of the space.

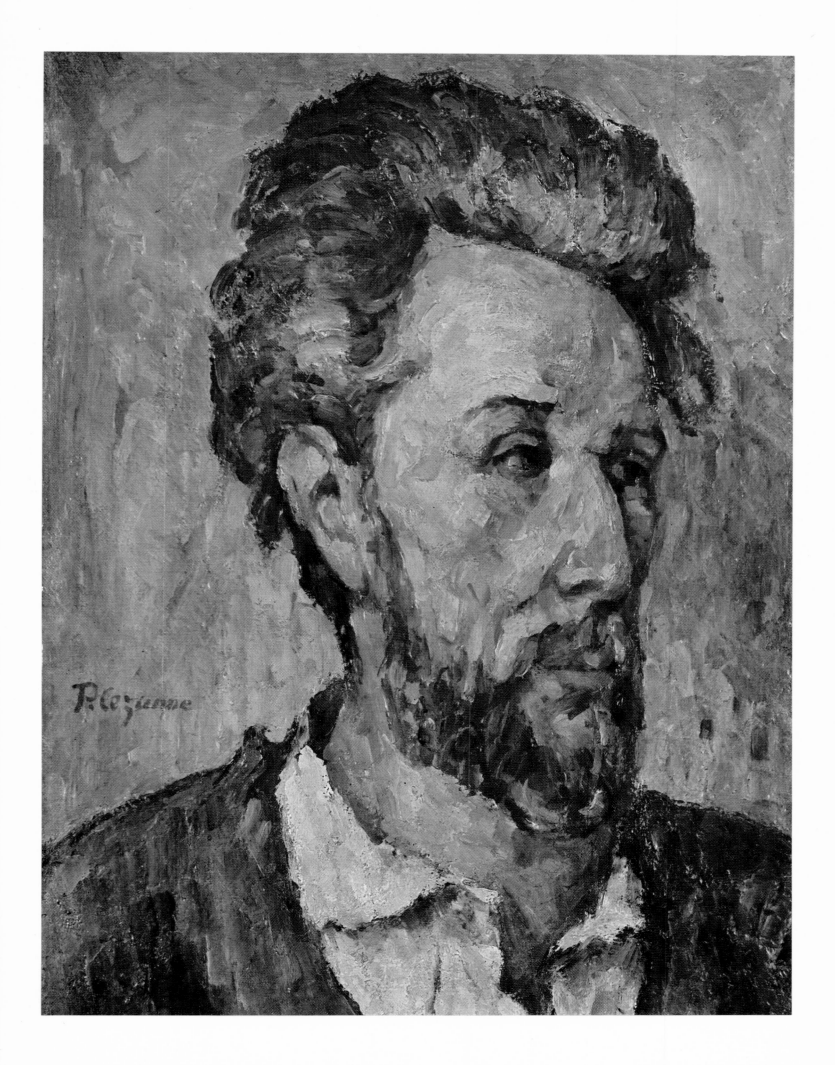

Painted about 1875–1880

BACCHANAL (LA LUTTE D'AMOUR)

Collection The Hon. and Mrs. W. Averell Harriman, New York

$(15 \times 18\frac{1}{8}'')$

THIS LITTLE PAINTING, which once belonged to Renoir, is a theme out of Venetian art, perhaps by way of a Poussinist artist, but is conceived in another mood. The Renaissance bacchanals are scenes that combine love-play, drinking, and dancing; they are images of gayety and joyous release. Cézanne's painting is of a struggle, the violence of love, even rape. Four men attack four women; a leaping dog adds another note of animality. These are not pagan idyllic nudes from Greek mythology, but a modern fantasy like Cézanne's solemn picnic of clothed and nude figures. The multiplication of figures increases the violence, but also makes it more natural, an action of all men and not a solitary crime.

It is a much simpler and clearer composition than the bacchanals of Titian and Poussin; the four pairs of nudes are distinct, isolated from each other, but grouped in succession with a continuous dance of richly curved lines. Their struggling forms, their rippling silhouettes, appear again in the agitated clouds and trees, diffusing the passion and energy of the bodies throughout all nature. The swirl of forms has a baroque animation. Everything moves—figures, trees, clouds, ground, dog. It is the fury and intoxication of desire.

A passage in a letter of Cézanne to Zola written in 1878, commenting on his friend's new book, *Une Page d'Amour*, and observing its superiority to an earlier work, *L'Assommoir*, applies very well to this picture: "The backgrounds are so painted in that they are suffused with the same passion that motivates the characters, and thus are more in harmony with the actors and less detached from the whole. They seem as it were to be alive and to participate in the sufferings of the living characters."

At this point in his art, the subject represents for Cézanne not his essential theme, but an isolated idea, which he is able to carry out, however, with a remarkable ease, as if it were a habitual subject. The brushwork is rarely more fluid and sure. The two trees at the left are a fascinating invention of opposed forked shapes—metaphors of the standing and inverted figures—joined by a branch. This painting from imagination shows the power of Cézanne's compositional fantasy, his ability to find the expressive shapes when nature is not before him to stimulate and guide him. His own strong feelings are also a source; the vital movement of the bodies, like the elaboration of the landscape, comes from within. But comparison of the picture with an earlier version, near it in time, shows how much Cézanne's work owes to self-criticism. A great deal has been revised, the advance to the final form is immense; yet the latter looks perfectly spontaneous and free.

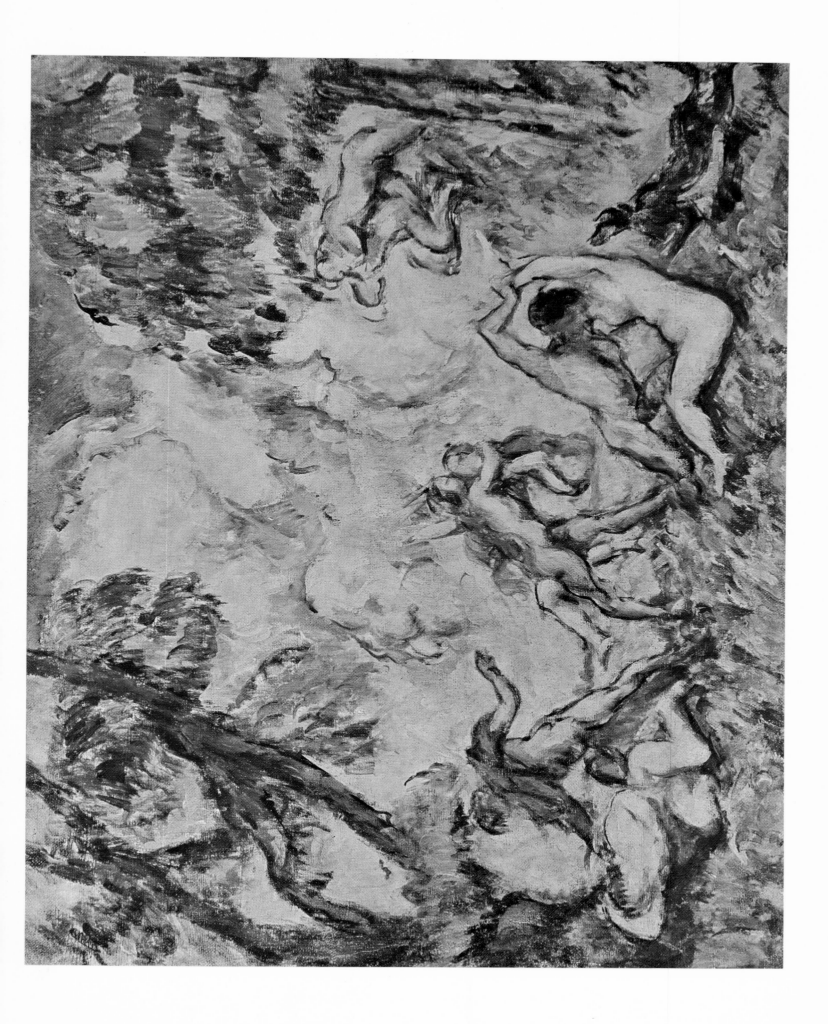

Painted about 1877

CHOCQUET SEATED

Gallery of Fine Arts, Columbus, Ohio

$(25\frac{1}{2} \times 22\frac{1}{2}'')$

THE EARLIER PORTRAIT OF CHOCQUET (page 47) is a superb head in which we feel an independent spirit akin to the artist's own. The little sketch of Chocquet at home among his pictures, although not a searching portrait, is perhaps truer to the man, for something of his mildness and savoring, receptive attitude comes out.

It is painted in an original way, a further step in Cézanne's striving for a constructed form. The whole is a banding and fitting of mainly horizontal and vertical strips of rich color, like a section of mosaic or a patchwork rug. The treatment of the interlocked hands is a good example of Cézanne's idea. The texture of the pigment is more pronounced than the texture of the represented objects, and the painted pattern is clearer than the structure of things. We are aware of the colored marquetry of the desk before we recognize the desk itself. It is hard to know exactly the large form of the desk or to determine where floor and wall meet. No object is complete and several are obscure; everything is cut somewhere and in a unique way, even the figure which is intercepted by the chair and the upper canvas edge. In the foreground the pattern of an actual rug—as part of the world of represented things—is broken up and quite impossible to read. At the same time we observe surprising contacts or continuities of things that lie in different planes in depth: among others are the verticals of the back of the chair and the picture frame above, and the horizontal cast shadows joining the rear legs of the chair and the vertical canvas edge. The figure, too, is divided into strips like the objects around it; and these strips or their edges continue the neighboring forms. Still another device, which weakens the depth in favor of the painted surface, is the peculiar meeting and crossing in one point—at Chocquet's left wrist—of the lines from five different planes. The color, too, is applied in this sense; observe how very similar bright touches of yellow, red, and light grey occur in clear groupings on objects in far separated planes. Complementary to these devices is the contrary discontinuity of lines that belong to the same plane; the dark band at the lower edge of the wall is on different levels at left and right—a deliberate blurring of the right angle between wall and floor (the angle is also obscured by the similarity of tones above and below the band.

The principle is clear: to break up what lies in one plane; to unite on the picture surface what lies at different depths. Through all these means and through the texture of the painting, the latter has become almost as distinct an object as any of the things it represents.

The material surface is appealingly tangible; the dense fabric of paint has a constructed, adhesive look. Yet the whole is a convincing image with the light and atmosphere and intimate suggestions of a particular person and place. It may not have the concentration or grandeur of the later works; but it shows the same sensibility in the beauty and robustness of color and touch.

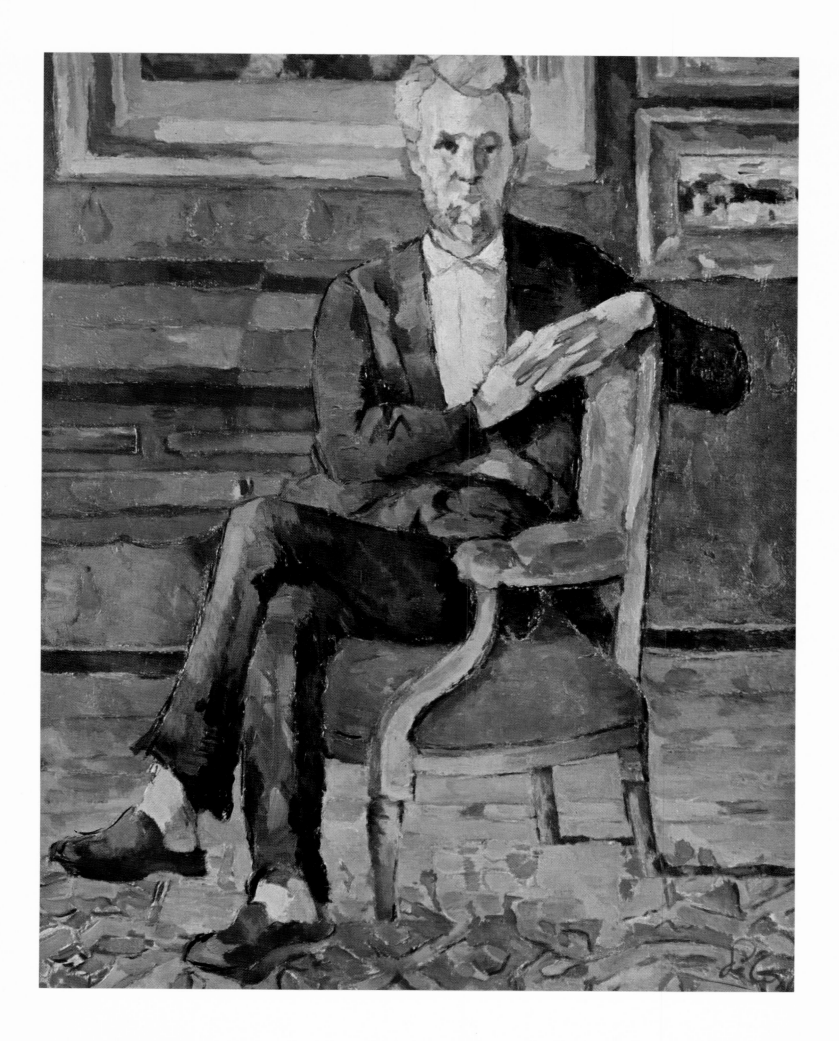

Painted 1879–1882

SELF-PORTRAIT

Tate Gallery, London

$(25\frac{5}{8} \times 10\frac{5}{8}'')$

WE HAVE FROM CÉZANNE'S HAND over thirty self-portraits. They are not only documents of his appearance over the four decades of his career as a painter; they also indicate a continued self-concern surprising in an artist of classic tendency. In several of them, this self-awareness struggles with his pictorial impulse or habit, and we sometimes find together in the same portrait acutely observed physiognomic features and some geometric detail that gives an abstract inhuman air to the part. We have become so used to looking at Cézanne's forms as constructive relationships that we enter with difficulty into the expression of the lines and areas. In this portrait with the intense right eye, the prominent brow, the beard and mouth sunk into the body with hunched shoulders, what is the meaning of the lozenge pattern of the wall paper? What does it do to the face and the picture? It surrounds and glorifies the bald head with a starred angular halo—its enclosing character is assured by omitting the lines of the ornament that would meet the head and pass behind it. This angular form, so much like the zigzag of the lapel, is opposed to the massive roundness of the head and of the shoulder thrust towards us. The duality of round and straight forms appears at first as a contrast of the living and the geometric, but we discover soon that the zigzag of the ornament and the lapel are not altogether distinct from the face; their diagonal angular form recurs, though less rigidly, in the nose and beard and eyebrows; and the little star-cross lozenges correspond to the eyes and nose. This wedding of the organic and the geometric has a beautiful simplicity which makes us overlook or accept the arbitrary treatment of the wallpaper pattern. The ornament is not used for surface interest, but as a necessary element of structure in a whole of great concentration and weight. The opposition of curved and straight is only one of several strong dualities pervading the work: light and shadow, the modeled and flat, the vertical and diagonal, the concave line and convex, the open and closed—all interwoven or crossed. On the physiognomic level, there is a similar search for contrast in the upper and lower parts of the head and especially in the eyes, one dulled and recessive, the other more strongly marked, alert, and opened towards the light.

In execution as well as in forms, this portrait marks a new stage. It is painted in a cooler, more meditative spirit than the head of Chocquet, with greater economy of pigment, pressure and movement, and is more beautiful in substance and tone. The search for clarity and a firmer order determines a smaller, more uniform brush stroke, with a common slanting direction which is subordinate, however, to the power of the larger forms. There is more drawing of shapes—we see this especially in the dark lines defining the curves of the bald brow and the shoulder; but these rhythmical lines, which are so clearly responsive to the neighboring forms, are also notes of color in the grave scheme of interchanged contrasts of dark and light, warm and cool.

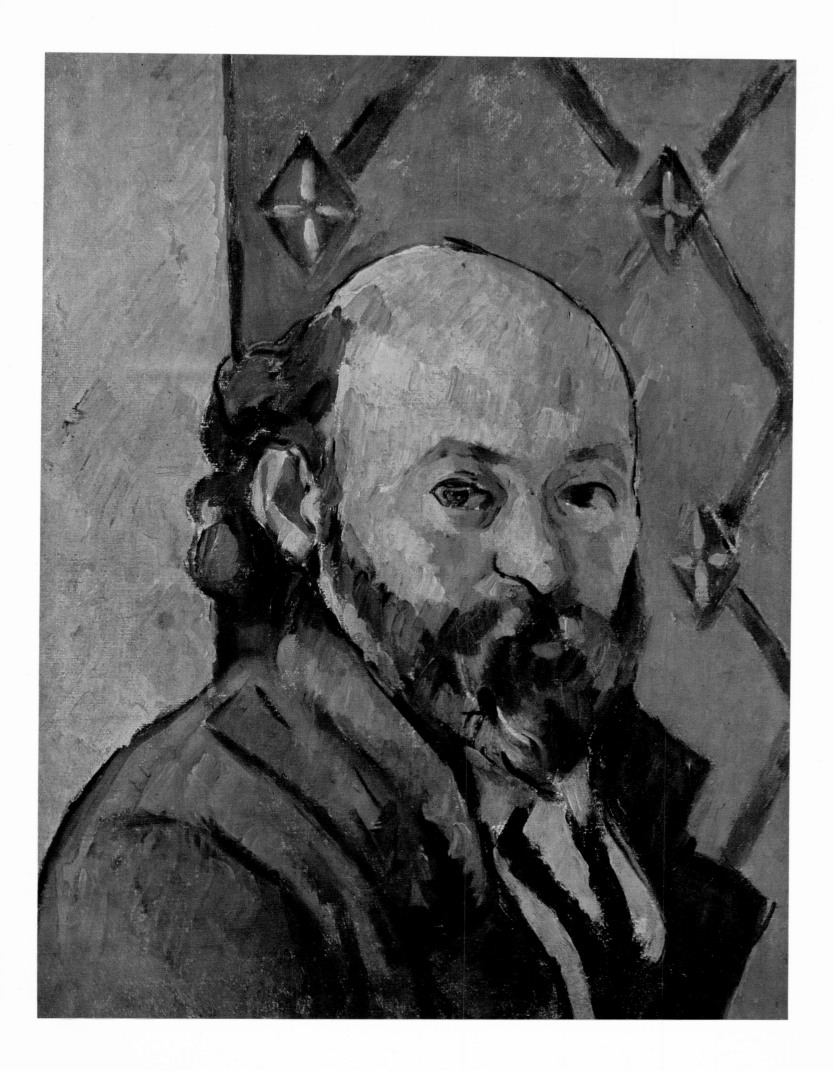

Painted 1879–1882

STILL LIFE WITH COMPOTIER

Collection Mr. and Mrs. René Lecomte, Paris

$(18\frac{1}{8} \times 21\frac{5}{8}'')$

WITH THIS PAINTING begins the series of great still lifes of Cézanne's middle and late periods. Beside the others, it seems a return to tradition in its studied outlines and great depth of shadow. It seems also one of the most obviously formal in the sober pairing and centering of objects, from the apples on the cloth to the foliate pattern on the wall. But through the color, which has its own pairing of spots, the symmetries of the objects intersect or overlap; the same object belongs then to different groups. The resulting rivalry of axes gives a secret life to the otherwise static whole. In the foreground plane, a dark spot— perhaps the keyhole of the chest—anchors the design and ties the vertical elements above to the horizontal base.

The color is beautifully mellow and rich within its narrow range. In the long passage from light to shade, different in every object, each color unfolds its scale of values in visible steps. How solid the forms emerging in atmosphere, deep shadow, and light through subtle shifts of color from transparent tones to luminous pigment of a wonderful density and force!

Indifferent to the textures of objects, Cézanne recreates in the more palpable texture of paint the degrees of materiality: the opaque, the transparent, the atmospheric, and the surface existence of the pictorial itself in the ornament on the papered wall—the shadow of a shadow, an echo of his own art.

To define the forms in this unstable medium of air and light in which the colors at the contours merge with the surrounding tones applied in similar slanting strokes, Cézanne has drawn dark lines around the objects. More definite than in his other pictures, these outlines are not as uniform and thick as the enclosing lines that later artists derived from them. Gauguin, who owned and passionately admired this still life, reproduced it in the background of a portrait in which he took one of his first steps towards a style of abstracted decorative lines.

Most original in the drawing are the ellipses of the compotier and glass. Just as Cézanne varies the positions, colors, and contours of the fruit, he plays more daringly with the outlines of the vessels. The ellipse of the compotier becomes a unique composite form, flatter below, more arched above, contrary to perspective vision and unlike the symmetrical forms of the glass. In its proportion, it approaches the rectangular divisions of the canvas and in its curves is adapted to the contrasted forms of the apples and grapes, the straight lines of the chest, the curves of the fruit below, and the foliage on the wall. A line drawn around the six apples on the cloth would describe the same curve as the opening of the compotier. If we replace it by the correct perspective form, the compotier would look banal; it would lose the happy effect of stability and masculine strength.

This magnificent painting, at once subtle and strong, has the grave air of a masterpiece of the museums. Like other masterpieces by young artists who aspire to a grand order, it is a little meticulous and stiff. The idea of the work, its method and devices, are more tangible than in Cézanne's later art; but this absorbing seriousness and frankness are part of the charm of the work.

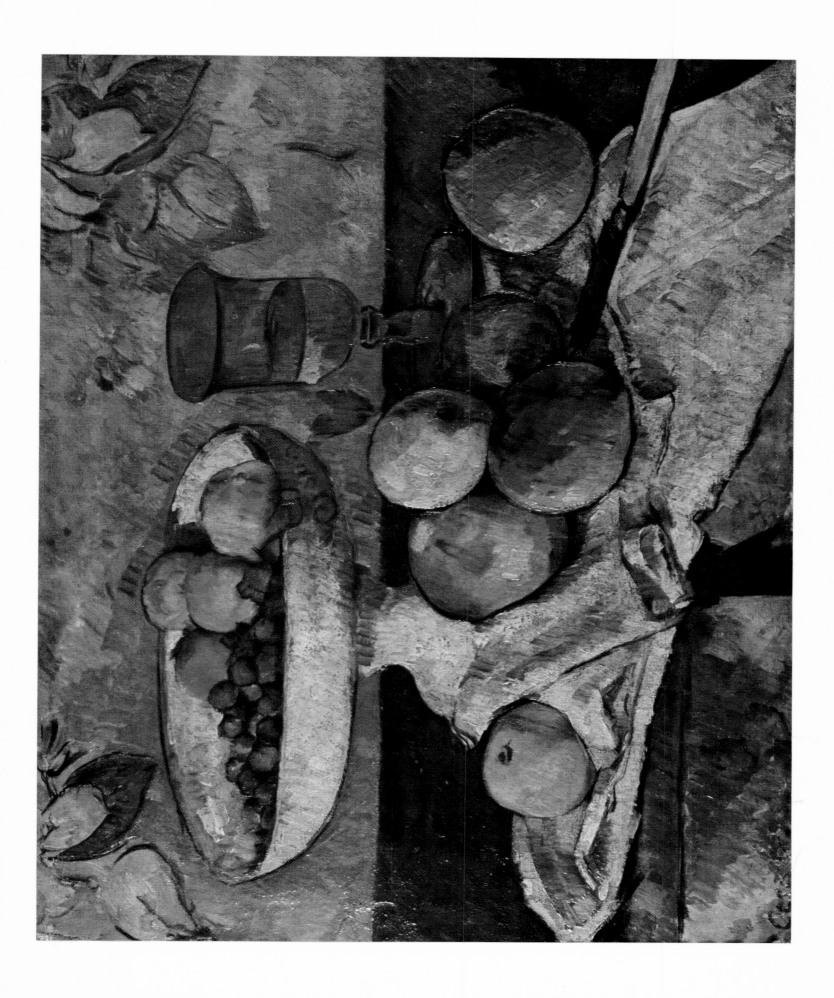

Painted 1879–1882

PORTRAIT OF LOUIS GUILLAUME

National Gallery of Art, Washington, D.C. (Chester Dale Loan)

$(22 \times 18\frac{1}{2}'')$

BEFORE CÉZANNE'S PORTRAITS, it has been asked whether the faces are expressionless masks or express an aloof, impassive state of mind. This uncertainty will hardly be felt before the portraits of Boyer or Chocquet (pages 41, 47), or some of Cézanne's self-portraits. But it is a real question for many of the later portraits and is indeed hard to answer because a portrait, besides being an image of an individual, is also a painting with its special problems of composition and color. If the artist projects his own nature into a portrait, that nature may be one indifferent to personality, it may itself be a personality that seeks to free itself from the difficulty of communication with others by creating a solitary expressive domain where it is master. It has been said that Cézanne painted the heads of his friends and family as if they were apples; but an artist so closed to the physiognomic would ordinarily content himself with still life or landscape or views of buildings. There is in Cézanne an evident desire for the human being; his retreats, his shyness, his often hysterical anxiety at encounters, never abolished this desire. He returns to man with hopes of understanding or love, but painting as a discipline governed by his need for a private world of mastership is already so strongly set in his nature as to impress its most characteristic methods upon his portraits. Yet he often surmounts this influence of the still life and the landscape and creates portraits of great insight and fellow feeling.

In the portrait of Louis Guillaume, the son of friends of his wife's family, the subject is no challenge to the artist as a person. Yet there is a far-reaching abstraction of the head and body as elementary solid forms, the most advanced in the art of this time. No less uncommunicative than the face is the immobile body, in which we cannot imagine a gesture or movement. The muteness of the face represents perhaps the boy's unformed nature rather than Cézanne's detachment or feeling of an abyss between human beings; but it has also a nuance of shyness or reserve in keeping with the painter's sobriety and grave mood, which we feel in the cool, low-keyed color, the depth of the shadow tones, and the accented closure of forms within an atmosphere of revery. The whole has something of the somberness of his early works refined by the new discovery of color and his more contemplative approach. The tones of the face are pearly, lustrous, transparent, exquisitely delicate and pure; but the face itself as a human surface is without spiritual light; the eyes are lusterless and unfocused—they belong to a world of shadow. The dark cap of the hair has been cut into a severe pattern, and the features strangely disarrayed by a twisting of the axis of nose, mouth, and chin, a torsion continued in the knotted cravat which isolates the head from the body. This cravat is an extraordinary invention of form, related to the inner lines of the face, and echoed in the ornament of the wall. Through deviations from the inherent symmetries of the human being, and through the beautiful play of dark folds on the costume, the more regular, imposed geometrical form acquires an aspect of living strain and disorder.

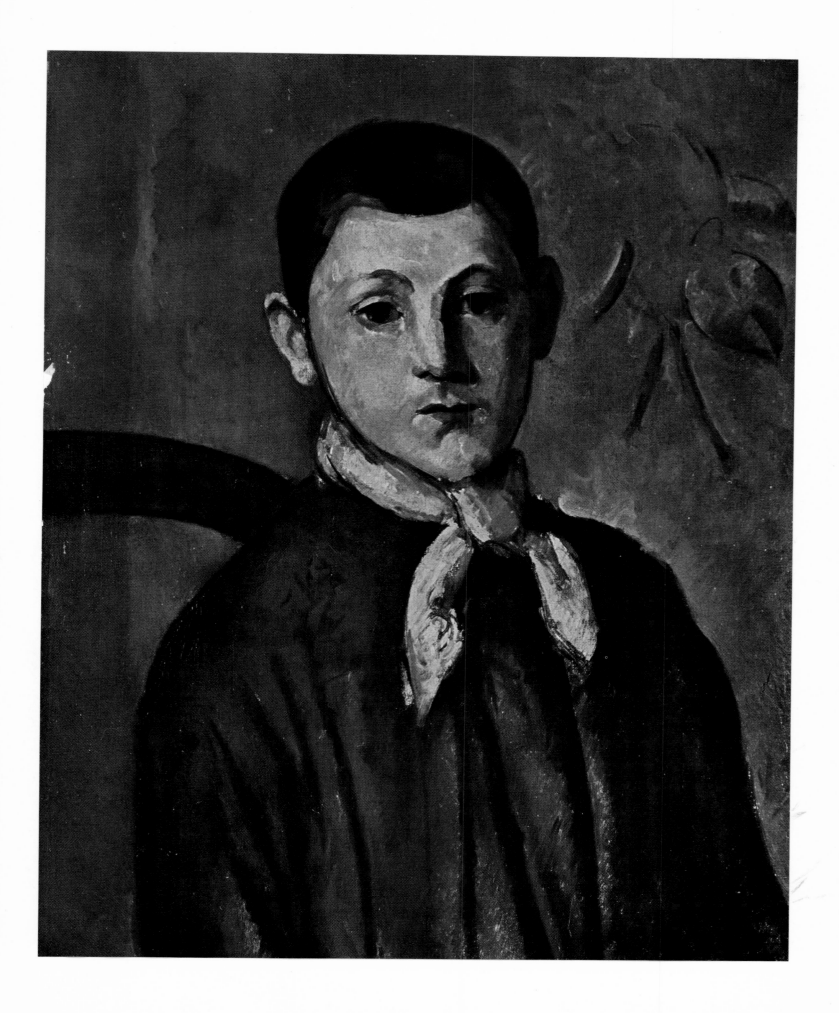

MADAME CEZANNE

Collection Henry P. McIhenny, Germantown, Pennsylvania

$(24\frac{3}{8} \times 20\frac{1}{8}{}'')$

THE PURE OVAL of the face, its vague eyes and lips, and the cool tones of the painting, suggest a detached, abstract conception of the model. Yet it appears to us a very human portrait, sensitive to the passive and frail in this feminine nature—traits conveyed by delicate means. In the light key, with the almost shadowless face against a light ground, in the exquisite relation of the warm and cool tints of the face to the greyer wall, the painting is Impressionist in spirit. In the Impressionist portraits the inner life of the woman is often overlooked for the sake of an outward charm that requires an open smiling face and features like blossoms. In retaining from this art the softness of the features and the beauty of the skin, Cézanne has produced a tender image of ascetic feeling. It is as if he transferred to his wife his own repression and shyness. Characteristic is the pathetic inclination of the head, an axis of weakness, submission, and self-concern, such as we find in old images of praying and penitent saints—an expression which is completed by the extreme closure of the body, with the high striped dress and the loosened hair falling to the shoulders. The remarkable egg shape of the head is no simple reduction of a more complex form, but a subtle line expressive of the object, an approach to the perfection of a refined, withdrawn nature. This beautiful contour of the face corresponds to the eggshell delicacy of the flesh tones it encloses.

In the creation of this portrait, the added forms that assure the unity of the painting are also expressive parts of the image of Madame Cézanne. The important spot over the head, irregular on one side, straight on the other, like the stripes of the dress, belongs more to her than to the wall; in balancing the head, this vertical form also helps to measure its tilt and the waviness of the hair and costume. On the right shoulder at the sleeve, the odd little puff continues the movement of the hair and accents the inclination of the head. The bands of the dress contribute a soft, wavering current of feeling channeled to the head and prolonged in the silhouette of the hair.

This expressive use of posture, costume, and background recalls the devices in pictures of religious personalities in late mediaeval art, when portrait painting was just beginning to emerge.

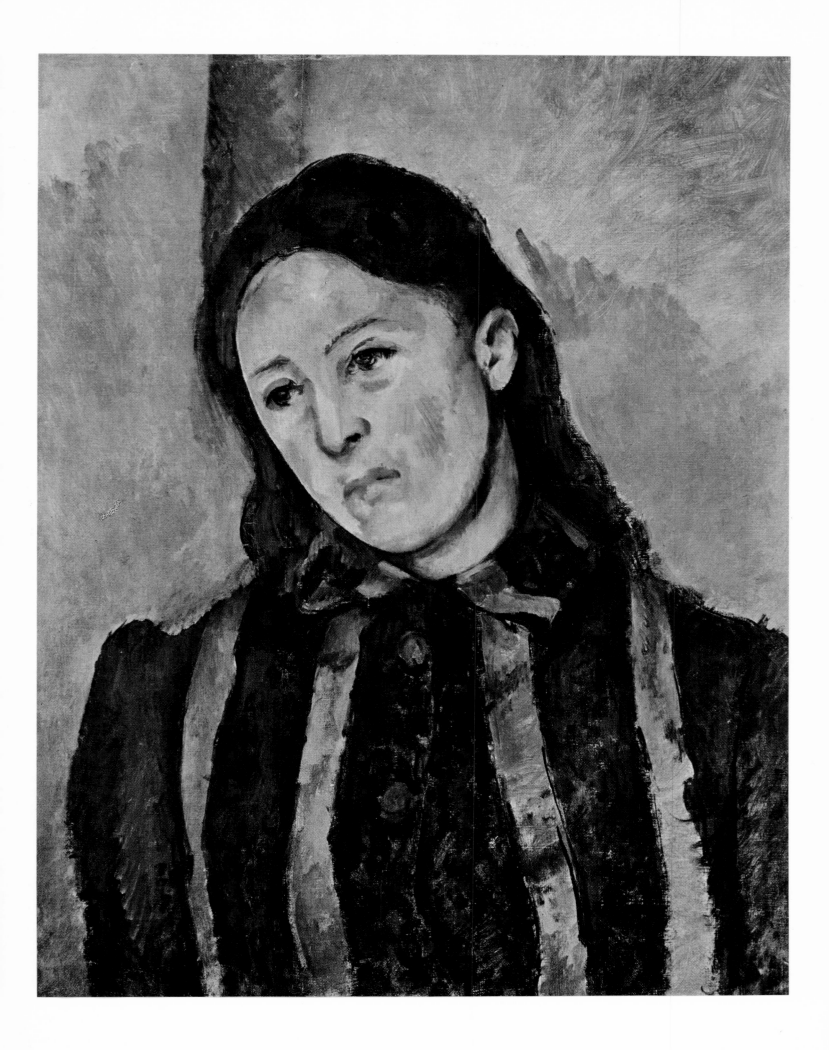

Painted 1883–1887

STILL LIFE

Courtesy of the Fogg Art Museum, Harvard University
(Maurice Wertheim Collection)

$(25\frac{5}{8} \times 31\frac{7}{8}'')$

COMPARED TO THE EARLIER STILL LIFES, this magnificent painting is an advance, both in clarity and subtlety. It is still like the early style in the dark background; but although deep shadow has been almost eliminated, the contrast of light and dark is even more pronounced in the broad opposition of the foreground objects and the bureau. It is hard to imagine a simpler, more direct arrangement: the objects on the table closely crowded together, with the fruit in the center; the table and bureau, in the most obvious frontal position. Cézanne's will to stability, closure, and compactness is very evident here. It appears also in the color in the centering of the most intense tones—the mottled reds and yellows of the apples—between the broadly symmetrical masses of the green jug and greenish white peak of the tablecloth, and, in depth, between the great masses of darker red and yellow in the bureau and table, with which they form sonorous chords.

In the forms—a corresponding balance of curves and straight lines. The straight forms enclose the curves, they are outside them, but are also harmonized with them through the rectangularity of the groupings or symmetries of the curves. Some of the rounded objects—the jug at the left, the large platter—are finely flattened to approach the rectilinear. The big tablecloth, the most living object, is a complex world of straight and curved.

In this stable rectangular composition, the tablecloth is a powerful contrast and an element of disorder; we are surprised by its complexity, its alien character among the compact objects of single axis on the table, although it is assimilated to these through its colors and the tilting of the distorted platter. It is like a mountain, a rocky creviced mass, or like some human figure, twisting and turning, with an inner balance of directions. Each bend, fold, and tone is strategically considered in relation to neighboring shapes and colors. Without this fantastic body of cloth, the picture would be tame and empty, though still harmonious in color.

The painting has many fascinating refinements of drawing and composition. It is instructive to observe Cézanne's scruple in giving to each detail a unique form adapted to the adjoining objects and its place in the whole. To consider a minute example: the dark vertical keyhole of the bureau is opposed to the horizontal ellipse of the open jar which is in precise line with the lower knob. The keyhole plate and the two knobs at the right are flattened at the sides vertically, and we see that this relates them to the horizontal flattening of the ellipses of the jars. These are aligned with the lower knob and the horizontal band of the bureau. The axial contrast of the knobs and ellipses is an expression of the dominant contrast of vertical and horizontal in the bureau, the table, the wall, and floor. The musicality and perfection of this canvas overwhelm us. Wonderfully constructed, minutely considered, full of patterns yet without a prior governing pattern, precise yet unexpected in detail, it is rich in variation like life itself.

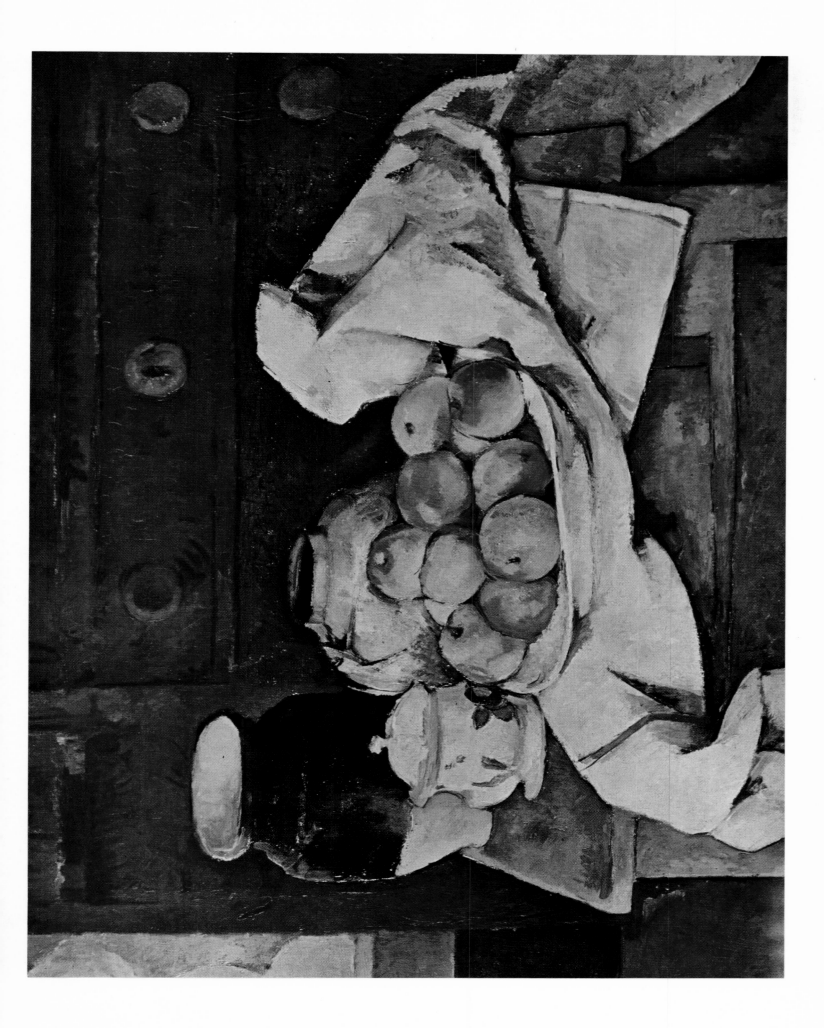

Painted about 1886

THE BAY FROM L'ESTAQUE

The Art Institute of Chicago

$(31\frac{1}{2} \times 38\frac{1}{2}'')$

A FAVORED HIGH VIEW, the landscape gave Cézanne a command of vast space with elements of grandiose span and force; buildings, water, mountains, and sky follow in alternating movement and repose, projection and calm surface. Without paths or human figures, the world is spread out before his eyes, a theme for pure looking; it invites no action, only discernment; it is sunny, but not gay or cheerful—a balance of warmth and coolness, the momentary and the timeless, the stirring and the stable, in perfect harmony and fullness.

The painting lives through the power of great contrasts: the luminous, richly broken field of reds, oranges, and greens against the blue sea; the modeled wavy mountains, convex, against the filmy, substanceless sky. These mountains have a human, or at least organic, quality—sleeping limbs at rest upon the earth—opposed to the rigid architecture below. The broad strata of the landscape are interlocked pairs, forming larger rectangular zones which become more cohesive still through the horizontals in the diagonal fields and the sloping forms in the horizontal. An ever-active touch, responding to the lie or swerve or rise of objects, unites this extended world from point to point. Nothing is perfectly still; the dark water has its pulsations and nuanced mood, and the pure sky, a delicate quivering of ethereal tones.

Below, a great block of a building breaks the alignment of the buildings beside it and the banding of earth, sky, and distant mountains. Parallel to the ascending shoreline, it looks to the puff of smoke and the highest mountain and induces an undrawn diagonal between them across the sea. But mountain and smoke are parallel to the major rooflines of this building—these are directed like the slope of the shore and re-enforced by the unique cast shadow of the chimney. Following these lines, each of another color, we come upon the finesse of the far-off jetty pointing to the puff of smoke along the same inclined axis, and below this jetty we discover the little red house on the shore and the high chimney— a mysterious unstressed grouping of isolated elements which take their places in the harmony of the whole. The chimney is an object for wondering contemplation, so beautifully wedded it is, in its multiple character, to the forms and colors of the whole—rising from light warm to dark cool, re-enacting the contrast of earth and sea, ending at a level where an inlet dovetails the line of water and land, opposing and uniting the strong horizontals of roofs and ground, and focusing the play of scattered verticals by its culminating form.

A marvelous peace and strength emanate from this work—the true feeling of the Mediterranean, the joy of an ancient nature which man has known how to sustain through the simplicity of his own constructions.

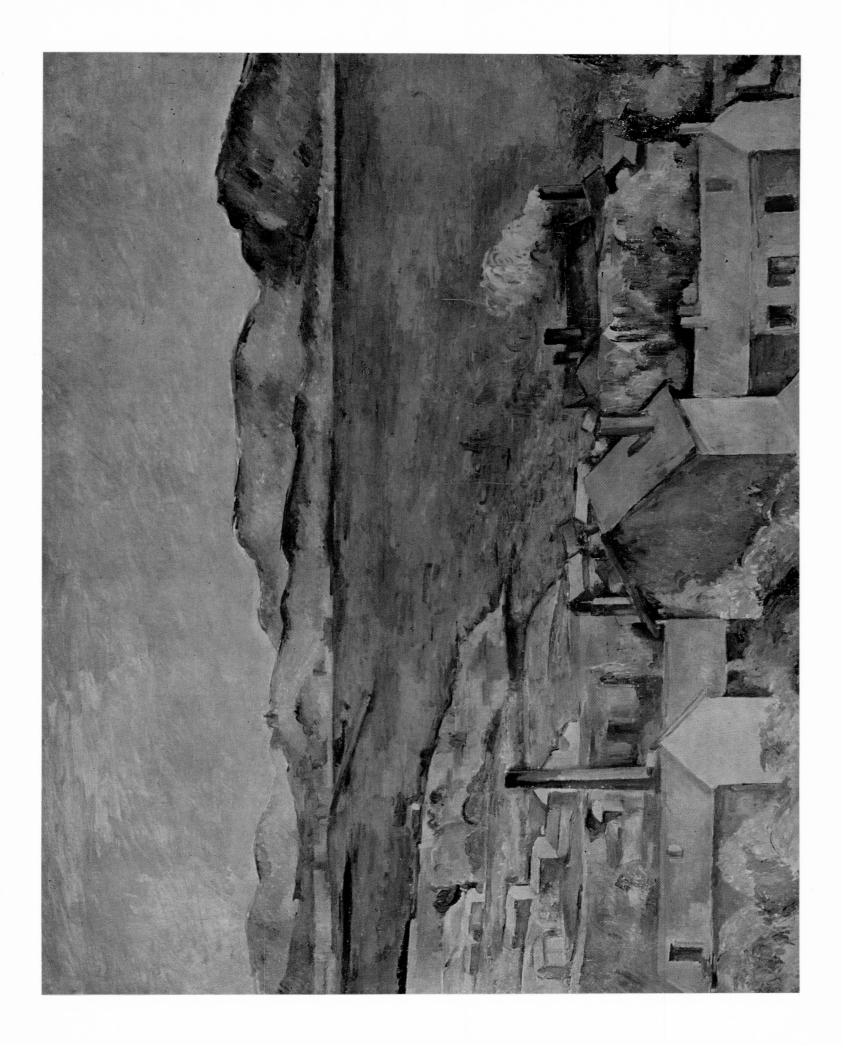

Painted 1885–1887

SELF-PORTRAIT WITH PALETTE

Collection the Artist's Family, Paris

$(36\frac{1}{4} \times 28\frac{3}{4}'')$

IT IS ONE OF THE MOST IMPERSONAL self-portraits we know—and not simply because the face and especially the eyes are unfinished. The painter stands behind his easel and palette, assimilated to their lines even in small details. The rectangle of the canvas is felt within everything it contains; the head and body are rectangularized and framed by the palette and easel. The color of the head is very close to their tones and to the jacket. Within the broadly rectangular face, the inner edge of the hair and beard is curved like the rounded corner of the palette; the indentation of the beard on the cheek corresponds to the outline of the thumb on the palette, and to the notch of the lapel. The most human element is bound to the non-human and both are stable and constrained. This bond reaches its extreme in the surprising continuity of the vertical edge of the palette and the sleeve, which seem to form one body, parallel to the frame. (Similar is the ending of the tips of the brushes at the line of the coat.) The normal, irregular overlapping of things has given way to a constraining form. Submitted to the same strict, closing pattern, these carefully realized objects assume an air of artifice and abstraction, like the diagram of a building plan. Yet the whole is intensely objective and monumental, with a stony strength of modeling in the limited depth between the palette and the wall. The lower left corner— a reddish table—has the flatness and severity of a Cubist work. This rigorous and forced cohesion is what the Cubists admired, among other things, in Cézanne and carried further in their own art. The palette continuous with the body appears in an early self-portrait of Picasso.

A purely formal interpretation is hardly just to the expression of the painting. The devices mentioned not only reduce the depth and adapt the picture to the rectangle and surface plane of the canvas. They carry also an affect of self-isolation in forms that otherwise advance boldly into the spectator's space. Cézanne comes forward here, more than most painters would venture in a self-portrait; but he does not face the observer or move freely in space. Concentrated on his canvas, he is absorbed in the closed world of his own activity. The palette, with its naively objective form, unforeshortened and attached to the painter's body, is a barrier against the outer world. If the palette projected towards us, it would create a convergent shape, drawing us more rapidly into the depth of the picture. In their actual form, the palette, the head, the body, and easel are analogous patterns of stability and detached existence, all adapted to the ideal rectangle of the picture, a closed plane surface.

The color, too, is a vehicle of this conception, but expresses also within these limits the undercurrents of impulse and self-release in the solitude of the artist. Cool, subdued, and severe, and dominated by the rare blue-black of the costume and beard, it ranges from the most vigorous contrasts of modeling, as in the powerfully painted coat, to the beautiful patching of the palette and the free, lyrical effect in the delicate landscape tones of the background, which contains the colors of the solid objects in a vaporous state.

64

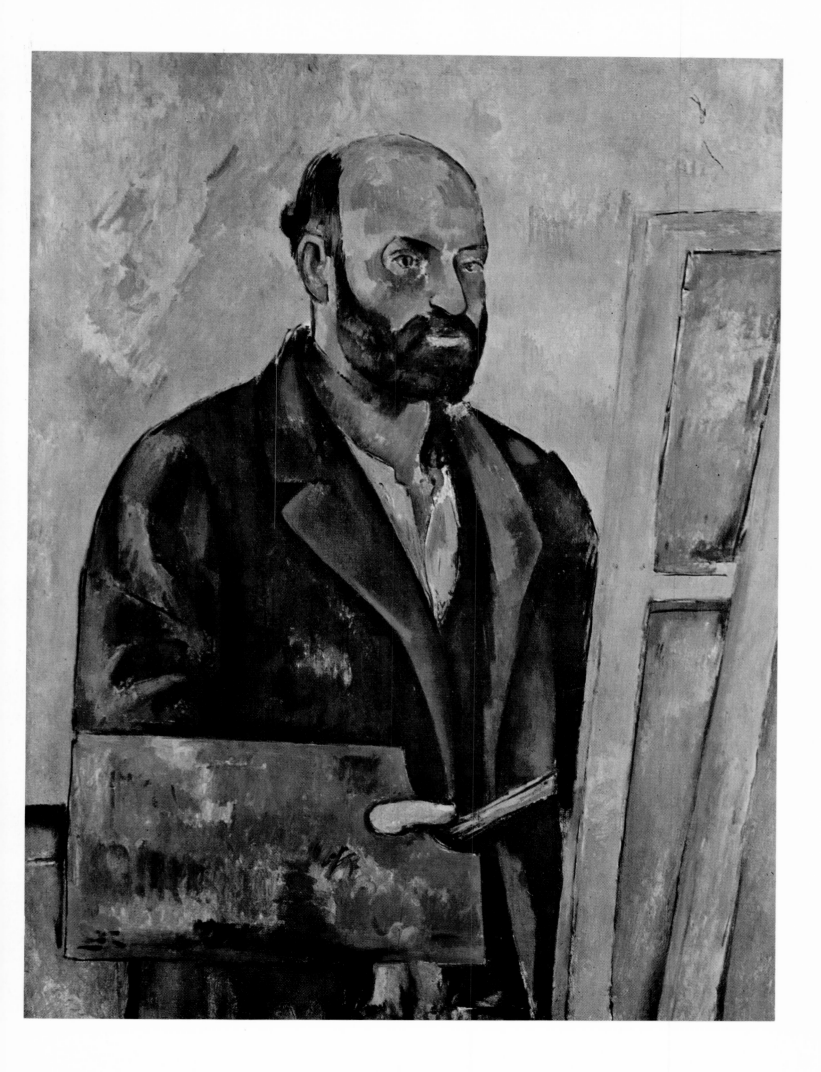

Painted 1885–1887

MONT SAINTE-VICTOIRE

The Metropolitan Museum of Art, New York
(Bequest of Mrs. H. O. Havemeyer, 1929.
The H. O. Havemeyer Collection)

$(25\frac{3}{4} \times 32\frac{1}{8}'')$

ANOTHER PANORAMIC VIEW, of a delicate, tranquil beauty. Admirable is the thought of opposing to the distant landscape the high tree in the foreground, a form through which the near and far, the left and right, become more sharply defined, each with its own mood and dominant. Breadth, height, and depth are almost equally developed; the balance of these dimensions is one of the sources of the fullness and calm of the painting. We experience the vastness of the space in the broad valley with the viaduct; we feel the equivalent depth in the long, endless passage from the house in the foreground to the mountain top; but we also measure the great height of the space in the central tree which spans the whole vertical dimension, crossing every zone of the landscape and reaching from the lower to the upper edge of the canvas.

The contrast of the vertical and horizontal is tempered by the many diagonal lines which are graded in slope through small intervals. The central, almost vertical tree is one of a series of trees more or less tilted, and the most inclined trunk approaches the slope of the mountain and the strong diagonal of the road. But this road, too, resembles in its sinuous form the long silhouette of the mountain, which in its lower ranges and foothills gradually settles into a pure horizontal, like the distant viaduct. The transition from vertical to horizontal through many small changes of axis is like the gradations of color which span the extremes of warm and cool, light and dark, in tiny intervals to create the opaline delicacy of the whole.

With so many diagonals, there are none that converge in depth in the usual perspective foreshortening. On the ground plane of the landscape, Cézanne selects diagonals that diverge from the spectator towards the sides of the canvas and thus overcomes the tension of a vanishing point, with its strong solicitation of the eye. In the roof in the foreground, he has run together the gable and ridge as a single slope, parallel to the diagonal paths, in defiance of perspective rules. The depth is built up by the overlapping of things and through broad horizontal bands set one above the other and crossed by the vertical tree and the long diagonals. The play of color contrasts is also a delicate means of evoking depth. The same deep green in the foreground plane of the tree is contrasted with a strong ochre below and the light vaporous blue of the sky above. Reddish tones on the upper tree trunk pick up the rose of the mountain peak, but are set against a darker blue tone than the sky. The contrast of warm and cool shifts gradually from the foreground couplings of green and yellow to distant couplings of blue and rose.

The brushwork is among the essential beauties of this painting and is worth the most careful attention. It is perfectly legible and frank, a sober, workmanly touch—and through its countless shiftings of direction and size is a lyrical means, senstitive to the tiniest changes in the visual stress of the forms and colors, their modeling and accents.

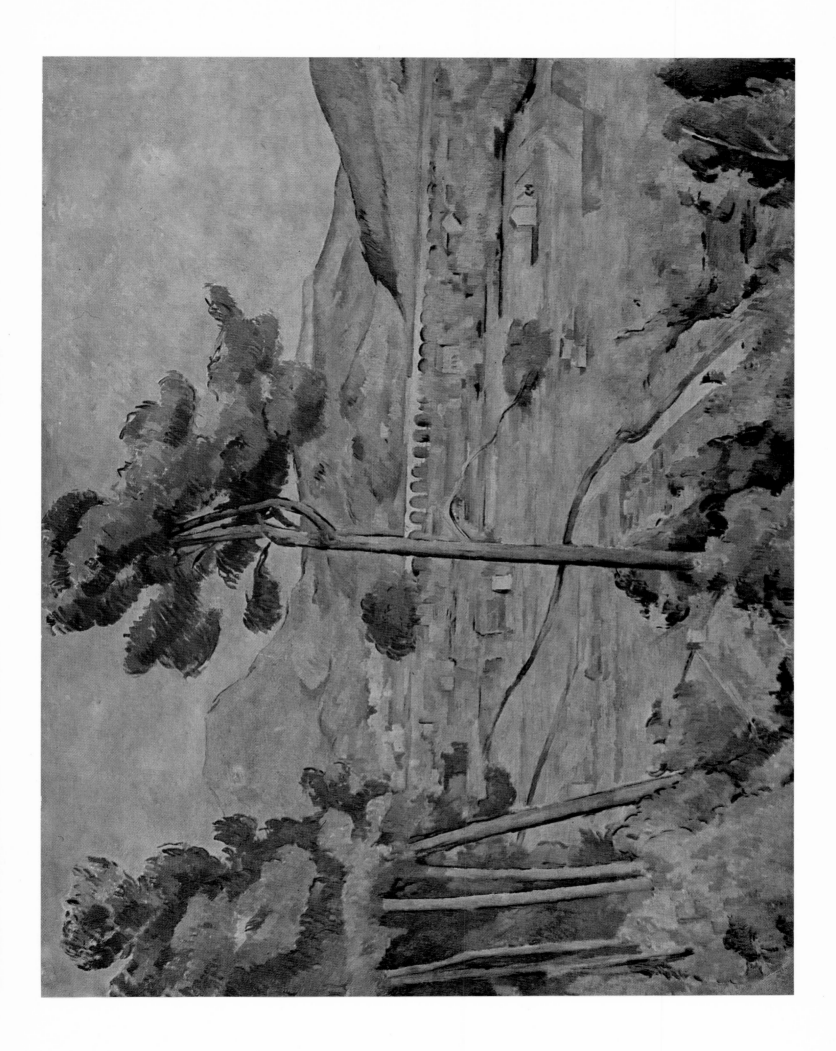

Painted about 1885–1887

THE BATHER

The Museum of Modern Art, New York (Lillie P. Bliss Collection)

$(50 \times 38\frac{1}{8}'')$

IT IS A STATUE IN A LANDSCAPE; not of a bather but a man in thought. Completely absorbed in himself, he is welded to his surroundings: the color of his flesh is like the ground, and the shadow tones of blue, violet, and green, the rosy and lightened high lights, are like the water and sky. His great vertical form rests on a world of horizontal bands; verticals and horizontals belong together. The bent arms resemble the sloping rock profile at the right. The opening of the legs is like the fingers of water laid out on a contrasting ground. Besides the symmetry of the rock edge and the bent arm, there is the symmetrical pattern of the segments of sky between the body and the arms and the related belt—a tight construction of upright and horizontal forms. On the belt, the banded lines are seen together with the fingers above them, but also with the banding of the earth at the left—the reddish prongs of the ground which alternate with blue inlets of water.

It is a strange landscape, imagined in the studio, yet natural for the naked figure, his only possible milieu—empty, mostly barren, and delicate like revery. Figure and landscape echo each other and bear the same brushwork, the same substance of color, equally free, spotted, and changing. The main lines of the landscape coincide with divisions of the figure. The upper body is in the sky, the lower is on the earth. Where the knee advances, marked with red, begins a green band of the earth. The bent arms call out luminosities and turbulence in the adjoining sky, like the angels fluttering about a holy figure in old art.

The drawing is an effect of naive searching, an empirical tracing and fitting of the forms, a little awkward yet rhythmical and strong, and finally right; some touches, as in the well-articulated legs, exploit a past study; other parts are more arbitary and fresh. This drawing, so earnest and free, was a revelation to young artists about 1906 and helped to liberate them. The body is not stylized nor reduced, but reconstructed scrupulously according to an ideal of harmony and strength. It is a drawing without banality or formula, even a new formula.

But is it essentially a "pure form," an "abstract" construction? I do not think so. There is in this monumental bather a complex quality of feeling, not easy to describe. Rigorously tied to the landscape, the figure is nevertheless detached, unaware of the world around him. But the meditativeness is only half the story. The upper body is immobilized by its posture; it looks inward and closes itself. The man walks, yet holds his sides. This upper body is ascetic, angular, strictly symmetrical, and relatively flat, the lower body is more powerful, athletic, fleshy, modeled, and in motion—an open asymmetrical form. Two opposed themes are joined in one body, and this opposition appears also in the character of the sky and earth, one vaporous, the other more stable and solid. The drama of the self, the antagonism of the passions and the contemplative mind, of activity and the isolated passive self, are projected here. The contemplative dominates in the end, but the body remains warm in color, powerfully set, while the world—an enveloping void—is distant and cool.

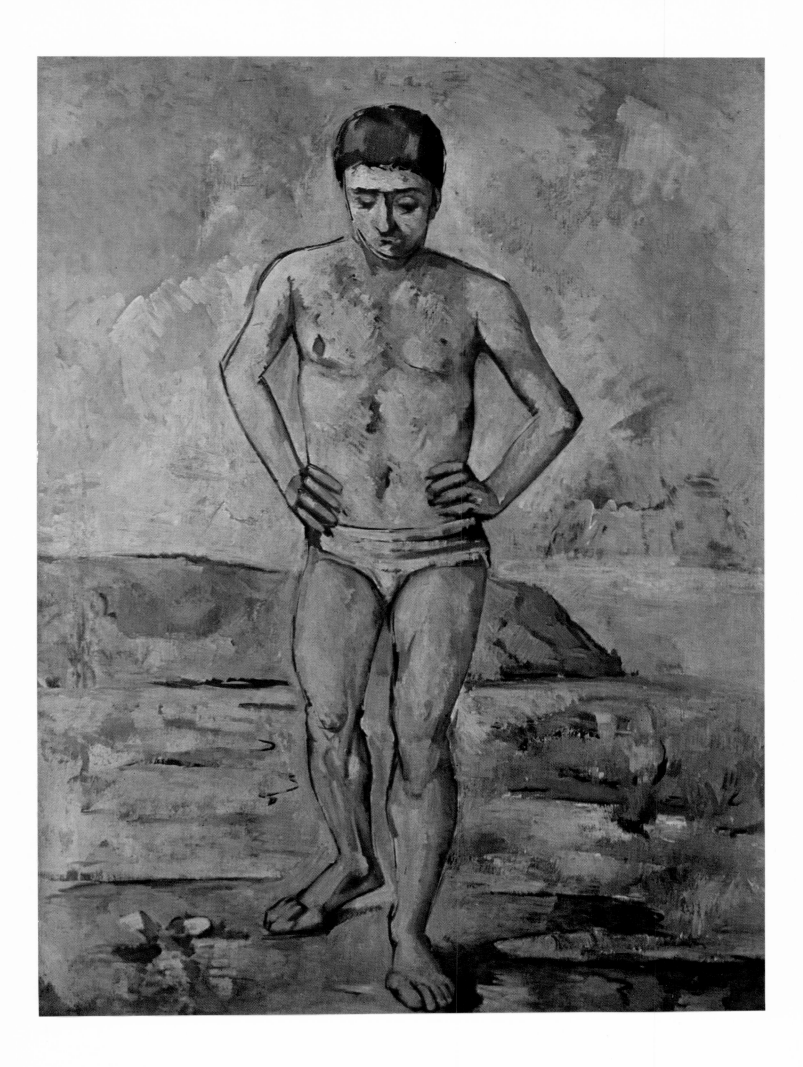

Painted 1885–1886

HOUSE IN PROVENCE

The John Herron Art Institute, Indianapolis

$(25\frac{5}{8} \times 31\frac{7}{8}'')$

THIS IS ONE OF THE EXEMPLARY CÉZANNES—an original poetic harmony of the artificial and the natural. The house is like the mountain in its vertical and sloping planes, the mountain is in places clean cut and bare like a human construction. The man-made looks abstract and impersonal, without accident of history, while the natural shows many signs of wear—irregular outlines, notched and broken slopes, and varied stages of growth—together a scale from the geometric to the organic, terminating in the rounded broken shapes of the trees. By a typical inversion, poetic too, the straight forms have the warmest colors, the less regular mountain and trees are cold; but the natural and artificial penetrate each other through common tones as well as parallel shapes. The ridge of the house, subtly broken, is prolonged in a wavering line of vegetation.

Very fine is the composition of trees isolating the house from the rest of the landscape. They are broadly symmetrical in pattern, and the edges of the farther group are related to the breaks and shadows on the mountain directly above. The rightmost tree, highest of all, rises from the chimney, as though a part of the house; it creates an axis near the middle of the picture, uniting the house and the mountain. This tree is just beneath the lightest spot on the mountain, the focus also of discreetly converging lines of the hillside below, of the farthest tree at the lower right, and of the leftmost gable of the house. Two foreground trees, superposed to suggest a single tree, mask the joining of the two walls. This bold device strengthens the horizontal of the house and reduces the intensity of convergence of these walls—they seem to merge vaguely, as if at an angle approaching 180 degrees. The placing of the windows and door—oddly, yet in harmony with nearby forms—is an example of Cézanne's great scruple and delicacy in the design of details. See how the tree masks one window, and how the door and the other window form a slightly sloping line with the chimney and the tree above it; imagine the dullness of the first window complete and the stiffness of the other openings in a normal alignment and you will admire Cézanne more for his arbitrariness and discretion. Especially beautiful—and like his water colors—is the painting of the leafless tree and of its repeats at the right, an element of the immaterial and tentative in this eternal, substantial landscape. The horizontals are something to meditate; no picture I know has such perfection in disposing parallel lines for interest and grandiose effect. When writers, carried away by the sublimity of such a work, speak of the "essential" or "underlying" forms of nature revealed by Cézanne, we may reject the philosophy of nature implied in such a view, but we respect the metaphor—the forms seem to us indeed a revelation of a harmony in nature not given in ordinary perception and requiring for its expression in art a mind preternaturally sensitive to order.

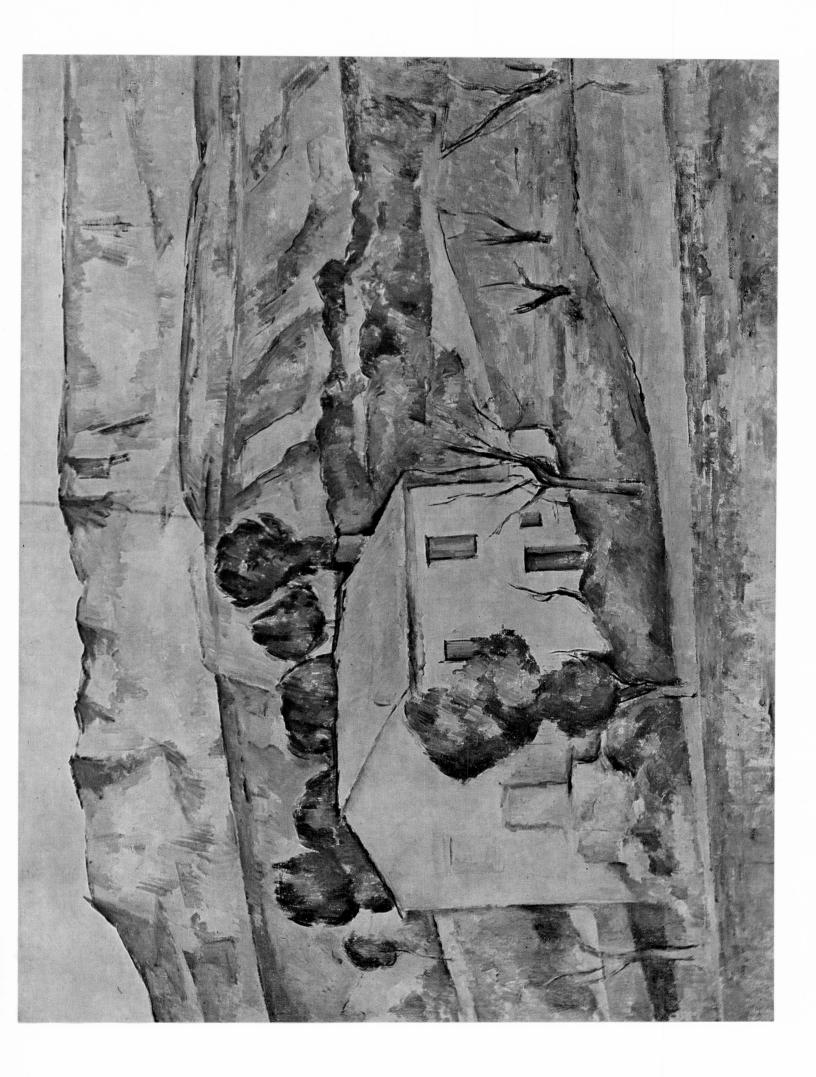

Painted 1885–1887

CHESTNUT TREES AT THE JAS DE BOUFFAN

The Minneapolis Institute of Arts

$(28\frac{3}{4} \times 36\frac{1}{4}'')$

THE EFFECT OF A NOBLE CALM in Cézanne's painting does not require an obvious dominance of horizontals and bare geometric forms. There is a similar quality in this painting with many repeated verticals and intricate branching lines. Its repose is an outcome of more delicate relationships in the colors and forms. What is architectural in the conception reminds us of mediaeval rather than classic buildings, although it is so tranquil and relaxed. Cézanne has re-discovered here a principle of Moslem art: complicated ornamental lines, lacy and elusive, set above sparser, stable forms. In the late Gothic, too, the spreading ribs of the vaults often rise from simple piers. Cézanne, however, has chosen a viewpoint with a minimum of perspective play and hence little tension in depth. The side wall of the building at the left seems to face us like the front wall. The peak of the distant mountain, which might be a focus of the scene, is hidden by two trees. Cézanne places himself far off to the left, but sees the two rows of trees as an openwork screen parallel to the picture plane, like the stone wall and the low horizon. The separateness of things, their simple alignment in space, with only slight diagonal movements in depth, adds to the prevailing calm. The tree trunks, gently varied in thickness, tilt, branching, interval, and illumination, are unique organic shapes, firm but without the rigidity and strain of pure columnar forms. The upward striving force of the vertical lines is gradually dissipated in the all-over network of thinner, lighter branches which are finally lost in the vaporous sky. These graceful branching forms are beautifully designed, without a dull repeat. They arise imperceptibly from the heavier limbs and merge with the drawn outlines of the buildings and smaller trees. Their diagonal movements also parallel the sloping edges of the muted mountain peak.

We must not ignore, however, the importance of the horizontal in this work in which horizontal elements are so few and are broken by the stronger vertical forms. At the base of the whole is the broad band of green, a subtly painted carpet of many tones opposed to the greyed violet and brown of the vertical trees—a contrast of color that re-enforces the contrast of supporting and supported forms and is more striking still through the difference in brush stroke on the ground and trees. Behind are intermittent horizontal bands of yellow and lighter green, followed by the stone wall and the house which together repeat the alternation of the light and shadow tones in the trees. The succession of bands of varied color and stroke, with a progressive lightening of both color and touch, creates in the lower half of the space a grid of horizontal and vertical lines, which is gradually transformed into the diagonal network above through the sloping forms of the roofs, the hillside, and the distant peak.

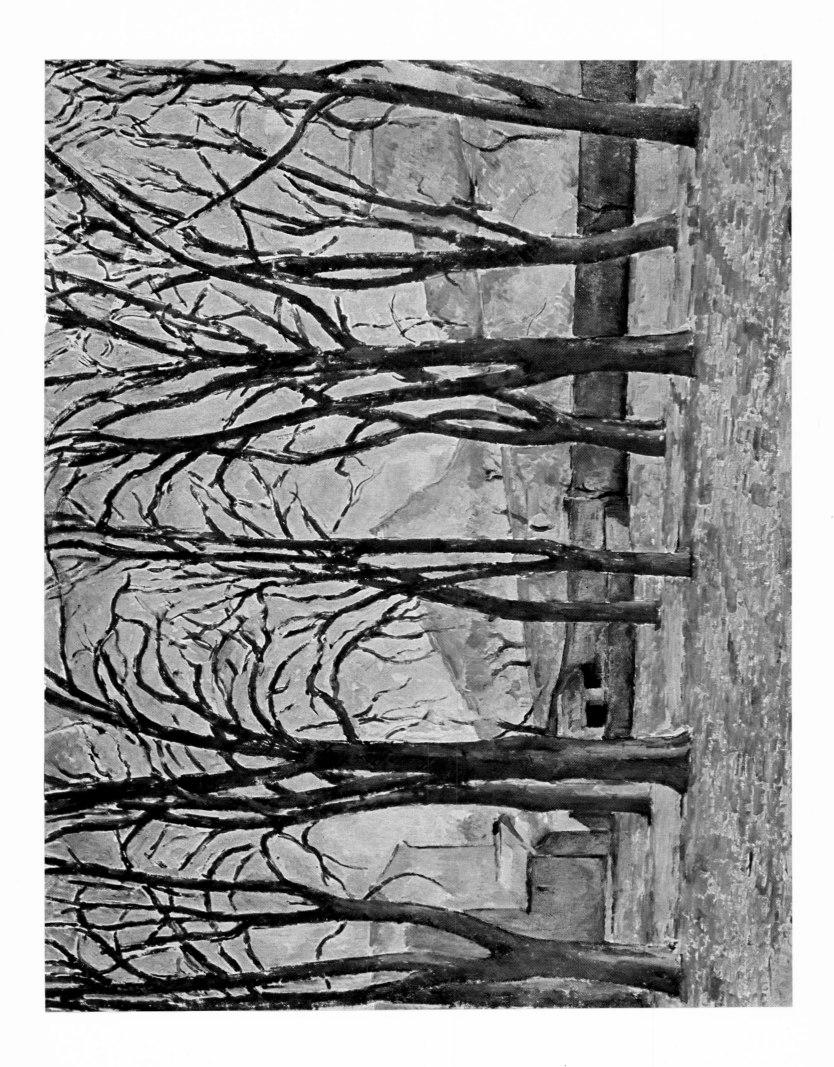

Painted 1885–1887

MONT SAINTE-VICTOIRE

Courtauld Institute of Art, London

$(26 \times 35\frac{3}{8}'')$

THE PEAK OF MONT SAINTE-VICTOIRE near Aix attracted Cézanne all his life. He identified with it as the ancients with a holy mountain on which they set the dwelling or birthplace of a god. Only for Cézanne it was an inner god that he externalized in this mountain peak—his striving and exaltation and desire for repose. In the painting in the Metropolitan Museum (page 67), the mountain comes less fully to view; its majesty is diminished by the foreground trees and the great extension of the valley at the right. The broader London picture renders the characteristic grandeur of the site, but also gives greater play, as I have said before (page 14), to the artist-observer and his turbulent mood. The stable mountain is framed by Cézanne's tormented heart, and the peak itself, through more serene, is traversed by restless forms, like the swaying branches in the sky. A pervading passionateness stirs the repeated lines in both. Even the viaduct slopes, and the horizontal lines of the valley, like the colors, are more broken than in the picture in New York. The drawing and brushwork are more impulsive throughout. Yet the distant landscape resolves to some degree the strains of the foreground world. The sloping sides of the mountain unite in a single balanced form the dualities that remain divided, tense, and unstable in the observer's space—the rigid vertical tree and its extended, pliant limb, the dialogue of the great gesticulating fronds from adjoining trees that cannot meet, and the diverging movements in the valley at the lower edge of the frame.

It is marvelous how all seems to flicker in changing colors from point to point, while out of this vast restless motion emerges a solid world of endless expanse, rising and settling. The great depth is built up in broad layers intricately fitted and interlocked, without an apparent constructive scheme. Towards us these layers become more and more diagonal; the diverging lines in the foreground seem a vague reflection of the mountain's form. These diagonals are not perspective lines leading to the peak, but, as in the other view, conduct us far to the side where the mountain slope begins; they are prolonged in a limb hanging from the tree.

It is this contrast of movements, of the marginal and centered, of symmetry and unbalance, that gives the immense aspect of drama to the scene. Yet the painting is a deep harmony, built with a wonderful finesse. It is astounding how far Cézanne has controlled this complex whole. If you wish to see his subtlety at work, consider only the bending of the tree which becomes perpendicular to the mountain's slope when it reaches the horizon. Or observe the rectangular and peaked forms of the house beside the trunk of the same tree.

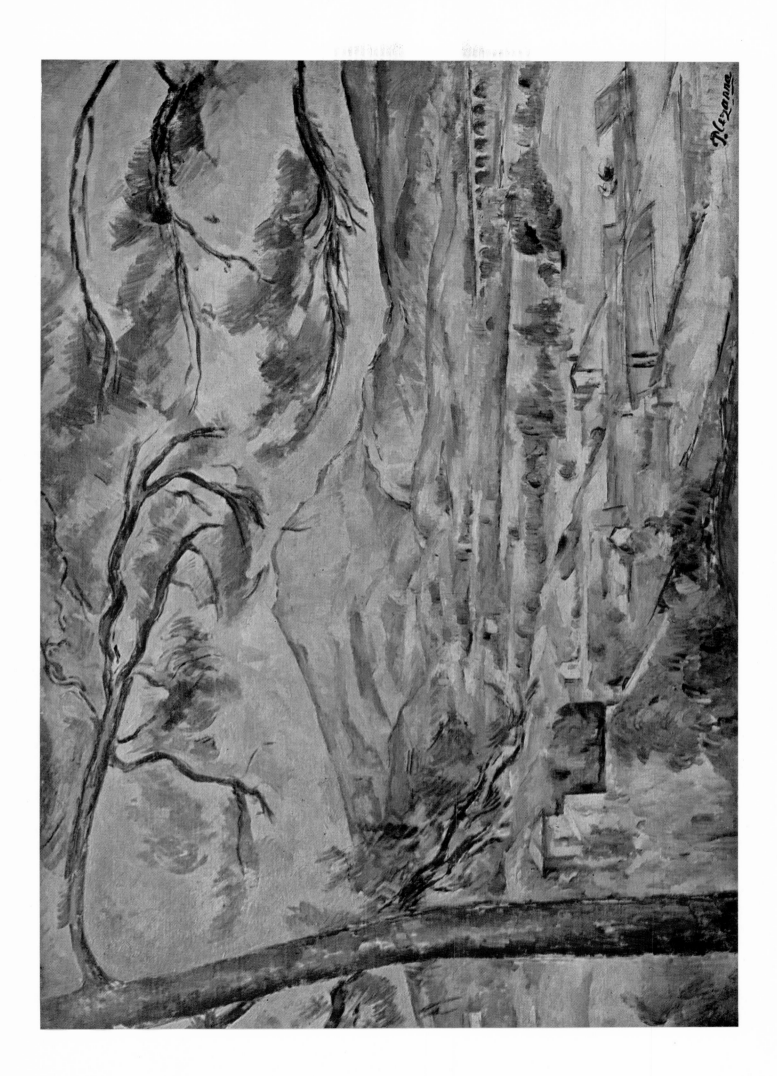

THE BLUE VASE

The Louvre, Paris

$(24 \times 19\frac{5}{8}'')$

A NEW TYPE of still life, of the mid–eighties, with luminous high–keyed colors throughout, in the background as in the objects. The relations of intensities and pure hues come to the fore.

In spite of the greater brightness, the small differences count for more in the harmony and expression of the whole. The sensitiveness is a marvel; to reproduce it perfectly is impossible. Together with the richness of hues goes an incredibly refined gradation of tones. The blue dominant, which is more than a local color—it is a prevailing mood—has a different quality in the vase, the wall, the platter, and the smaller units; observe the flowers and the blue touches on the table, which are contrasted with warmer neutral tones. The blue is an exhalation upward and into depth. The rich green is concentrated in space, the reds, yellows, and whites are in smaller scattered bits, the blue is diffused over a large area. The greys and neutralized tints are toned with yellow or blue in exquisite intervals.

The arrangement is no less interesting than the color and just as refined. It is formal, very deliberate looking, through the dominant theme of the vase, set in the middle between verticals; and through the calculated, naively stiff alignment of objects beside and behind the vase, as if in prescribed rows, parallel and frontal, like pieces on a chess board. But against this apparent rigidity plays the expansive lyrical movement of the bouquet, with its shapeless spots, reaching out to the limits of the space (yet the red, green, white, and blue spots maintain in their positions the perpendicular scaffolding of the whole). The formality is challenged, too, by the strong diagonal behind the vase, so sensitively broken near the vase's edge, and by the details of execution—they are amazingly free, like the details of a distant landscape, yet are so near that one object—the bottle—is cut by the frame. The fine scalloping of the edge of the plate is a pure painting variation in contrast to the smooth strong curve of the vase's shoulder, but seems inspired by the wavy mouth of the same vase. The many tiltings and discontinuities soften the severity of the architecture of the whole. In the fruit, the outlines lie partly outside the object. Such disengaged strokes deny the substance of things and make us more aware of the artist at work—a wonderfully delicate, scrutinizing, weighing, balancing, eye and hand.

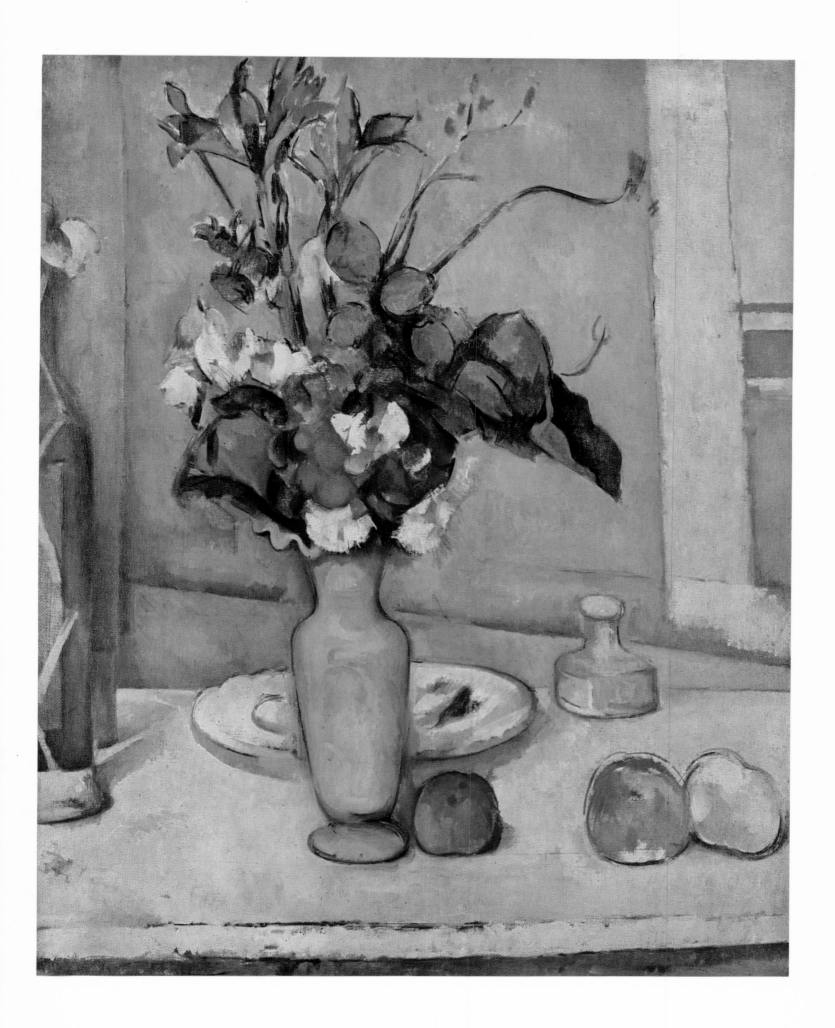

Painted 1886–1890

MOUNTAINS IN PROVENCE

Tate Gallery, London

$(25\frac{5}{8} \times 31\frac{7}{8}'')$

THE BARE FOREGROUND sets off the landscape like a craggy shore viewed from a passing boat at sea. The theme is typical of one side of Cézanne's art, his vision of nature as a detached presence, solid and stable, something we see and cannot cross.

In this suspended vision, so beautifully composed, is a great span of feeling. We pass from the steep, fractured rocks—modeled, unbalanced, dramatically illumined, ruddy in the light and grey in the shadows—to the gently sloping, rounded hillside with delicate surface markings under a soft light; from the bent, jagged tree which breaks the horizon to the smaller echoing trees, settled against the quiet hill; and beyond to the pale void of the sky.

The power and harmony of the scene, so passionate and still, rest on a most subtle invention of large contrasts, small gradations, and interwoven accords. We feel the ultimate balance of opposed, unstable forces, but we cannot isolate them as distinct parts; each is so complex within itself and involved in so many relations with neighboring forms and tones. What looks at first like an explicit geometric design in the strange symmetry of tilted horizontal bands soon reveals itself as more natural and free. The austere painting of this solitary world sacrifices little of the naturalness of the encountered scene. The rocks, like a town in their cleft upright planes with red tops like roofs—these recall the buildings in the distance—have also chaotic, accidental structures and vaguely organic shapes which merge with the trees.

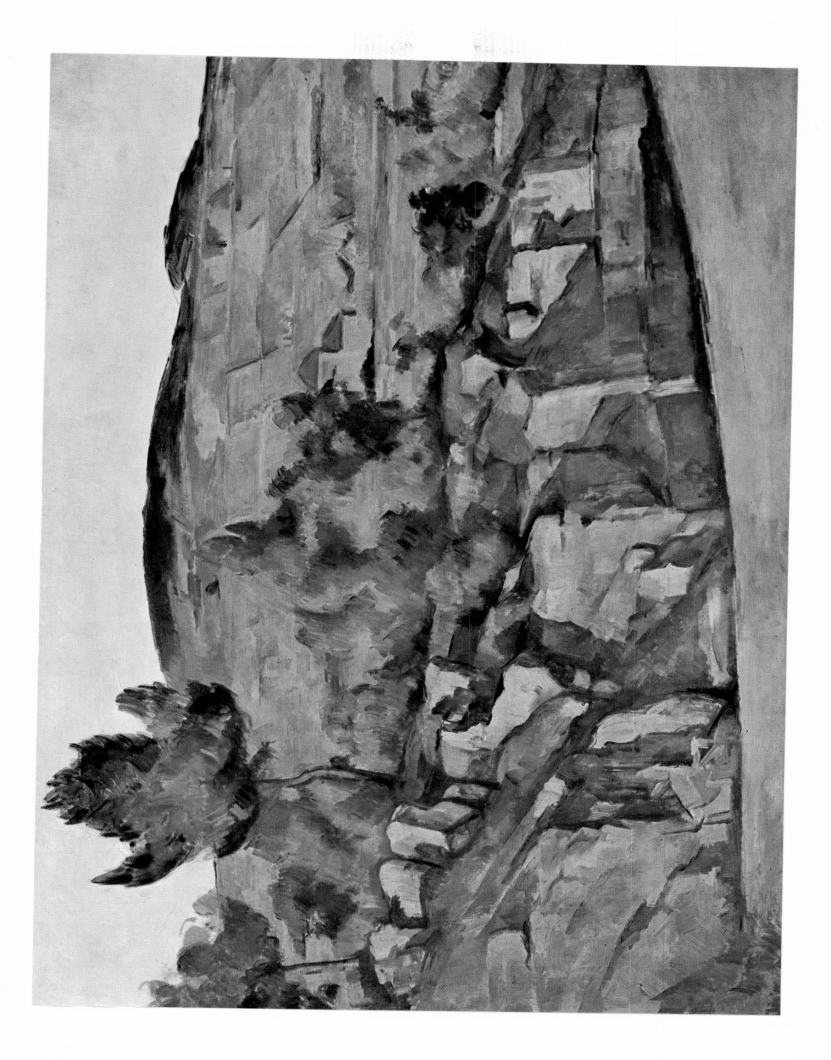

ROAD AT CHANTILLY

Collection Mr. and Mrs. William A. M. Burden, New York

$$(31\tfrac{7}{8} \times 25\tfrac{5}{8}'')$$

A MODEST, unlikely theme: a narrow, closed path flanked by trees, at the end of which we glimpse irregular segments of buildings, the whole seen in the most obvious way—the road in the middle, the opening, too.

We have observed before (page 14) the significance of the barrier for Cézanne's vision of landscape. He concentrates, looks attentively, but does not cross. It is an object isolated at random for the eye; the symmetry does not belong to the scene as a whole, but to the conditions of seeing; the frame is like the eye itself, the path is the axis of vision; what is sighted on this path and within this frame is incomplete—it is not the object as we know it to be; yet Cézanne disengages an order from it, establishes connections between the parts and finally unites it to his frame. He isolates a pair of windows, joined by a roof line; together, they correspond to the barrier in the road. The sloping gables are like the inclined trees which frame the narrow view. The frame of vegetation forms an arched structure with supporting posts of interestingly contrasted shape, and the distant, enclosed segment of buildings is a shuffled quasi-Cubist succession of overlapping planes of warm and cold color, which we discover again in a loose play in the varied masses of the trees.

Cézanne's object is a piece of the visual world that combines in a striking way equivalents of the subjective and objective in his own seeing. The object of vision is closed off, the space near the spectator is open to him; the path of the eye is very marked, the path of the body is obstructed or absent. But the object and the spectator's space cohere in a rigorous way, through both the shapes and the colors. The object is accepted as directly given; it is in the center of the eye's field. In this picture it is perhaps reduced in size. If you sight the buildings through one eye, the depth is very marked.

What counts in the end is Cézanne's color sense and the life of his brush—vigorous, expressive, sure, and always in motion. We enjoy a beautiful play of greens beside the yellows, violets, and blues. The spots of green seem shapeless, in contrast to the geometrical lines of the buildings; yet they possess their own free harmony of form.

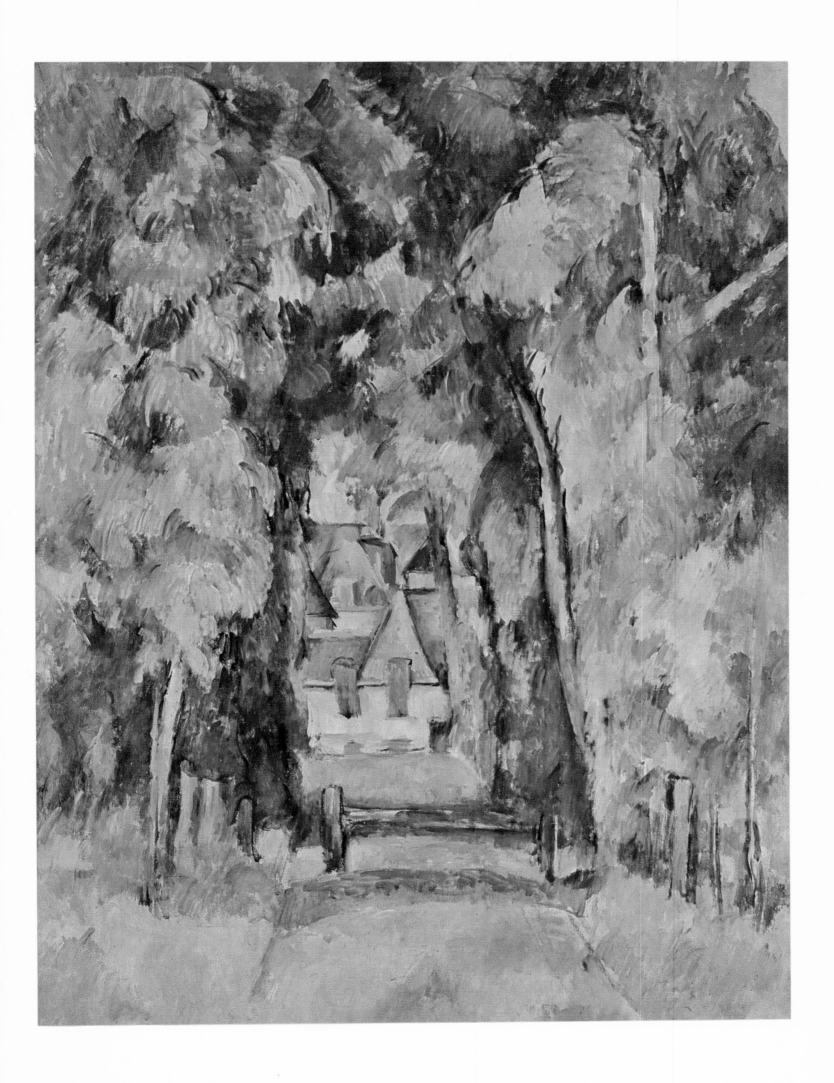

Painted about 1890

MADAME CEZANNE IN THE CONSERVATORY

The Metropolitan Museum of Art, New York
(Bequest of Stephen C. Clark, 1960)

$(36\frac{1}{2} \times 28\frac{1}{2}'')$

A PORTRAIT UNUSUAL FOR CÉZANNE in the search for a tender, idealized, graceful expression. An unfinished work, it gives us a glimpse of Cézanne's methods. We see his first strokes, very sparse and thin like water color, and the progressive enrichment and strengthening of the entire canvas as he proceeds. Building up the head, modeling the features with subtle tones, he adds parallel and counter touches around it. The inclination of the head—the bearer of a delicate submissiveness and revery—belongs as much with the tilted lines of the wall and the trees as with her own body. Foreground and background are united in the common sweep of the tree trunk and the sitter's right arm. So rich an interplay of the person and the surroundings is uncommon in Cézanne's portraits; another example, but of a contrary, virile, intellectual quality, is the painting of Geffroy (page 95).

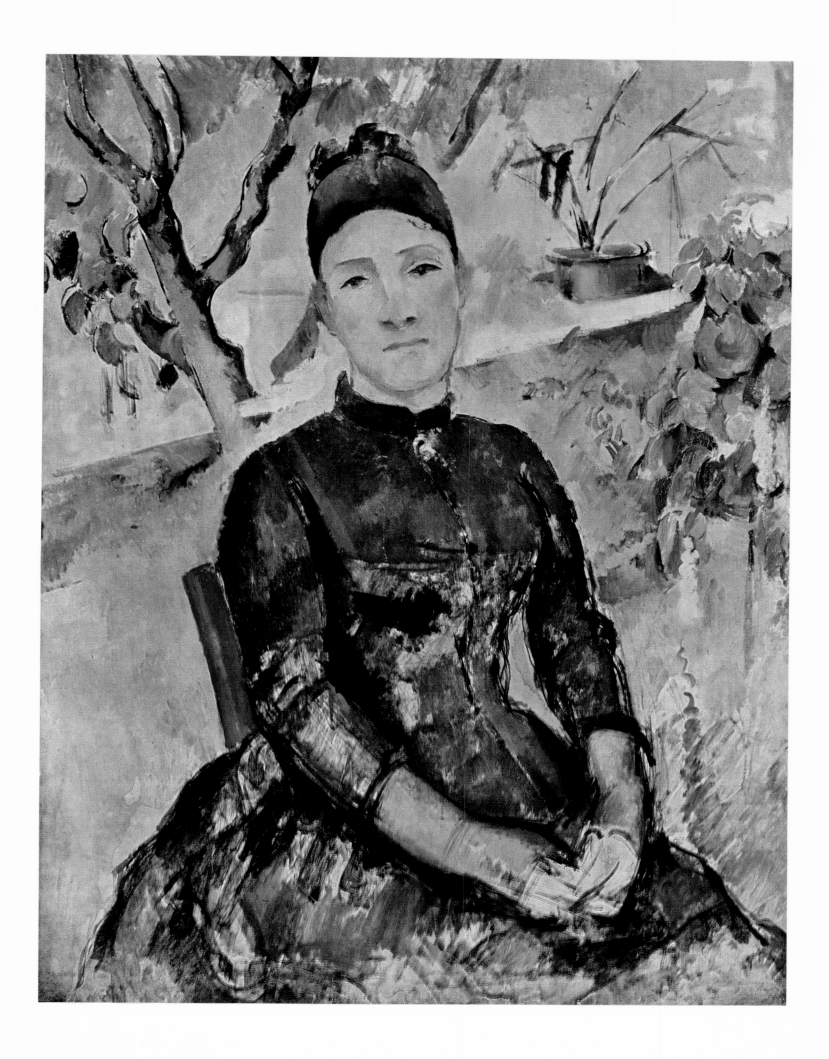

CHATEAU DE MARINES

Collection J. K. Thannhauser, New York

$(29\frac{1}{2} \times 36\frac{1}{4}'')$

A SKETCHY, THINLY PAINTED PICTURE, remarkable for the *motif* and the intellectual approach. It is an imaginative treatment of perspective, in which Cézanne experiments with depth and surface, freely adjusting the sizes of things to compositional and expressive ideas, without giving up altogether the perspective phenomenon. He plays with the latter paradoxically; just as in other works he makes the distant objects larger than in normal appearance, here he makes a fairly near object—the central building—so small that we judge it to be far away. At the same time he reverses the conception of his *Road at Chantilly* (page 81). There he concentrated on a building seen incompletely at the end of a barred path; here the whole building—cut off from us by the bushes in the foreground—is visible in the center, but the image is expanded at the sides, and the larger segments of buildings at the periphery of the visual field compete with the object in the middle. The strongest accents of color are two exceptionally bright vermilion spots attached to the buildings at the sides. The central house, very tiny beside the others, seems to belong to a different perspective, as though it were a picture within a picture, a montage. In this odd game of vision, the centrally focused is devalued; what is diminished by perspective is also the emotionally distant—it is a doll's house, enclosed by thick vegetation. Only the lateral buildings can be approached directly from the road. Yet in form this apparently tiny building is a synthesis of the large ones; its vertical tower and horizontal wings combine the separated vertical and horizontal dominants of the others. We are reminded of the Impressionist device of placing an enlarged object at the side and cutting it by the frame. But Degas would treat the object as if seen from the side or from the corner of the eye, whereas here we have symmetry and a central focus. It is as though Cézanne wished to produce the effect of something seen directly before him, yet less important for the observer than what lay at the sides, near and incomplete. An exaggerated perspective here becomes a means of detachment.

There is another equally interesting aspect of paradoxical vision and spacing: the three buildings, of very different quality and in distinct planes in depth, are united through the mass of trees which lies between them. The outline of the daringly tilted building at the right is prolonged in the edge of a tree—a distant tree on the horizon—which by this device is tied to the foreground, to the yellow path below. The same tree belongs to the shapeless mass above and behind the central house, merging at the left with trees that rise from trunks in the foreground. Undoubtedly, these trees would have been more sharply distinguished in their color from the more distant ones, had Cézanne finished the picture; but the idea of a continuity between the near and the far through common edges and parallels would have been preserved.

These paradoxes of the visual—an emancipation from old habits of seeing—are justified finally by the harmony of the pictorial effect and by the fascination of the image, which has a certain truth to feeling in evoking the rivalry between the central and marginal in vision.

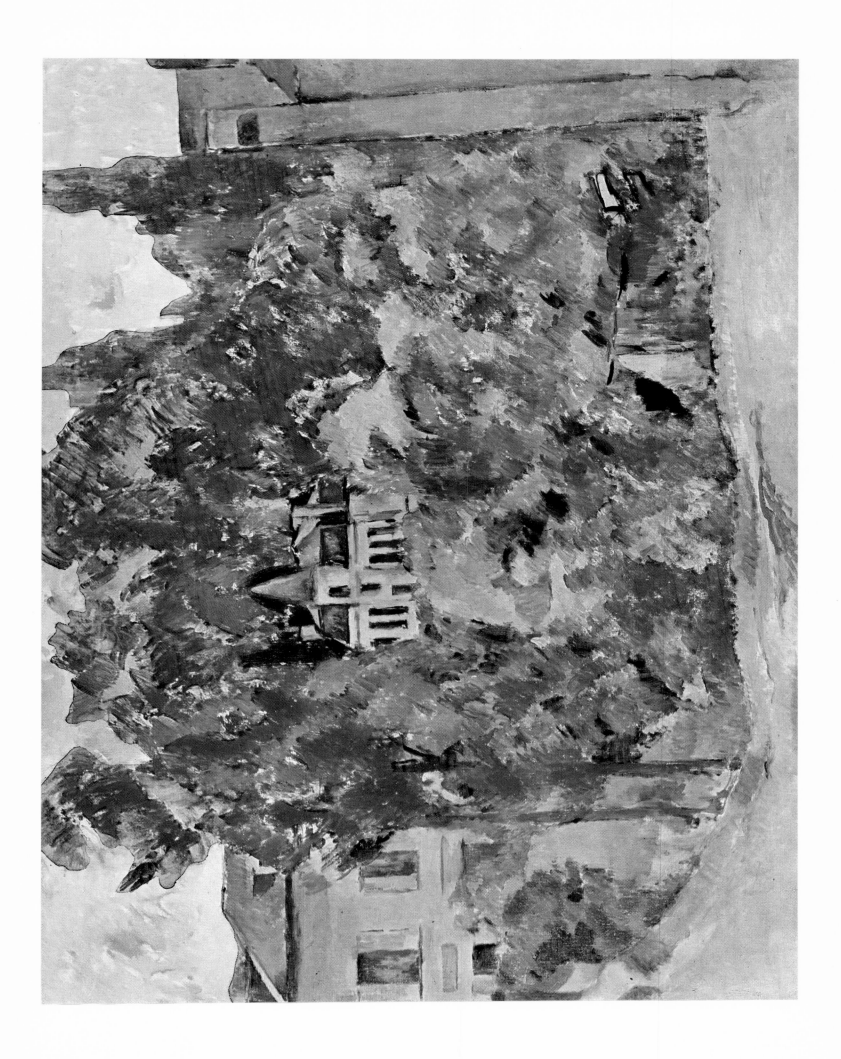

Painted 1890–1894

TULIPS AND APPLES

*The Art Institute of Chicago
(Mr. and Mrs. Lewis L. Coburn Memorial Collection)*

$(23 \times 16\frac{1}{2}'')$

IN THIS BEAUTIFUL STILL LIFE the contrasts of forms and colors, their adjustment to each other, are astonishingly subtle. We see the two red tulips together with the two apples below; the dispersed little flowers repeat in a different way the concentrated yellow of the apple behind the vase; and the spread of the outermost green leaves resembles in reverse the wide angle of the warm dark edges of the table. But the elements of the bouquet are active forms, lively and even charming, a cluster of growing, expanding things painted with great freedom; the apples and the table are closed forms, detached, inert, silent—a sparse world. It is a harmony of opposed elements, a strange balance of contrary qualities, united through hidden analogies and a most sensitive play of color. We feel a vague human drama in this still life, especially in the separateness of the apples, as if the relations of people, their desires and constraints, have been translated into the contrasts and groupings. The severer fields of the table and wall are painted in subdued light tones— contrasted warms and cools—of an extraordinary delicacy; the living plants have angular thrusting forms, large and small, with strong zigzags sharper than the edges of the table and repeated in the great silhouette of dark green in the extended right leaf and the vase. The lower part of the vase is colored like the table, its rounded outline is like the fruit, and the slight curvature of the horizontal boundary of its two colors responds to the faint convexity of the back of the table. Between the apples and the tulips is an undrawn diagonal— an implicit and unescapable line of attraction—which parallels the side of the table and unites tulips and apples with the former. These and many other nice unstressed relationships compel our admiration. Fascinating is the curved shape, like the end of a leaf or petal, observed on the wall between the legs of the table.

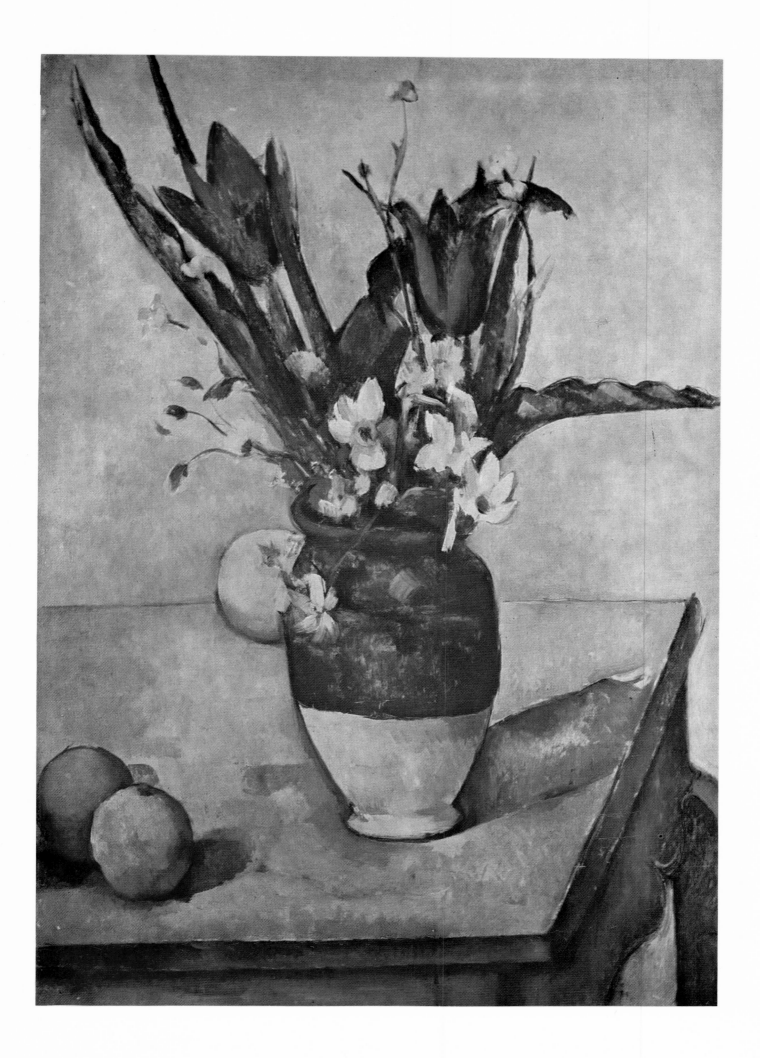

THE CARD PLAYERS

The Louvre, Paris

$(17\tfrac{3}{4} \times 22\tfrac{1}{2}'')$

OF THE THREE VERSIONS, the little painting in the Louvre is the last and undoubtedly the best; it is the most monumental and also the most refined. The single shapes are simpler, but the relationships are more varied. The extraordinary conception of the left player is the result of a progressive stabilizing and detachment of this meditating figure.

It is the image of a pure contemplativeness without pathos. Given the symmetry of the two card players looking fixedly at their cards, Cézanne had to surmount the rigidity and obviousness of the pair and yet preserve the gravity of their absorbed attitudes. It is remarkable how thoroughly interesting is this perfectly legible picture, how rich in effective inventions of color and form.

The problem: how to image the figures as naturally symmetrical, with identical roles—each is the other's partner in an agreed opposition—but to express also the life of their separateness, without descending to episode and weakening the pure contemplative quality, so rare in older paintings of the game.

It is accomplished in part by a shift of axis: the left figure is more completely in the picture; his partner, bulkier, more muscular, is marginal—but oddly also nearer to us—and takes up more of the table. His head is bent forward; he is more intensely concerned. The first man is the more habitual player, relaxed and cool, and his long columnar form is contrasted with the horizontal line behind him. The two hats, one with arched brim, firm and poised, the other with turned-up, irregular brim, soft and battered, convey this difference of feeling—two tonalities of meditation. The left player has a bright mind and a sluggish body, the right has a slower mind and a livelier body or temper. The former's arm begins very low, his limbs are detached from the tiny head which is intent but not anxious (it is remote from the body and is like the hat on the head). The other has a hunched effect; if he is ready to play, he is more strained in deciding. The arms of the first are parallel, the other's arms converge. The first head is set against a vague landscape, the second against an architecture of verticals, a more rigid, pressing form which measures the inclination of his body. The long man's face is shaded and lit with inner contrasts that subdue the silhouette; the other's is more open, more fully given. The first has light cards, the second, dark, and his hands are nearer to us. The tablecloth ends in a stable right angle at the left, in a sharply pointed form at the right. The color too is a subtly contrasted expression: violet against yellow, but both neutralized; in the left figure, violet jacket, yellow pants; the converse in the right. The latter is therefore more strongly contrasted with his surroundings in color as well as form. But this contrast is crossed: the straight figure against a sloping chair, the inclined figure against a vertical edge.

The inherent rigidity of the theme is overcome also by the remarkable life of the surface. There is a beautiful flicker and play of small contrasts, an ever-responding sensibility on every inch of canvas.

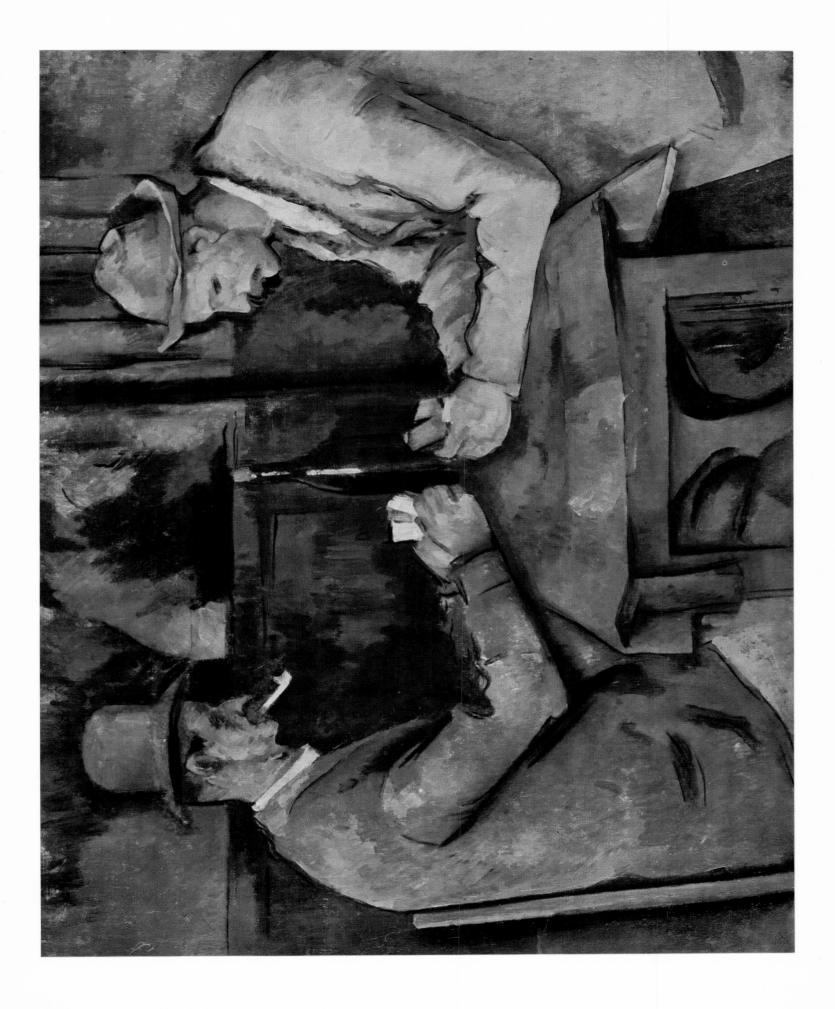

Painted 1890–1894

STILL LIFE WITH BASKET OF APPLES

The Art Institute of Chicago
(Helen Birch Bartlett Memorial Collection)

$(24\frac{3}{8} \times 31'')$

IT IS HARD TO IMAGINE A CIRCUMSTANCE of everyday life in which these objects would occur together in just this way. We are led to consider the whole as an arrangement by the artist, a pure invention. The basket rests on a block, the cookies on a platter set on a book, the apples on a richly folded cloth, and all these together lie on a table. This insistent superposition of things—very clear in the biscuits—is the clue to the artistic idea: the painting is a construction. The table too is treated as a kind of masonry with strongly banded forms. What makes all this more interesting is that so many of the elements are unarchitectural in feeling: the thirty or more apples, irreducibly complex in the sequence of colors, each fruit a singular piece of painting, a unique object; the tilted asymmetrical bottle and the basket; the hanging, rumpled tablecloth. This carefully considered still life, so exact and subtle in its decisions, retains an aspect of randomness, of accidental grouping. It is an order in which sets of elements of different degrees of order are harmonized; the apples in the basket—the apples on the tablecloth; the broken folds of the latter—the regular pattern of the biscuits. Balanced as a composition, the painting risks a great unbalance in the parts. It is not simply an equilibrium of large and small units, but of the the stable and the less stable. The odd tilting of the bottle must be understood in relation to other instabilities as part of a problem: to create a balanced whole in which some elements are themselves unbalanced. In older art this was done with figures in motion, or with a sloping ground, or hanging curtains and reclining objects. What is new in Cézanne is the unstable axis of a vertical object— a seated figure, a house, a bottle. Such deviations make the final equilibrium of the picture seem more evidently an achievement of the artist rather than an imitation of an already existing stability in nature. Here we cannot help but see together as balanced variations of a common unbalance the diagonals in different planes—the tilting of the bottle, the inclined basket, the foreshortened lines of the cookies, and, corresponding to these three tilted forms, the lines of the tablecloth converging to the lower edge.

The color is luminous, robust, and clear; tempered in the large objects, more intense in the small; and everywhere finely nuanced—the product of a visibly active brush. Although the bottle has the smoothness of glass, the other objects are fairly neutral in texture; assimilated to the qualities of the pigment and the stroke, they look solid but are not distinct substances—in the table this character goes with the astonishingly radical "abstract" treatment of its structure. The bottle too is submitted to this concreteness of paint and touch in the loosened, open rendering of its right edge.

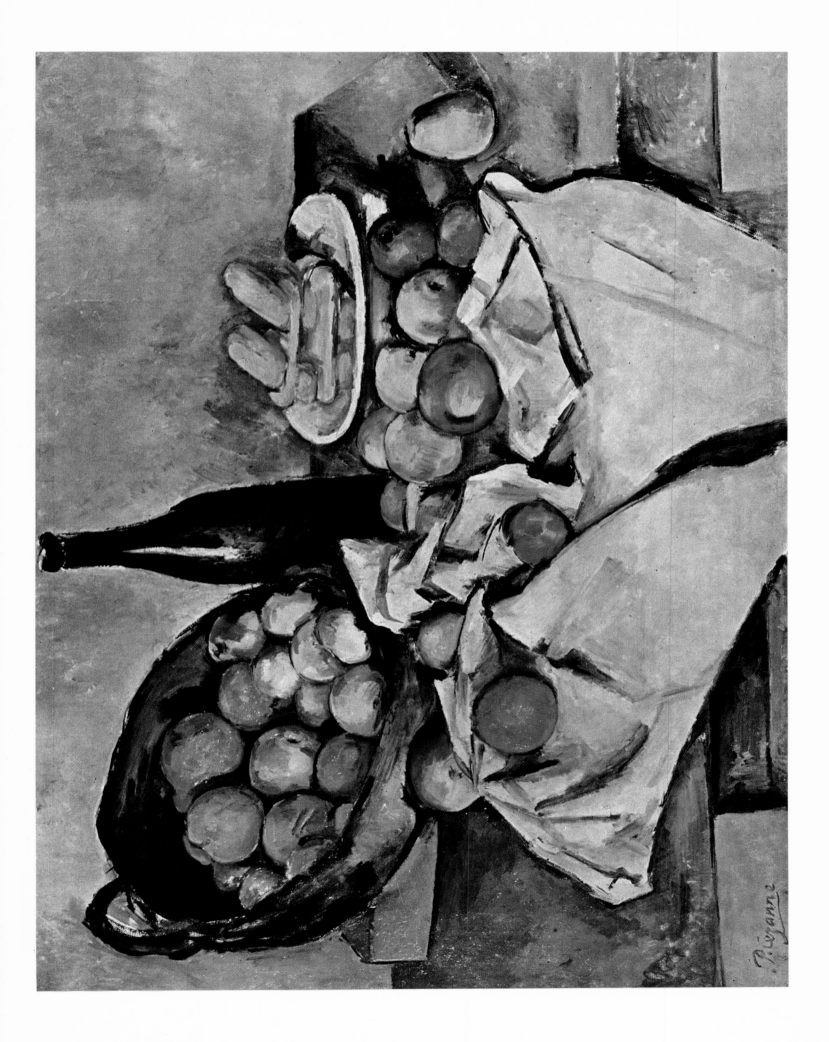

BOY IN A RED VEST

Collection Mr. and Mrs. Paul Mellon, Pittsburgh

$(36\frac{1}{4} \times 28\frac{3}{4}'')$

IT IS ONE OF A CLASS OF LATE PAINTINGS with a pensive, youthful figure; there is an example in which a boy sits at a table beside a skull. Here the languid posture and the close envelopment by heavy sloping drapes convey the mood of depressed revery, without pointing to its theme. The boy, wrapped in a costume that resembles in substance the oppressive drapes around him, looks shrouded in his space. The red vest, too, is an element of the mood. This exceptional core of strong color is not expansive, but tends toward the cool and violet; the blues of the tie and sash are dark and greyed. The conventional classic pose of the academy nude, with one hand on the hip and the other hanging—a relaxed pose of movement and momentary rest—has become a posture of passivity and weakness. We measure against the limp, inert arm the delicacy of the balanced tiltings of the limbs and the great force of the repeated diagonal masses of the drapes. The long melancholy figure, with its sad grace, recalls the aristocratic Italian portraits of the sixteenth century in which activity has been arrested by introspection and doubt. Vague as they are, the boy's features are delicately drawn; we cannot help noting his shyness and troubled inner life. The faintly drawn lips are like the wings of a distant flying bird.

In contrast to this subdued tonality of feeling—surely important to Cézanne—the painting is vigorous and powerful, with that noble largeness of form we admire in the High Renaissance masters, and with a wonderful sonority and liveness of color realized through the animated brushwork, Cézanne's alone. It is a visibly arranged, formalized composition in which the self-balancing structure of the boy's pliant body is in turn opposed to the long rhythmical forms of the drapes and chair in alternating contrasts. The drapes, straight at the left, are curved at the right; the body, more bent and curved at the left, is rigid at the right. This highly imaginative composition, so carefully thought out, owes little to a direct impression. But the details of color and contour, in their infinite variation, betray the searching, sensitive eye, open to the visible world.

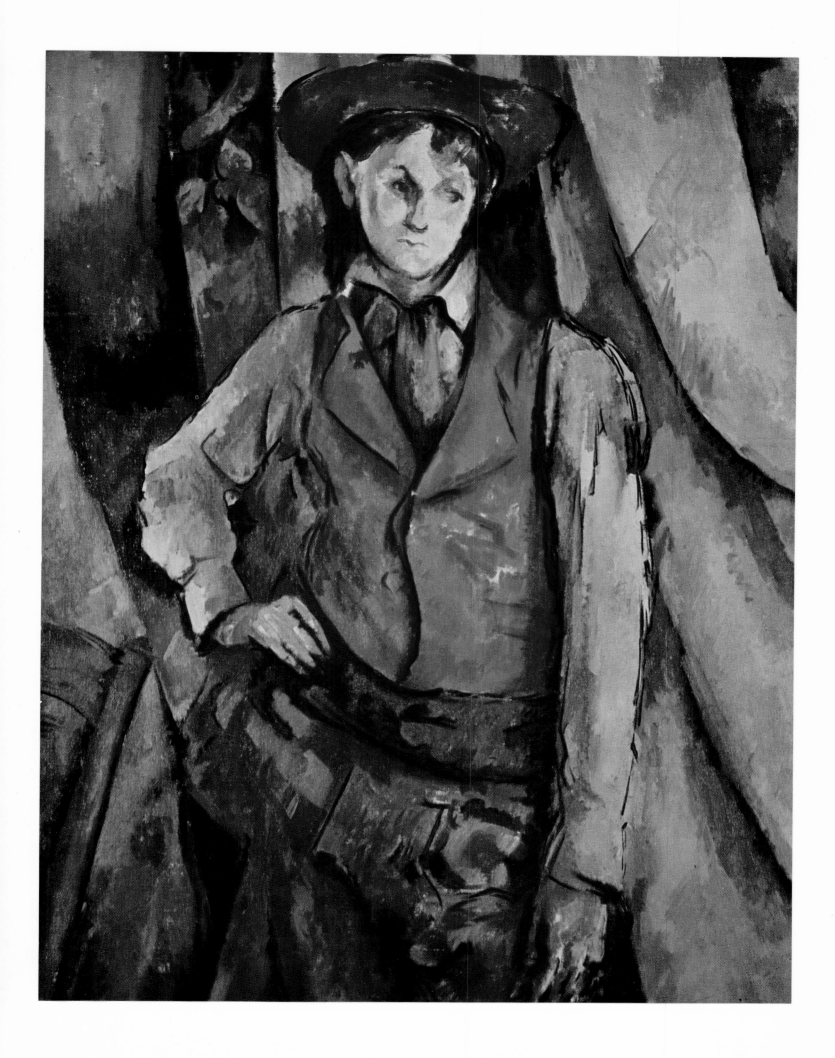

Painted 1895

PORTRAIT OF GUSTAVE GEFFROY

Collection Mr. and Mrs. René Lecomte, Paris

$(45\frac{5}{8} \times 35'')$

GUSTAVE GEFFROY WAS ONE OF THE FIRST CRITICS to recognize Cézanne's greatness; he wrote about him at length in 1895.

The portrait, so intricate in conception, was done over a period of three months in Geffroy's library. Cézanne despaired of finishing it, although it seems complete enough, a triumph of composition.

It is not a revealing study of the face, but an image of the man of books, the writer among his things. Cézanne often reduces the singularity of human beings; he is most happy with people like his card players, who do not impose themselves, who are perfectly passive or reserved, or immersed in their tasks. The portrait becomes a gigantic still life. The world of objects absorbs the man and lessens the intensity of his person; but it also enlarges him through the rich and multiple surroundings. His repressed activity is transferred to the complicated articulation of his books, the instruments of his profession. Indeed the arrangement of the books behind him, projecting and receding, tilted differently from shelf to shelf and ending in the open volumes below, seems more human than the man, reminding us of a long twisted body in classic counterpoise, like Michelangelo's *Slave* in the Louvre, a work that Cézanne admired and drew.

The man, by contrast, is fixed symmetrically with arms spread and bent—an immovable pyramid. The chair and table between which he is barricaded are another complex of tilted forms abstrusely counterposed to the wall of books and united to these by common tones, and by surprising correspondences of line. The open books lying on the table and the closed books standing on the shelves, all converging to Geffroy's head, belong to a common structure of balanced directions, although one group owes its tiltings to gravity and the other mainly to perspective. The different accents of orange in the bookcase and on the table confirm the contrast of the vertical and horizontal planes. With what care Cézanne studied the parts we can see in the warm strokes on the brow parallel to the slanting orange book nearby, with white and violet strokes between them, and in the slanting light spot at the right shoulder.

The painting is a rare union of the realistic vision of a piece of space, seen directly in all its accidents and richness of detail, with a powerful, probing, rigorous effort to adjust all that is seen in a coherent balanced structure with its own vitality and attraction. The whole looks intensely contrived and intensely natural. We pass often from the artifice of composed forms to the chaos of a crowded room, and from the latter we are soon brought back to the imposing order invented by the artist; the oscillation is permanent. No line is simply a device of design; it has always the quiver of existence in light and is a product of Cézanne's robust, sensitive touch. The straightest and most irregular lines are sensitive alike and are equally parts of the whole in its double aspect of image and painting-fabric. If the little feminine statuette softens the severity of the books, it is also in its axis and bent arm a counterpart of the rigidity of the man; the tulip in the blue vase is inclined with his arm; and his delicately painted, living right hand recalls the distant books above.

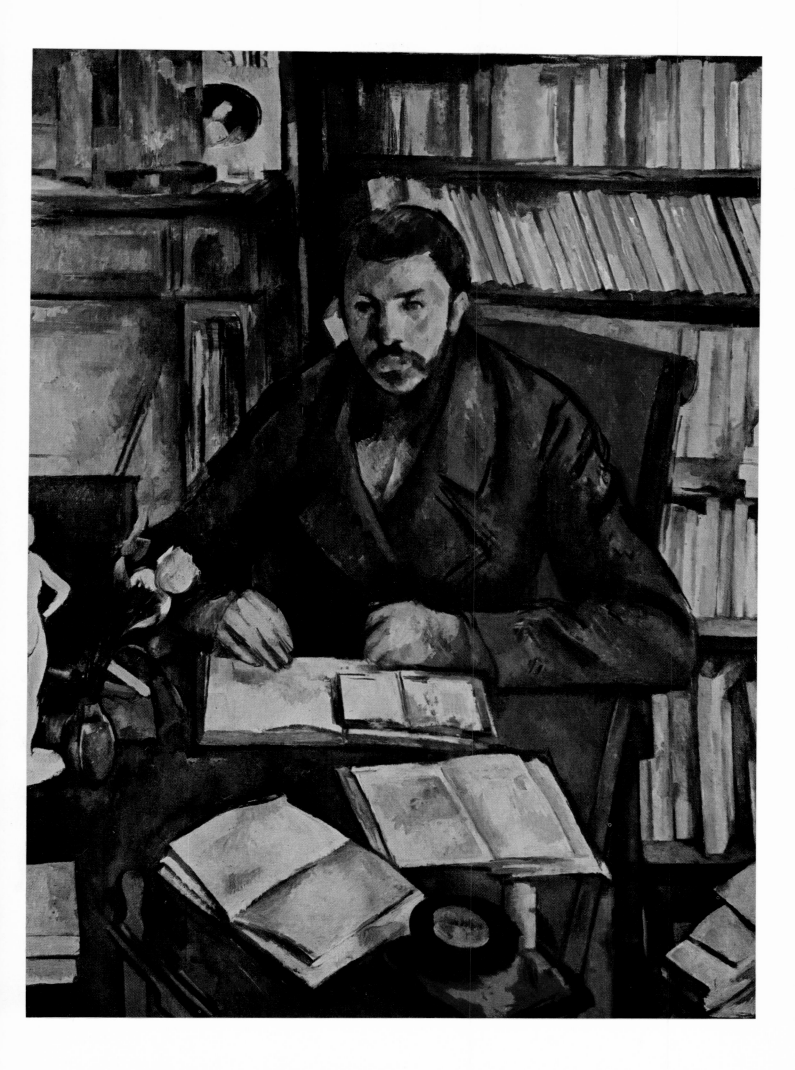

Painted 1890–1894

STILL LIFE WITH PEPPERMINT BOTTLE

National Gallery of Art, Washington, D.C. (Chester Dale Loan)

$(25\frac{5}{8} \times 31\frac{7}{8}'')$

ONE OF THE MOST ORIGINAL of Cézanne's still lifes—although every one is singular in conception. He has repressed the depth of the table—we see nothing of its top—and the objects seem to be suspended in vertical planes, like the wall itself, a wall that has been brought into closest connection with the objects through its colors and severe lines. But in this contracted space, Cézanne has ventured to paint, with exquisite skill, transparent glass through which we see several layers of objects; he has also kneaded the drapes into complicated folds in which the objects are set like trees and buildings in hidden depressions of the ground. In suppressing the horizontal plane, he has given a more evident cohesion to the forms and colors on the surface of the canvas; but he has also played more fondly with the material properties of things, their solidity, weight, opacity, and transparency.

The painting is marvelous in the invention of lines. Few of Cézanne's works are so abundant in curves and continuities. The peppermint bottle with its elegant double curvature, the large flask—simpler and grander—are two melodies of great purity and strength. Their parts reappear in the simpler roundings of the fruit. Grandest of all are the curves of the cloth—perfectly fresh forms that remind us of no past conventions for drapery lines, but are freer than any we know, although in strict harmony with the neighboring shapes. On the heavy blue cloth is an engaging play of black ornamentation—secondary rhythms of curved and straight forms ingeniously adapted to the lines of the other objects and so deployed that we cannot make out the inherent pattern on the cloth—we know only the more interesting pattern that results from its interception by the accidental creases and folds. It is a free pattern of lines, now rigid like the lines of the wall and table, now curved like the bottles, here florescent, elsewhere branching, and in places with small notes of free floating form, which remind us of the first abstractions of Kandinsky. Characteristic continuities and crossings of line are the dark reddish band on the wall prolonged in the flask; the vertical line continued in the side of the bottle and re-emerging in the line of the cloth touching the lemon from which descend vertical stripes on the blue drape. The wall, the figured drape and the bottle and flask belong to the same austere range of green, grey, violet, and blue with many black accents; the spots of contrasting intensity and warmth—the red and yellow fruit, the table, the cork and label of the bottle—are grouped in vertical and horizontal sets, which maintain the severe architecture of the wall.

One must observe also the daring asymmetry in Cézanne's drawing of the flask—the swelling of the more luminous left side reduced and flattened, adjusted to the vertical forms of the adjoining objects, including the apple seen through the glass, and the edge of the white cloth below, which encloses an apple and pear. It is a vivid example of Cézanne's independence of nature in asserting his constructive will. Chardin would have harmonized all these neighboring object-forms without distortion; but his contours would look less tangibly designed, less overtly marked by the operations of adjustment and cohesion.

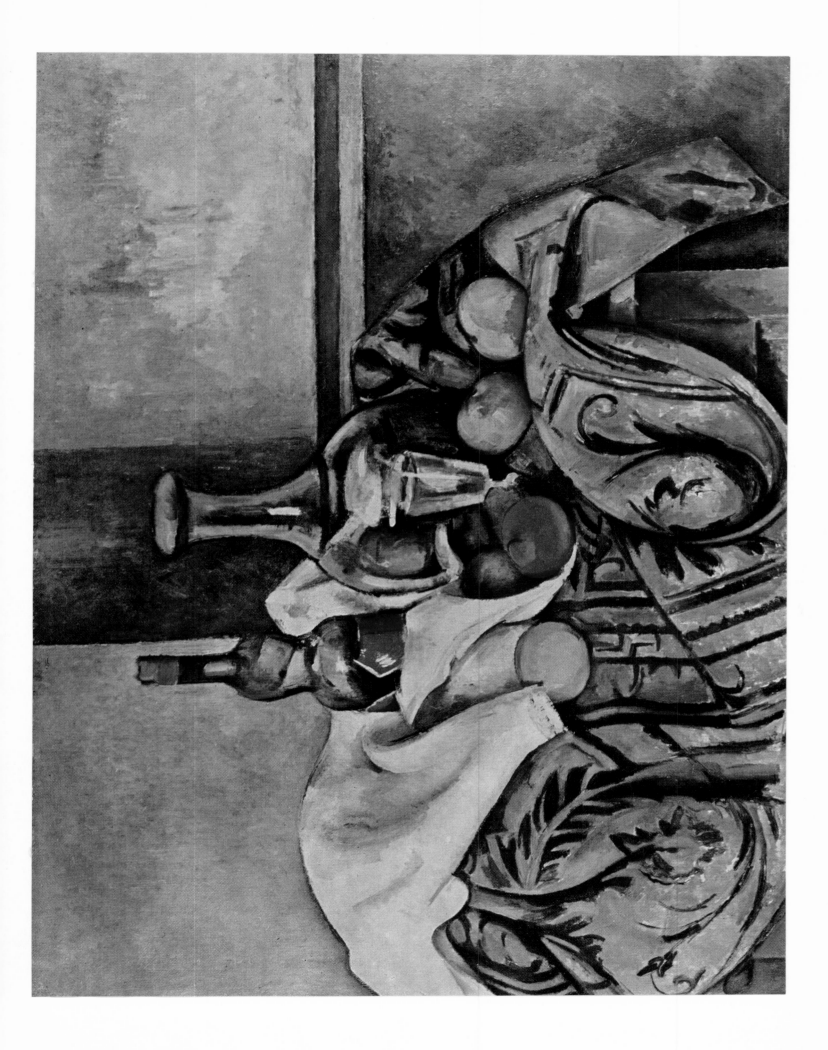

Painted 1895

STILL LIFE WITH PLASTER CUPID

Courtauld Institute of Art, London

$(27\frac{1}{2} \times 22\frac{1}{2}'')$

AMONG CÉZANNE'S STILL LIFES, this one is remarkable for the presence of a work of art, a cast of Puget's *Cupid*. Two works really, for in the background is a sketch after another statue, *The Flayed Man*. Both are sculptures he studied from casts—we have many drawings from them in his notebooks. His taste in sculpture is revealing. He drew mainly from works of baroque character, with rich contours and powerful contrasted movements; they are often themes of passion or struggle. To place such figures in a context of apples and onions is strange; what other painter would do this? The marriage of the heroic-passionate or idyllic to the commonplace-domestic corresponds to Cézanne's complexity as a man.

Here we sense these poles in the formal contrast of the apples and the statuette: the first, centered and without articulation; the Cupid, a body rich in convexities and turns. But the Cupid is white and the scattered fruit, red, yellow, and green. The two opposites are united, or at least bridged, through the onions—more articulated forms. Three apples at the Cupid's foot continue the rounded bodily line; others in the dish strive to build up to a head. In the upper right, the drawing of the crouching figure confirms the "unreality" of the Cupid, which, as a plaster cast, belongs to a third order of existence—a copy of a copy among real fruit, yet no less tangible than these. The drawing is a fourth step away from nature and is already remote and curtailed.

So much for the conception of the objects—the artistic conception is no less original. From a close viewpoint which places the foreground objects below us, we see behind them an intricate composition of tilted lines and planes, ambiguous in places yet so contrived as to belong together and re-enforce the down-stage world. A canvas set behind the Cupid is doubly tilted, and by a paradox of design parallels the main lines of the statuette. At its lower left corner, the canvas meets what seems to be the edge of the floor, but is also the edge of the beautifully formed blue drape and, by a startling artifice, coincides with the line separating the onion from its green stem (a stem fitted neatly into an angle of the drape). Through these devices, all frankly exposed, that whole region of the painting, which is built of straight lines, acquires an appearance of the constructed and "abstract," while other parts look more directly "seen." But these opposed attitudes do not clash, for the colors and forms of both parts harmonize and are inseparably joined; the most abstract regions have the same qualities of modulation and touch as the more natural parts. The blue drape, at once angular and curved, is also a liaison between the two.

We return to our reflections on the objects: the Cupid and the drawn statue participate in both worlds of the natural and the artificial; they are works of art, and as such represent the erotic and the suffering in a transposed form, which is colorless yet takes its place without strain in the sphere of simple, non-human things. As parts of the visible world, their root colorlessness is modified by the common light which endows them with a delicate range of warm and cool tints and the attenuations of color in space.

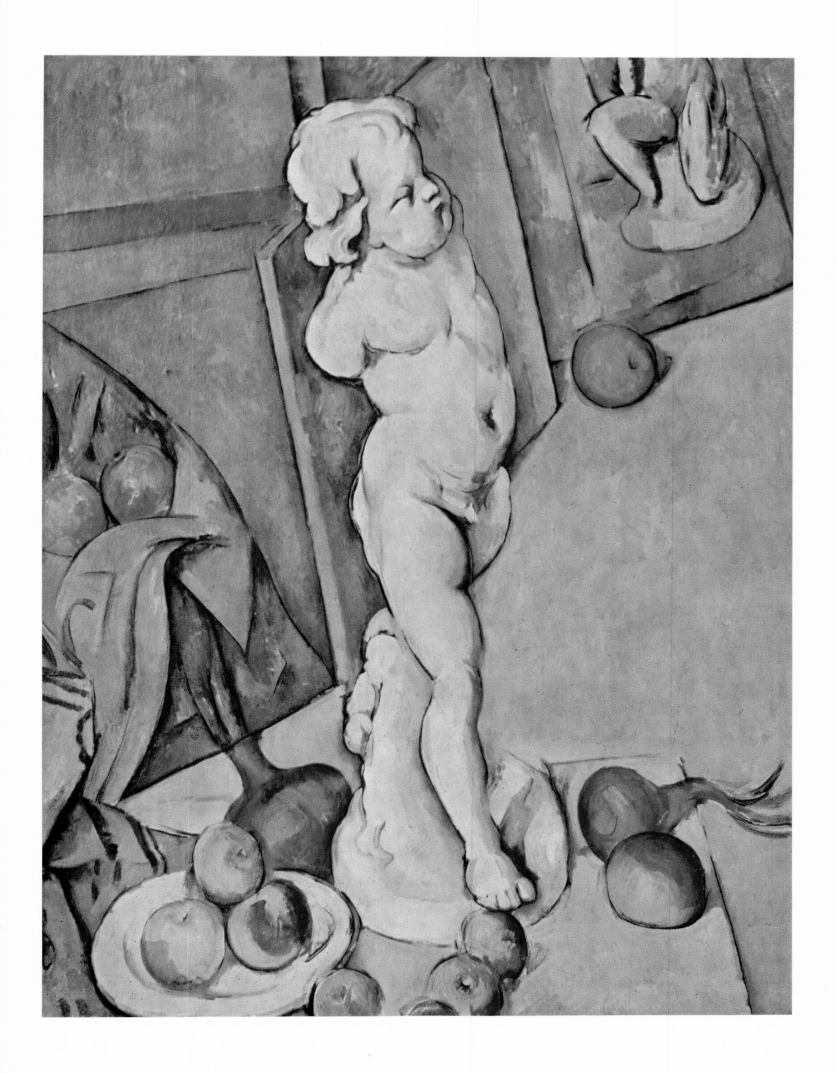

Painted 1890–1894

STILL LIFE WITH APPLES

Private Collection, U.S.A.

$(18\frac{1}{8} \times 21\frac{5}{8}'')$

A VERY DIFFERENT APPROACH to still life than the last is the extraordinary search for compactness and solidity in this work. It is hard to remember another painting of fruit so densely colored and so appealing to the touch. Yet reality is sacrificed here in many details, not for the pleasure of fantasy but for the sake of a more concentrated, coherent painting of what exists very close to the eye. The dish under the apples disappears abruptly at the right; the ellipse of the round table flattens and contracts oddly behind the plate; the saucer has a corresponding asymmetry; the second row of apples is tangent to the first in a way that contradicts their supposed positions behind the latter and in contact with the plate.

Why could not Cézanne have continued the plate on the right, simply darkening its color and compensating in the nearby objects? Would this have weakened the composition? Hardly, for so inventive a composer as Cézanne. But in this picture the silhouettes resulting from the distortions are so powerfully coherent that we cannot (and do not wish to) imagine an alternative. Important here seems to be the desire for variation: the right side of the dish with symmetrically placed apples is distinguished from the left, just as the symmetry of the cup is broken by the handle, and the two sides of the saucer are remarkably unlike. On the left, the dish emerges from under the apples; on the right, the apples completely cover the dish, and the contrast of their color with the bluish white dish is displaced to the small arc against the light wall. The contours of the apples, round and angular, are opposed more sharply to the adjoining card and saucer. What is paradoxical is that a man so free with real forms should also be so devoted to the constant qualities of things.

The dish of apples is a wonderfully realized piece of painting. One should observe the different posture of each apple. Together they are a symmetrical formal group in which each member is tilted in its own way. And what is more original, each is modeled distinctively, with unique transitions of rich color and light and shade. The dark spots of the stem ends, like the poles of rotating spheres, form an interesting group. We appreciate the qualities of these apple-forms against the flatness and the straight lines and larger, shallower curves of the surrounding objects. With their round contours the apples form a triangle unique in the canvas. It has a kind of perspective in the convergence of the outlines to the vertical jamb of the fireplace. Beside it at the right is another approach to depth through the succession of overlapping objects with shifting axes in vertical alignment—apple, cup and saucer, card, poker and tongs. Within this series Cézanne has created a secret counterpoise of small accents through the shadows. The varied directions of the brush strokes too are a decided factor in the construction of the whole.

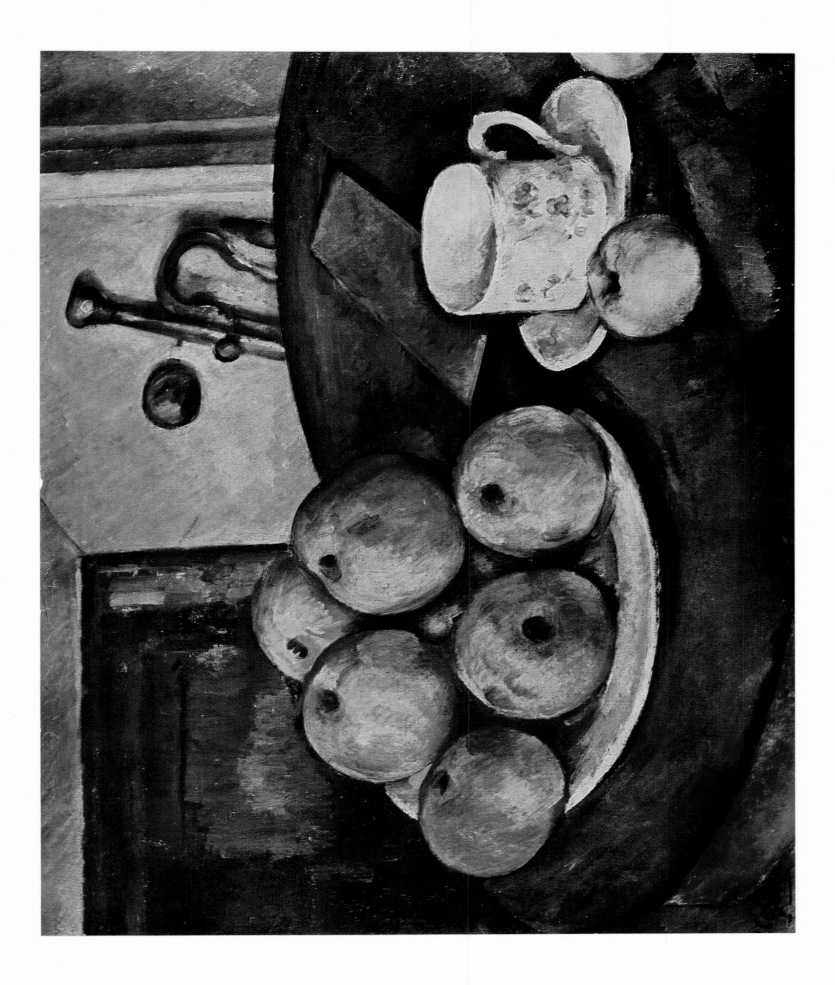

Painted 1895–1900

STILL LIFE WITH APPLES AND ORANGES

The Louvre, Paris

$(28\frac{3}{4} \times 36\frac{1}{4}'')$

ANOTHER SIDE OF CÉZANNE comes into fullest play here. The Louvre still life is of an imperial sumptuousness. We feel throughout the work the painter's joy in the luxuriance and profusion of colorful things, unconstrained by his meditative habit. The old stabilizing (and detaching) construction—the rectangular framework of the table and the clear plane of the wall—has disappeared. Instead, the space as a whole is draped and richly broken; the difference between depth and surface, the vertical plane and the horizontal, is veiled. Everything comes forward; yet there is also a palpable depth, as in the succession of fruit at the left. We are reminded of the space of the quarry and the mountain in the picture of Mont Sainte-Victoire (page 111).

Cézanne seeks here a continuity of elements more complete than in his earlier work. The compotier grows out of the beautiful white cloth, and the decorated jug seems to be a fusion of that cloth with the apples and oranges and the ornamented drape behind it. The effect is dense, even crowded, like his landscapes with woods and rocks, and is enormously rich in unexpected shapes and chords of color, almost to the point of engorgement. It is not at all a "natural" still life—something we might encounter in a home—but a fantastic heaping up of things, in which we discern, however, a clear controlling taste. The complexity of this work belongs both to the pride of a well-exercised masterliness and the delight of the senses. More than most of Cézanne's still lifes, it impresses us as an orchestrated work, because of the wealth of distinct, articulated groups of elements carried across the entire field of the canvas. The white cloth is magnificent in its curving lines, its multiplicity of contrasted directions, its great rise and fall, and in the spectrum delicately toning its brilliant white surface. Against this complication of whiteness and the subdued chords of the mottled drapes (warmer and more angular in ornament at the left, cooler and with curved ornament at the right) play the rich pure notes of the fruit. These are grouped simply, in varying rhythms, and are so disposed as to form together a still life on a horizontal axis— a secret stabilizer among the many sloping shapes. A delightful metaphoric fancy is the decoration of the jug with red and yellow flowers like the nearby fruit; it is a bridge between the fruit and the ornamented drapes, of which the patterns, broken by the folds, are a rich flicker of less intense, contrasting tones.

A characteristic theme in the larger design is a sharply pointed form, which appears in many parts: in the silhouette of the white cloth, in its angles with the table and the edges of the canvas, in the drape at the upper left in the tall, peaked fold, and elsewhere.

Painted during a period when Cézanne produced many powerful images of solitude and unrest, this still life has the same emotional force and masterful inventiveness in the expression of joy.

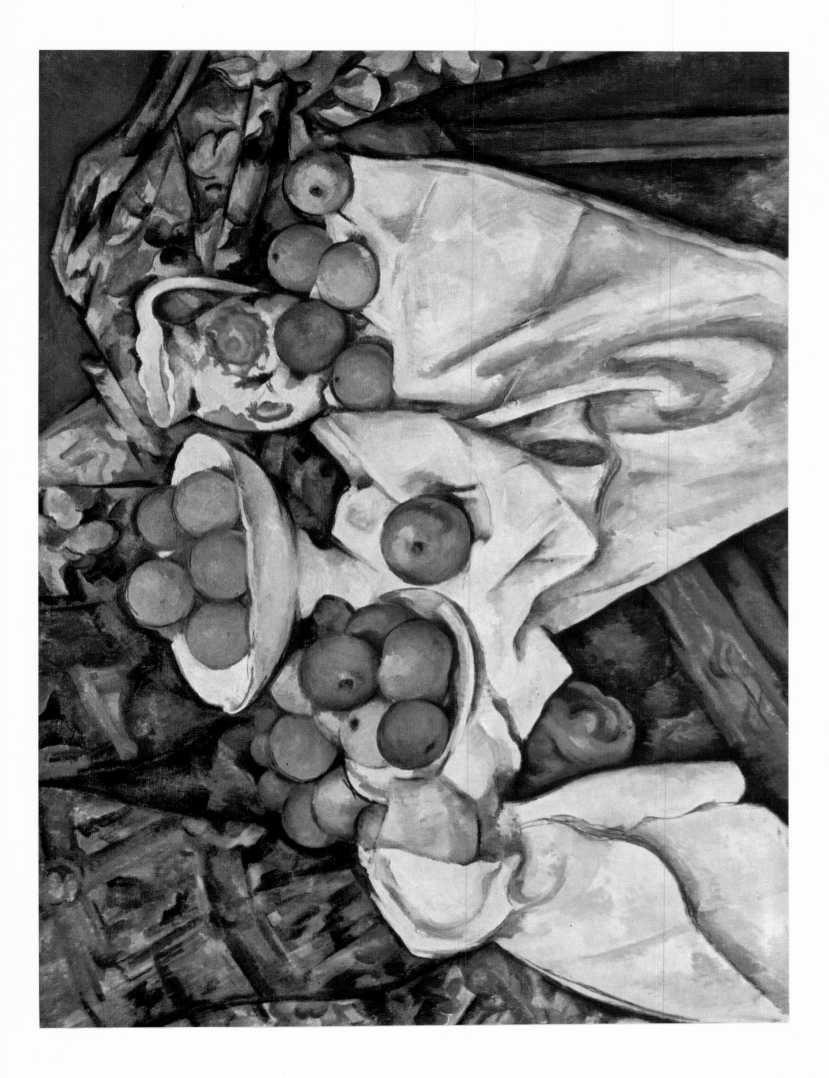

Painted about 1896

THE YOUNG ITALIAN GIRL

Collection Dr. and Mrs. Harry Bakwin, New York

$(36\frac{1}{4} \times 28\frac{3}{4}'')$

CÉZANNE USES HERE several of the elements and devices of the Louvre still life (page 103)—the ornamented drape, the table tilted upward, the large mass of white with many tints. It is also like the still life in the big slant of the dominant form. Yet the effect is very different—a more balanced play of the simple and rich; the stable and unstable. The whole is treated with a breadth that recalls the great Venetian portraits of the Renaissance. The forms are amazingly substantial and well-defined. The bent figure fills her space grandly.

It is a powerfully constructed work, compact and clear, with parts beautifully fitted to each other and to the canvas surface. The tilted mass of the upper body (with right angle at the elbow) is opposed to the rectangular masses of the skirt and drape; yet the vertical and horizontal rarely come to view, and then only in short segments (as in the bracelet and the wall) or as parts of more complex lines. The most stable masses are covered with lines and spots of unarchitectural quality—diagonal, crossed, or curved on the draped table, convergent on the skirt—a typical device of Cézanne's later art by which the severity of construction is softened and opposed qualities are interjoined.

The color is rich, grave, and strong. The simplicity of the large aspect conceals at first the variety of the color relationships that have been employed. Consider only the dark blue of the skirt, which has a different kind of contrast with each of the large areas of color. Its darkness or low value is opposed to the white; its coolness, to the warm complementaries of yellow and orange in the fichu and face; its uniformity or evenness, to the mottled color of the drape; its purity, to the mixed, neutralized brown of the wall. At the same time, the blue mass is harmonized with all these distinct, opposed fields: its convergent stripes reappear in the white sleeve, which is also toned with blue and grey; dark blue lines mark the contours of the face and features and right arm, and there is blue, grey, and black in the fichu; it is tied to the wall, not only through vague green and purple tints within the brown and through the lines of the wall and dado at the left, but through the dark key—there is a progression from the skirt to the purplish dado to the upper wall; and last, the blue area is related to the tablecloth through its similar position and shape, and also through the analogy of lines. Touches of red and green bind the face to the decoration of the drape.

In this analysis of the color, I have ignored other equally interesting aspects, for example, the position and order of these colors, which have an expressive sense—the warmer, closer, more intimate range being in the left half of the picture, the side of revery, and the cooler, but more powerfully contrasted, elements on the right half, the side of the body.

Beautiful too is the refinement with which Cézanne has related the varied inclinations of the large masses in a depth without horizontal planes; the succession of overlapping tilted surfaces between the picture plane and the wall is an exquisite thing. Another subtlety is the handling of the vertical and nearly vertical directions in an unmarked band from the upper wall to the right side of the drape, passing through the head and fichu. I must mention finally the wonderful modeling of the head with its strong accents of the brush—thickly painted blue lines, very considered and precise—which give a sculptural firmness to the contours.

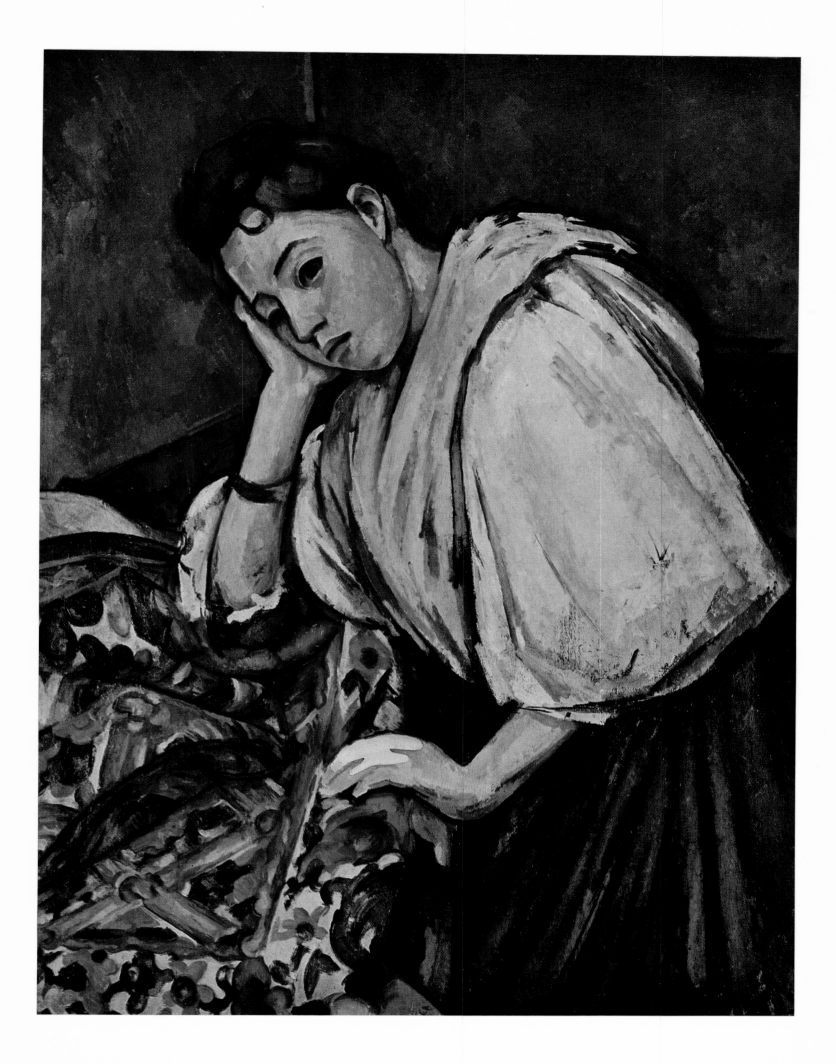

Painted 1892–1894

THE HOUSE WITH CRACKED WALLS

Collection Mr. and Mrs. Ira Haupt, New York

$(25\frac{5}{8} \times 21\frac{1}{4}'')$

A ROMANTIC PICTURE, a hermit's vision of heat, solitude, and ruin in nature—a space for the Saint Anthony of Cézanne's youthful imagination. The verticality of the picture, the upward tilted ground without perspective lines, create a strange world: everything is close to us, we are shut in by the intense empty sky, the irregular horizon, the steep and unstable ground, the ruined house. It is an effect of intimacy and strain, of restlessness and quiet. The theme of the cracked wall is carried through the landscape; the black lines of the cracks reappear in the forms of the tree trunks, in a path on the ground, and in the markings of the rocks. The one human object, the house, set in the fork between earth and rock, rests on a point, like the agitated trees, and repeats their branching form. The lines of the building, accented by the red tiles, are adjusted to the slope of the ground. There are fine decisions in the play of horizontals and diagonals throughout. The dark window, so starkly set in the hexagon of the wall, is no isolated shape; it is tied to the ground through two similar massive rocks.

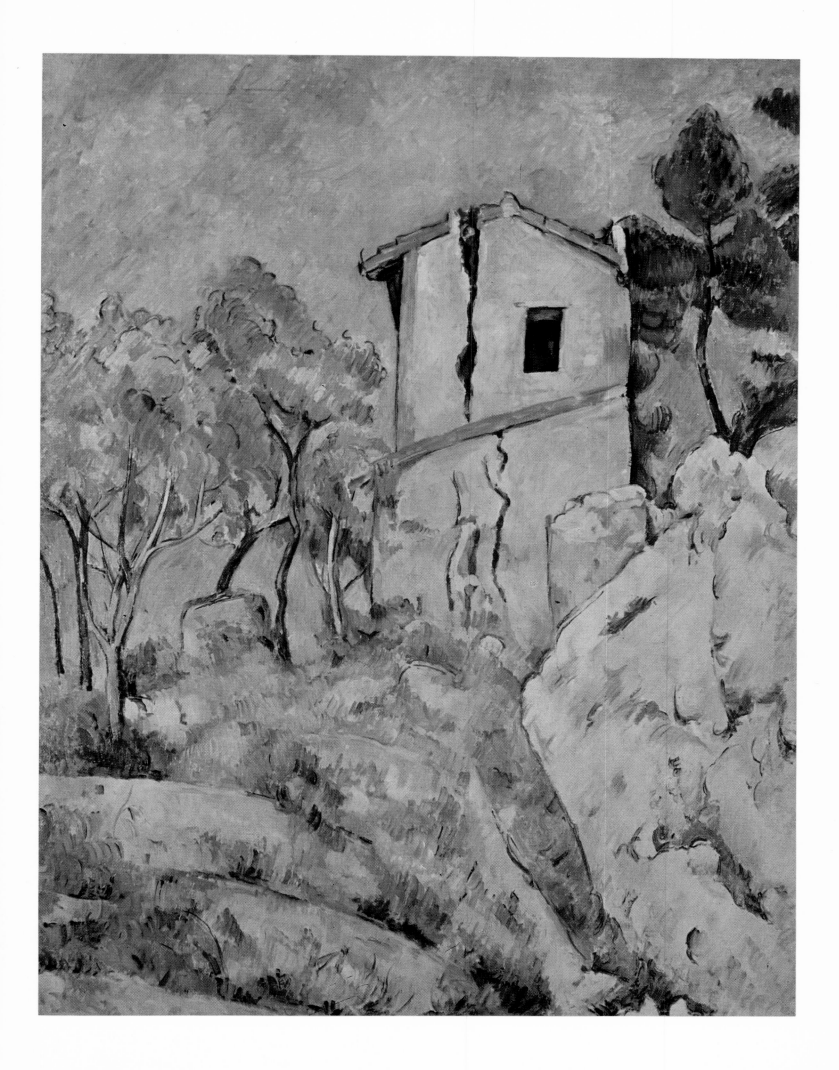

Painted 1892–1896

THE GREAT PINE

Museu de Arte, São Paulo, Brazil

$(33\frac{1}{2} \times 36\frac{1}{4}")$

A POETIC CONCEPTION OF THE TREE as a giant individual, rising to the heavens above the heads of its smaller fellows, twisted in axis and shaken by great forces, but supreme in its height and vast spread. Its rise from the ground is dramatic in its stages: through a sturdy bent trunk, far stronger than any other we see; through a region of bare and dying branches, leafless against the sky; then the great arched crown of foliage spanning almost the entire sky. The landscapists of the Romantic school, Huet and Dupré, had painted similar heroic trees, but the stormy sky and tormented ground in their pictures are a more obvious external motivation of the agony of the tree. In Cézanne's picture, the drama is in the tree itself, with its strained, conflicting forms, reacting to the wind. With a remarkable simplicity that often passes for naiveté but is the wisdom of great art, he presents his vision of the tree in the clearest way, placing the tree in the center of the field directly before us. But he knows how to use the surrounding elements to support the drama. The ground slopes and the other trees are inclined away from the big trunk as if they have been parted by the giant's upward movement. We see no branches beside those of the central tree; its torment and spread are a unique fact.

The picture is a beautiful harmony of blues and greens, in which the occasional warm touches in the branches and foliage pick up the strong ochre band of the road.

Simple and perfectly legible, it has also a great vitality and movement through the brush strokes. With few lines, they create by their changing directions a perpetual stirring of the space, great eddying currents, winds, and turbidities. Yet they resolve into a few large masses of color.

Cézanne's feeling for the great tree goes back to his youth. In a letter to Zola in 1858, he wrote: "Do you remember the pine on the bank of the [river] Arc, with its hairy head projecting above the abyss at its foot? This pine which protected our bodies with its foliage from the heat of the sun, oh! may the gods preserve it from the woodman's baleful axe!" And in a poem of 1863:

> *The tree shaken by the fury of the winds*
> *Stirs its stripped branches in the air,*
> *An immense cadaver that the mistral swings.*

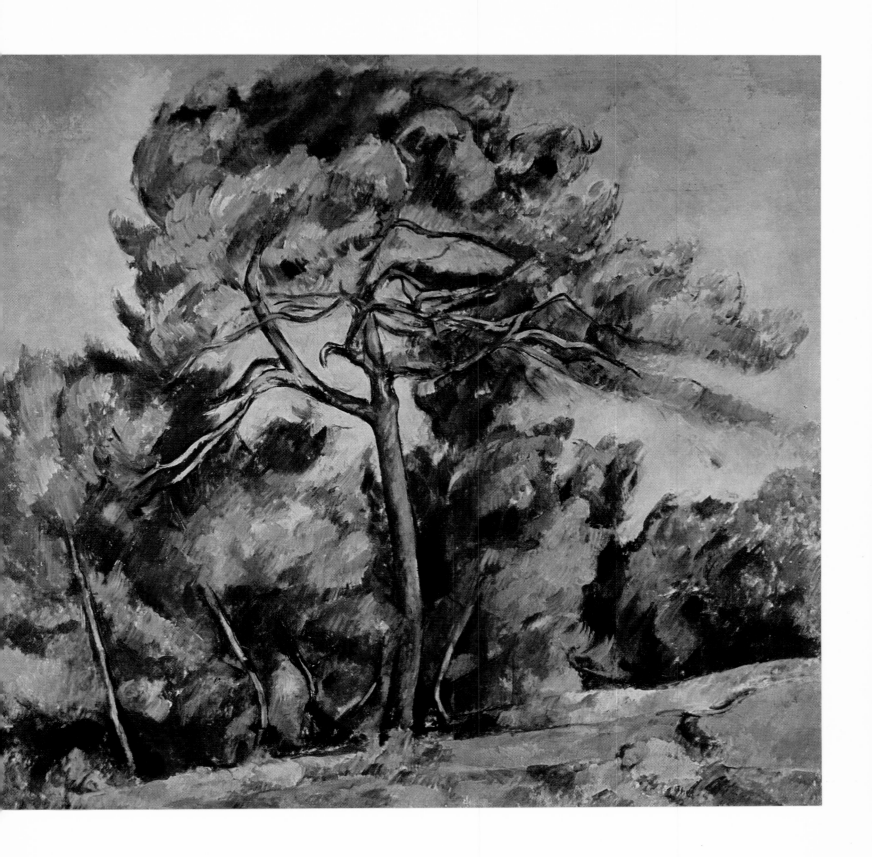

QUARRY AND MONT SAINTE-VICTOIRE

The Baltimore Museum of Art (The Cone Collection)

$(25\frac{5}{8} \times 31\frac{7}{8}'')$

IN THE EARLIER PICTURES of Mont Sainte-Victoire, the mountain was seen at a considerable distance, and its place in the broad panorama gave it a greater repose. Here, Cézanne comes closer to the peak; but it is even more inaccessible than before. Instead of suspending the observer above the valley, he places between him and the main object an abyss, the quarry across whose void he views the opposite rocks and the rising peak. In this process, the landscape itself has become dramatic, filled with striving, titanic energies; but these are outside the spectator's realm, beyond approach. The mountain, like a heroic sculpture, is set on a gigantic pedestal of rock enclosed by trees. One side rises in a sheer unbroken slope, the other, a strangely animated line, changes its course in several abrupt breaks. For the first time we see the peak as a personal object with a distinct profile, or with two sides, like a human face. It has lost the old classic symmetry and has become a complex, dynamic form. At the same time, its elevation, its strained upward movement, is more pronounced because of its position in space—close to the upper edge of the canvas and directly above the vertical walls of the quarry. There is no broad horizontal plane, no immense platform of earth, to tranquillize the natural pyramid, but a deep vertical cleft at its convex base, splitting the quarry wall in two and marked by unstable, tilted trunks, adds to the restless effect in this setting of great pressures and heat.

The taste for the vertical plane, which we have observed in the Louvre still life (page 103) as typical for the late style, is realized in this landscape with a grandiose force, but with another expressive sense. The mountain is as distinct as the nearest objects, even more distinct if we compare its drawn outline with the vaguer (sometimes vanishing) silhouettes of the trees below. As we move from the foreground to the distance, the objects become larger, as in a primitive emotional perspective. The great mass of the tree at the upper right seems to belong to the same region of space as the mountain, and only when we follow the wavy line of its trunk along the edge of the canvas do we recognize its true place in the foreground. Very similar greens occur in the foreground and distance, uniting their far-separated planes in a common scheme of accents. The strongest contrasting chord, the orange rocks and blue sky, also binds the most distant space and the nearest. A scale of lavender, rose, and purple tones extends across the same depth. As in the still lifes, this closer view is associated with a greater intensity of sensation. There are few landscapes before Cézanne in which orange and blue are applied in such large, luminous contrast.

There is a beautiful order in the conception of the objects. We mount in horizontal zones from the multiplicity of trees through the more compact twin masses of rock to the single but symmetrically formed peak which synthesizes the forms of rock and tree. In this passage, the axis shifts from the central tree to the vertical opening in the rock and back to an undrawn axis in the mountain, in line with the triangular tree below.

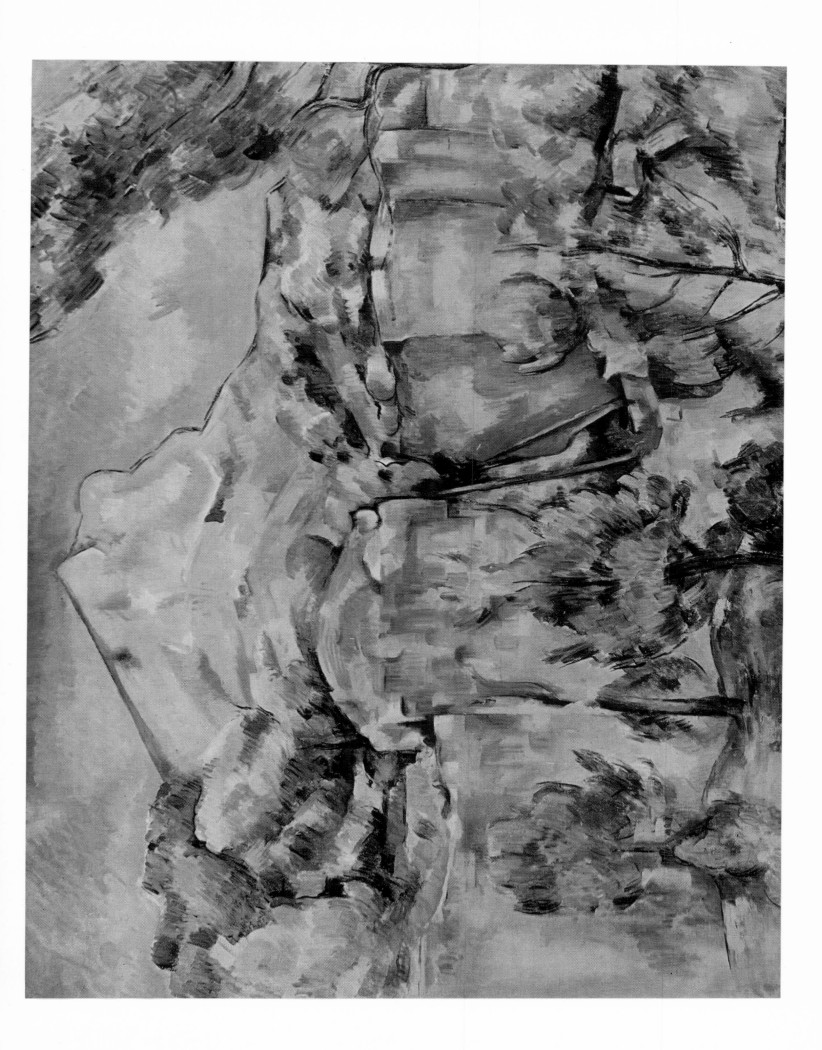

Painted 1899

TURNING ROAD AT MONTGEROULT

Collection The Hon. and Mrs. John Hay Whitney, New York

$(25\frac{1}{2} \times 20\frac{1}{2}'')$

IT IS AN UNDISTINGUISHED SUBJECT, without a dominant or a central point of interest, yet is picturesque for modern eyes. The Romantics found the picturesque in the irregular, the roughly and oddly textured, the ruined, the shadowy and mysterious; the painters of the beginning of this century found picturesque the geometric intricately grouped, the disorder of regular elements, the decided thrust and counterthrust of close-packed lines and masses in the landscape. A scene like this one was fascinating to the artist as a problem of arrangement—how to extract an order from the maze of bulky forms. It is one aspect of the proto-Cubist in Cézanne.

Here the severely geometrical is crossed with the shapeless, pulsing organic, its true opposite. The yellow road, cutting through the foreground vegetation, carries the angular thrusts of the buildings into the region of growth. In contrast to the solid, illuminated substance of the thickly painted buildings, rendered with dark outlines, the bushes and trees rise among them in loose masses of thin, cool color. There are similar tones in the roofs and shaded walls, but these are strictly bounded by drawn lines, unlike the edges of the bushes and trees. To the bareness of the bright, hot surfaces of the houses is opposed the polychromy and more impulsive brushwork of the darker foreground.

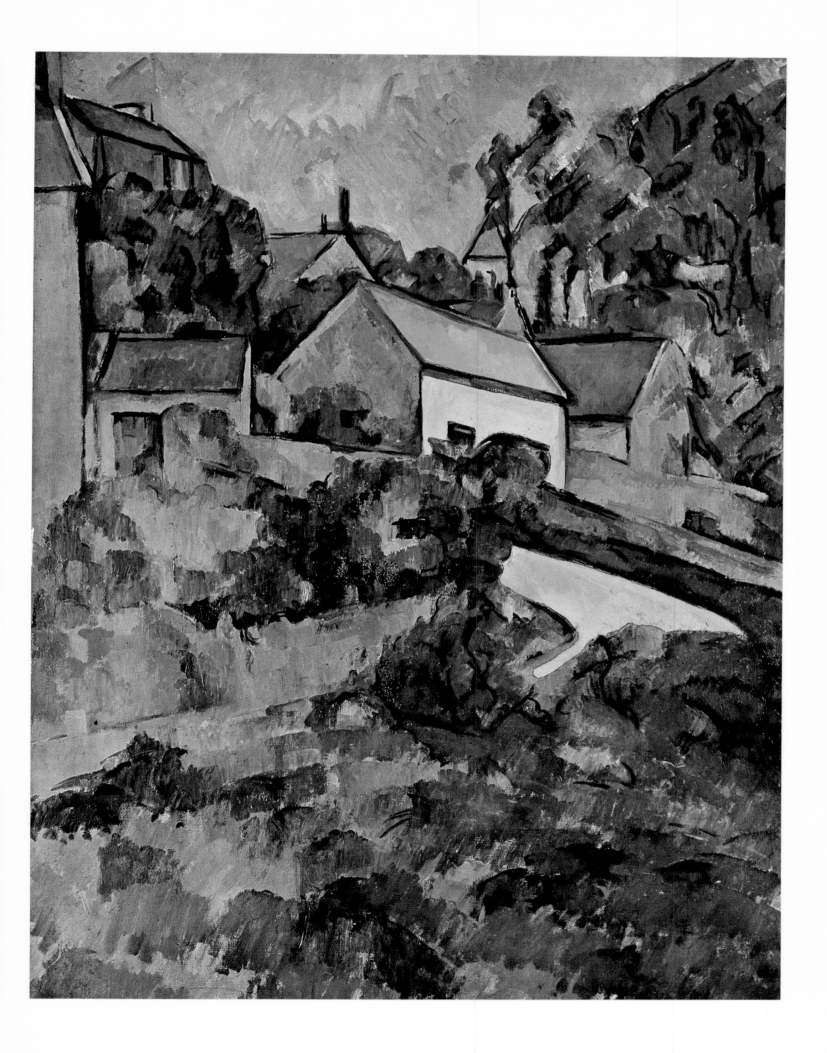

Painted 1895–1900

STILL LIFE WITH ONIONS AND BOTTLE

The Louvre, Paris

$(26 \times 31\frac{7}{8}'')$

FROM THE SAME PERIOD as the anti-architectural, festive *Still Life with Oranges and Apples* (page 103), perhaps a bit earlier—the exact dates of Cézanne's works are not known—is this still life which combines the large constructive elements, the verticals and horizontals and the broad, bare wall, with a close-packed abundance of small curves, tilted forms, and accents of free vegetation. In the cool tones and search for rhythmic lines, it is like the the *Bathers* (page 117), though less schematically composed. The rounded and flamboyant shapes also articulate the severest, most stable objects, as in the scalloped edge of the table and the outlines of the bottle and glass. It is one of Cézanne's most remarkable compositions, an ingenious development of lines in a musical manner, without drama or climax, and has an amazing delicacy of touch and refined richness of color within a subdued, atmospheric key. Meditative in mood, a result of the most serious meditation, it is a work to ponder and explore.

As a formal theme, the chief element is the onion, a shape more complex than the apple and congenial to Cézanne's later style through its greater flexibility of line and especially its more open, wavy form. We follow its development from left to right in groups open and closed, including the variant lemons, in ever-changing axes, spottings of color, and contacts with neighboring things. Together with the scallops of the table—an ambiguous pairing of concave and convex, of greater span than the similar curves of the onions—the billowing silhouette of the cloth, and the bottle and glass, they form a system of distinct parallel melodies which at certain points coincide.

The painting has many delightful, subtle touches; perhaps every stroke is of the same order of finesse and it is arbitrary to single out one rather than another. We may note, however, several examples within the same part, the beautifully painted wine glass. Its stem, off-axis to the right, shifts the whole away from exact alignment with the important point of meeting of two curves of the scalloped table edge below—curves related to the form of the glass stem and the base of the bottle. Through the shifting of the stem, and through the break in the outline of the ellipse in its upper left, the glass seems finely tilted, like certain of the onions with their pliant ends, and strengthens the diagonal grouping of the bottle, the glass and the onions in the plate. Another delicate, barely perceptible thought are the horizontal lines drawn inside the glass (and also the bottle); they are a discreet recurrence of the line of the table and belong with the horizontals on the lower right of the wall and an exposed bit of the table among the folds of the cloth; together, all these segments form a stepped series, with proportioned intervals. The glass itself, with the refracted onion behind it, is an amazing bit of sober painting in which the decisions, touch by touch, have an inspired daring and rightness; it could be painted thus only here, in relation to the unique structure of this harmony which it helps to constitute.

An Italian artist, admiring the subtleties of Velasquez's *Las Meninas*, called it the "theology of painting." The same may be said of this great still life of Cézanne.

114

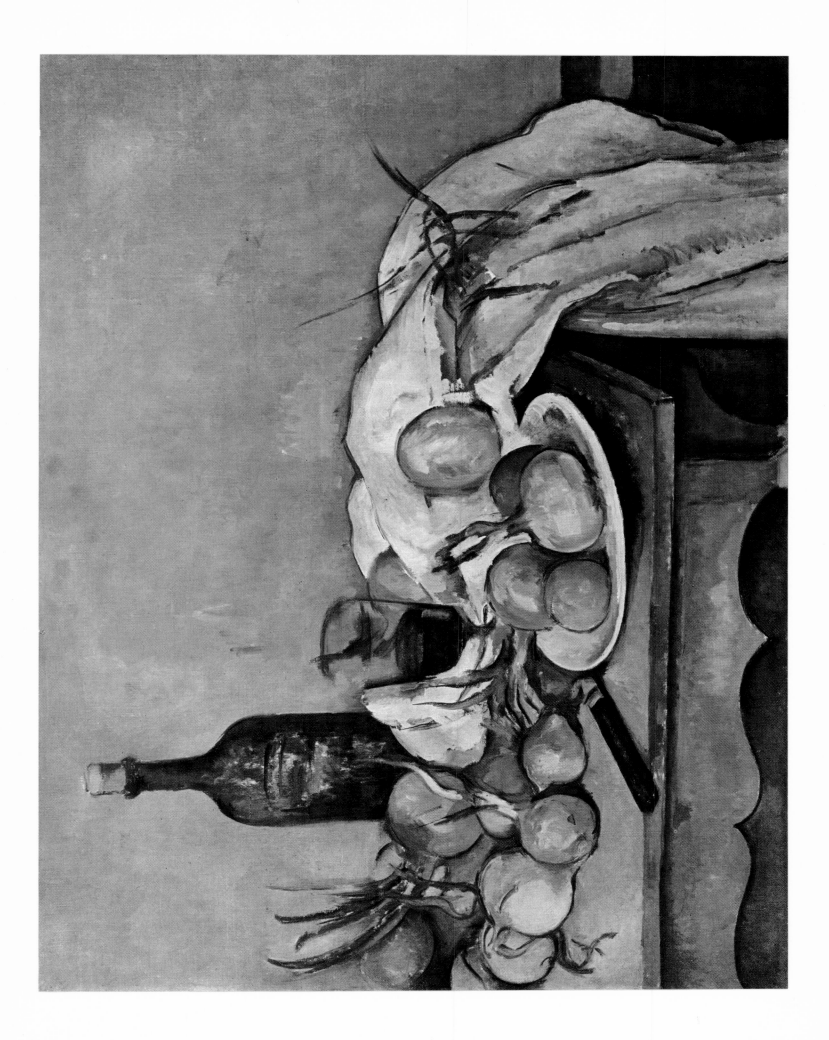

Painted 1898–1905

WOMEN BATHERS

Philadelphia Museum of Art (Wilstach Collection)

(82 × 98″)

IT IS THE LARGEST OF CÉZANNE'S PICTURES and because it is also the most formal in aspect, it has been cited often as an example of his ideal of composition and his restoration of classic monumentality after its lapse during the nineteenth century. It is exceptional among his work, however, in the marked symmetry and the adaptation of the nude forms to the triangular pattern of the trees and river. There is here, I believe, a search for constraining forms, an over-determined order which has to do with Cézanne's anxiety about women. Beautiful as it is, the composition is not the typical Renaissance pyramid, for the largest figures and the greatest compactness are in smaller pyramids at the sides; the central part, which is usually filled by a dominant object, is empty or unstressed, and the apex is intercepted by the frame. The triangle here is a form of constraint, with another expression than the older solemn design.

The formalism of this picture is the culmination of a lifelong concern with the problem. For thirty years, in paintings of women bathers, he arranged the nudes in a triangle, closed off by inclined trees, while the male nudes were grouped less compactly in a rhythm of *a B a B a*, open at the sides and giving an equal importance to the two large figures of whom one and sometimes both are seen from behind.

It is permitted to suppose that these two conceptions originate in different feelings about the subjects. The male nudes go back to an important part of Cézanne's boyhood to which he often returned in memory: the enchanted days spent with Zola and other friends on the bank of the river, swimming, playing, talking, and reciting verses—verses in which women were the objects of romantic fantasy. The grouping of the female nudes, whose postures reproduce the poses of models he had drawn in the art school or of statues in the Louvre, suggests in its extreme formality and closure an intense constraint which is unique in his art. We see this earlier in the 1860's in the triangle of fleshy nudes in his *Temptation of Saint Anthony*. Between this legendary theme and the *Bathers*, whose nudity is without episodic meaning, there are some "realistic" fantasies with nude women and clothed men, including two bathers with a fisherman on the other bank of the stream. In freeing himself from his troubled fantasy, Cézanne transposed the early erotic themes into less disturbing "classic" objects, nudes whose set postures and un-erotic surface, taken from the frozen world of the art school and museum, make them seem purely instruments of his art. But something of the original anxiety is reflected in the arbitrariness and intensity of the means of control.

The atmosphere of this painting is strange and beautiful—the landscape is largely bluish, a soft haze in which sky and water and vegetation merge and by which the masterfully drawn figures are delicately overcast.

Beautiful too are the flesh tones, painted in great thin patches, like water-colors. They are like the sleeve in the *Portrait of Vallier* (page 127), rare luminous tones with surprising greys.

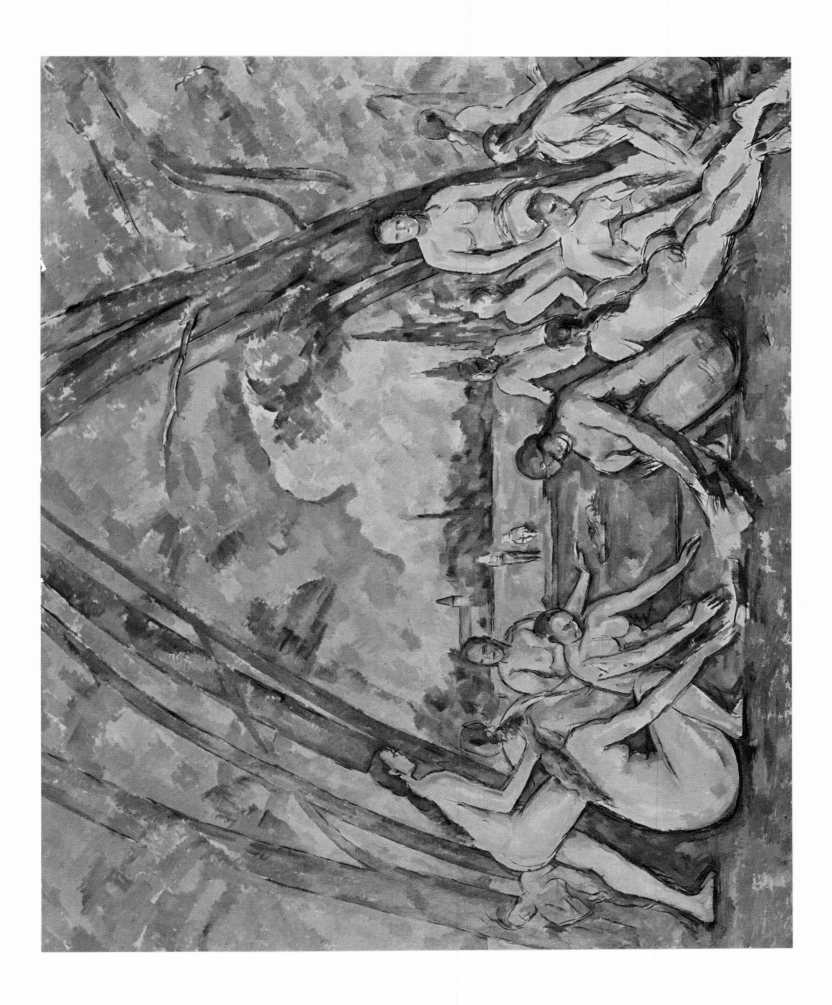

Painted 1894–1898

ROCKS AT FONTAINEBLEAU

The Metropolitan Museum of Art, New York
(Bequest of Mrs. H. O. Havemeyer, 1929.
The H. O. Havemeyer Collection)

$(28\frac{7}{8} \times 36\frac{3}{8}")$

IN CÉZANNE'S EARLIER PAINTING, a barrier in the foreground implied a detached position from which the painter might contemplate a quiet view. Here the landscape is formed mainly by the obstructing ground, which is pathless and convulsed—a space with deep clefts and hollows in a dark purple haze. The obstacles force us to stand still, but we cannot look serenely; they impose their violence and restlessness upon us. This cavern space is the vision of a hermit in despair.

In this somber, passionate painting, so saturated by the catastrophic mood, there is a remarkable inner development—a course of feeling moving upward and into depth. The powerful rocks in the lowest part have a strange organic quality—a visceral effect—in their curved and congested forms. We discern a vague human profile in the lower right and physiognomic intimations—a reclining head—in the brighter central rock with scalloped edge. Beyond at the left, the monstrous ground coils and twists into depth. In this tumultuous play of dimmed purple masses, the spectrum of Cézanne's marvellous palette enriches the monochrome surface with a transparent layer of deepened tones. Beneath the common purple is revealed the underground of feeling it has overcast, and out of these changing chords rises the unique orange and yellow lighting of the central rock.

From this region of crowded, pulsing forms, we pass to a higher barrier of angular rocks, one, especially, impending and architectural in form, sharp-edged like a block of cut stone; it slopes forward and to the left, in opposition to the lower rocks. From their hidden depths rise the tree trunks in tilted lines, parallel to the edges of the rocks; they carry a vaporous foliage, spotted like the rocky surfaces below, and crossed by the nerve-like branches which repeat the contours of the rocks in a disengaged line. The fourth region—the sky— is an immaterial void, pale, remote, and sunless, with a fantastic, spreading silhouette. The rare line of the horizon, marking the observer's point of view, is soon lost among the trees and rocks.

There is a similar landscape in the writing of Flaubert, who, like Cézanne, knew the alternatives of contemplation and despair, and bound himself in art to an exacting discipline of reality and the word. In his great novel, *The Sentimental Education*, he describes the same forest of Fontainebleau as the setting of two lovers who have left Paris for the peace of nature during the convulsions of 1848. "The path zigzags between the stunted pines under the rocks with angular profiles; this whole corner of the forest is somewhat stifling, a little wild and close . . . One thinks of hermits . . . Rosanette stumbled, she was in despair and wanted to cry. . . .

"The light . . . subdued in the foreground planes as if at sundown, cast in the distance violet vapors, a white luminosity. . . .

"The rocks filled the entire landscape, . . . cubic like houses, flat like slabs of cut stone, supporting each other, overhanging in confusion, like the unrecognizable and monstrous ruins of some vanished city. But the fury of their chaos makes one think rather of volcanos, deluges and great forgotten cataclysms. Frédéric said that they were there since the beginning of the world and would be there until the end. Rosanette looked away, saying that it would make her go mad."

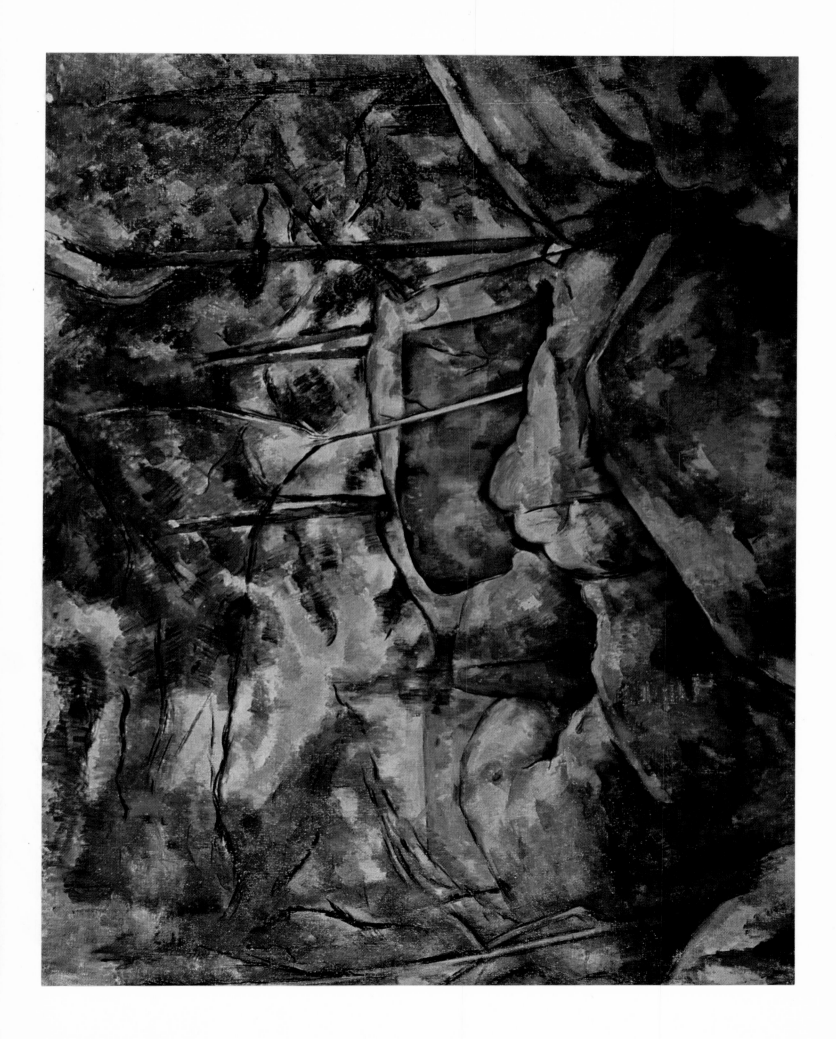

Painted 1898–1900

WOODS WITH MILLSTONE

Collection Mrs. Carroll S. Tyson, Philadelphia

$(29 \times 36\frac{1}{4}'')$

CÉZANNE PAINTED the *Woods with Millstone* in the South near his home at Aix. A photograph of the spot proves him remarkably faithful to the encountered scene which offered him an example of a natural chaos with traces of man in the abandoned blocks of quarried stone. But what concern us are the qualities of the picture which are more intense or of another order than those of the original site. The image is of an interior of nature, like a cavern, obstructed and without horizon or exit or outlook beyond, a wild romantic site with something of melancholy and hopelessness, but also the fascination of a huge disorder. It is the grotto of the raging, blinded Polyphemus, strewn with natural and human debris. Only the millstone with its smooth and centered form set oddly in a corner is a note of humanity at home, against which we may measure the turmoil of the other forms. Yet its purity or abstractness of shape makes it seem less human than the roughness of the rocks and trees.

The space as a hollow has no definite form; the tilted ground fuses with the objects that rise from it and with the masses of foliage in a vertical effect like the still lifes of the same time. Lines radiate in different directions from the same axis or cross each other in their opposed movements. It is a painting built of unstable forms, without vertical or horizontal lines, completely un-architectural in spirit. Yet it is a powerfully ordered canvas in which we discover as intense a search for harmony as in the most serene works. Very striking is the pairing of elements: twin trees, twin branches, twin rocks, twin blocks of cut stone, which are composed with an eye to contrast and delicate variation as well. Especially fine is the conception of the graceful trees, twisted and divergent at the left, more smoothly curved and parallel at the right. Within the chaos of the site survives something of a natural order and rhythm.

An interesting invention is the trail of the diagonal on the ground: a shadow line at the extreme right continued in the blocks of stone and resumed in a further shadow line carried to the other end of the canvas. In its slope and fine curvature, in its changing color and branching detail, this line is like the tree trunks and introduces in the ground an element that appears most strongly in the vertical planes.

The color is a somber harmony of brown, violet, green, and grey—mixed tones that belong to an enclosed, sunless world. But this scale is illuminated by a stormy flashing of lights and darks, which also create a powerful modeling. In the rocks are daring divisions of the surface modeled with abrupt contrasts of color. The whole is painted with a wonderful sureness, but also with a passion approaching fury. It is rendered as if by a giant for whom these objects are his most familiar world.

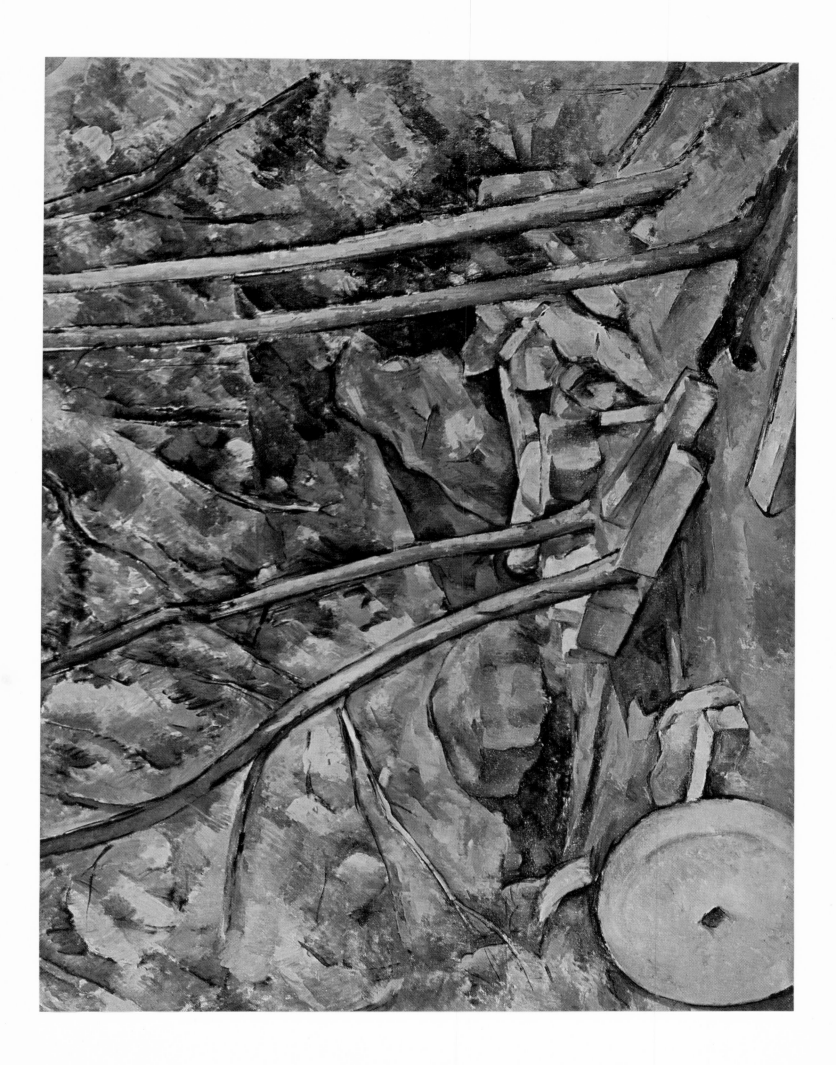

Painted 1904–1906

LE CHATEAU NOIR

*The Museum of Modern Art, New York
(Gift of Mrs. David M. Levy)*

$(29 \times 36\frac{3}{4}'')$

THE PAINTINGS OF CÉZANNE'S LAST YEARS have an epic largeness. He sees nobly and builds with a few clear objects; but these are tremendously alive, throbbing with color and the powerful rhythm of the brush strokes. Each area approaches an ultimate of movement and depth, within the limits of simplicity and grandeur of form. The strokes have become larger and more impassioned, the silhouettes more flickering in their contention with neighboring tones. In this impulse-charged rendering of great masses, the smallest inflections count, without appearing contrived. The pliant tree at the left, the thin wavering lines of branches in the sky at the right are responding forms, which seem to flow from the rhythm of the surrounding strokes. The irregular and, in places, flame-like silhouette of the trees against the sky and building has no drawn outline, but owes its moving form to the life within the colored mass. It is contrasted with the regular forms of the building—a stable ruin, in which we feel, however, through the patched, hot coloring and vibrant edges, the pulse and instability of life. It is an exalted, passionate meditation, in which the great constants of the forest, the building, and the sky are suffused with the artist's deep fervor.

Its simplicity belongs to the greatest masters. In the middle of the space is the roofless building with severely vertical and horizontal forms, like the canvas itself, and with burning orange tones; it is marked, near the center of the canvas, by a red door. This bare right-angled form, cut diagonally by the trees, and itself asymmetrical and broadly diagonal in profile through its stepped lines, resists and is absorbed into a more unstable whole of great asymmetrical zones—the deep blue sky and the darker trees below which slope across the entire canvas. (The yellow spot reserved in the lower left corner is a necessary element of this diagonal drift.)

The third dimension is achieved by the barest means, without a single horizontal plane and with only the slightest element of foreshortening, by the overlapping of the three large masses of trees, building, and sky, and by the unequal intervals of brightness in the series of the three major tones.

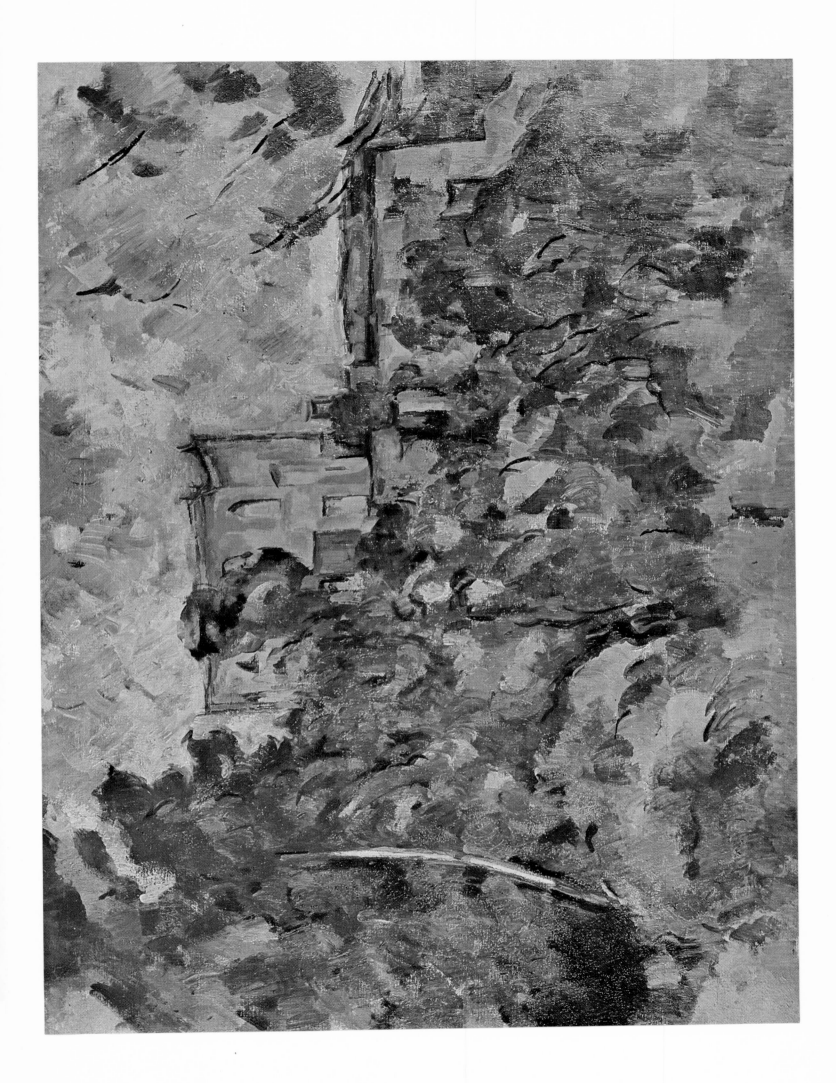

Painted about 1904–1906

MONT SAINTE-VICTOIRE

Collection Mrs. Carroll S. Tyson, Philadelphia

$$(25\tfrac{5}{8} \times 31\tfrac{7}{8}'')$$

TOWARD THE END OF HIS LIFE, Cézanne's painting becomes passionately free, to the point of ecstatic release. The intensity of feeling that marked his early romantic pictures returns in a new form. It is no longer a painting of excited mental images of human violence and desire, but a stormy rhapsody in which earth, mountain, and sky are united in a common paean, an upsurge of color, of rich tones on a vast scale. It is an irrepressible lyric of fulfillment which reminds us of Beethoven's music. The dynamism of fervid emotion possesses the entire canvas. The contrasts are not simply of the stable and the unstable, as in his other works, but of different kinds of movement and intense color. The mountain rises passionately to the sky and also glides on the earth. Its surface is like a perspective network of ascending lines, converging to the peak as a goal. The sky in turn bursts into a dance of colors, an explosion of clouds of blue and green, as deep and strong as the blues and greens of the earth—tremendous volumes of sonorous color which form a tempestuous halo of pure tones around the glorious mountain and give the latter a more living, dramatic quality. The earth approaches chaos, yet is formed of clear vertical and horizontal strokes in sharp contrast to the diagonal strokes of the mountain and the many curving strokes of the sky. These reappear in the lower foreground in blues and purples and violets, a reversed echo of the distant mountain.

Under all this turbulence of brushwork and color lies the grand horizontal expanse of the earth.

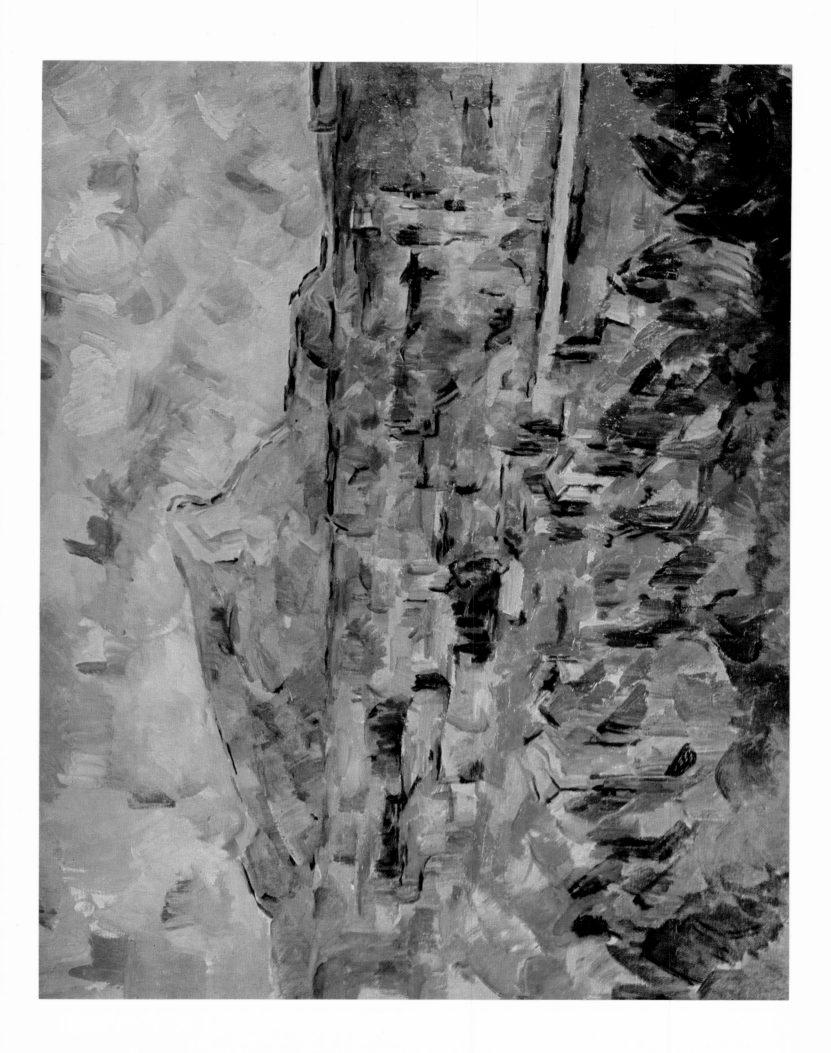

Painted 1906

PORTRAIT OF VALLIER

Collection Mr. and Mrs. Leigh B. Block, Chicago

$(25\frac{1}{2} \times 21\frac{1}{4}'')$

IN HIS LATE PERIOD, Cézanne often paints common people: peasants, servants, simple folk, always with great respect and in a posture and proportioning that gives them dignity and weight. In his taste for the peasant there is perhaps something of the conservative reaction against the modern city world and a desire for an older, simpler, more stable order of things—a common reaction among the French bourgeoisie of the time, which might underlie to some extent the classic turn in Cézanne's art in the 1880's. We observe it, too, in his friend Renoir who shifted from scenes of urban gayety to domestic subjects and idealized types of the mother and the peasant in a style more formal than his earlier Impressionist work.

The masterpiece among Cézanne's paintings of common folk is the portrait of his gardener, Vallier, one of his last works. It is an imposing image of a man, and represents Cézanne's ideal of simplicity and strength in repose, together with his own youthful, robust, rough-hewn nature carried into old age.

For a similar conception of man one must turn to Titian and Rembrandt. It concerns an aristocracy which is not founded on power or accomplishment, but on inner strength. This plain man is big without swagger or self-consciousness, at peace with himself without resignation.

The silhouette is grand in its breadth and fullness. In the choice of the profile view and in the clear placing of the half figure against the dark ground, there is a return to primitive design. So clear and compact an outline is uncommon after the sixteenth century. The body has the aspect of an early statue. Such compactness is rare even in the Renaissance. It is not a conventional form here, but a unique, newly devised solution inspired by Cézanne's sense of his subject; it is, in short, an interpretation.

Here the devices of continuity are felt not so much as means of composition or of surface unity as of expression: the beard flows on to the line of the shoulder and arm, as the arms meet in the lines of the sleeves, to create the stirring self-possessed quality of the whole mass of the figure. The features are hardly studied; the character resides more in the body, the posture and large form.

A characteristic grace of this image of the tranquilly self-sufficient man is its lyrical, exuberant color. Cézanne has transposed to the human form and especially the clothes all the life of his late landscapes. With a sure brush, with a freedom that is grandiose in its action, he disposes of his whole spectrum on the monochrome objects. No Impressionist has painted a beard so colorfully, or given a sleeve that marvelous abundance of tones. The elements are of big impact, but fuse into a whole which in its richness and brilliance remains noble and reserved. We feel within the boundaries of this most compact form a great energy and warmth of feeling. A wonderful luminosity, too, which is diffused through all the mass; it is no probing light and shadow, like Rembrandt's, and does not invite us to scrutinize the features more deeply, but is a quality of the whole contemplative being, which offers itself frankly and calmly.

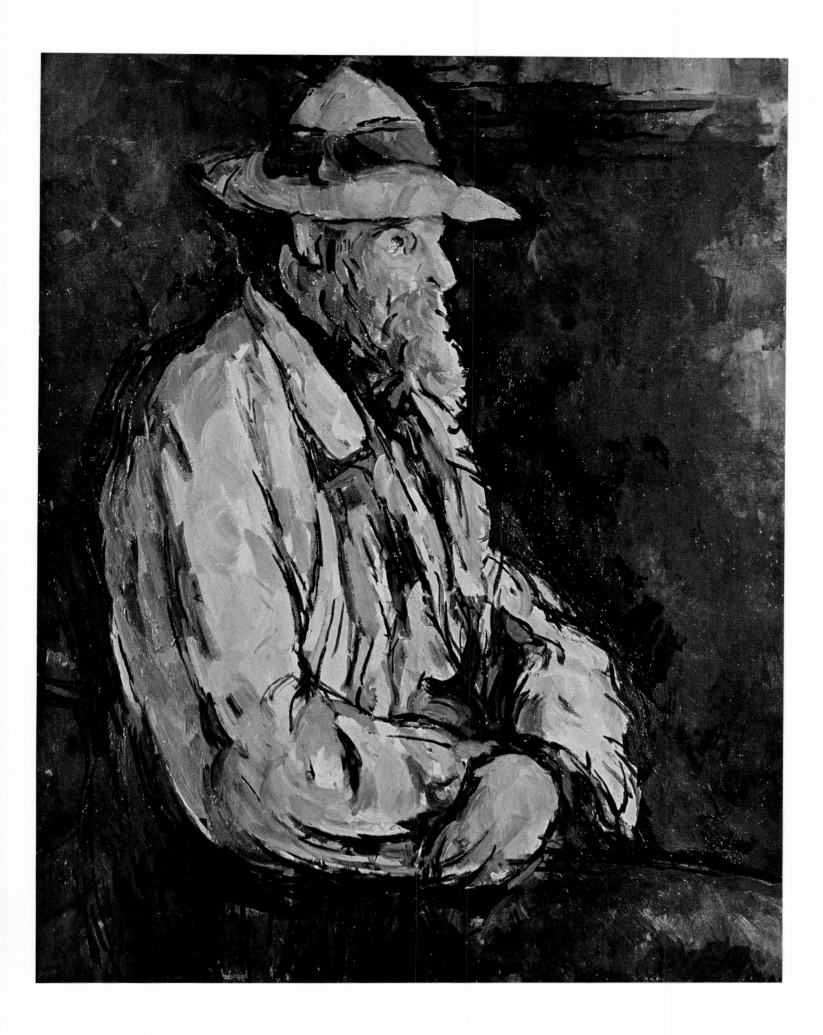